Keith Haring

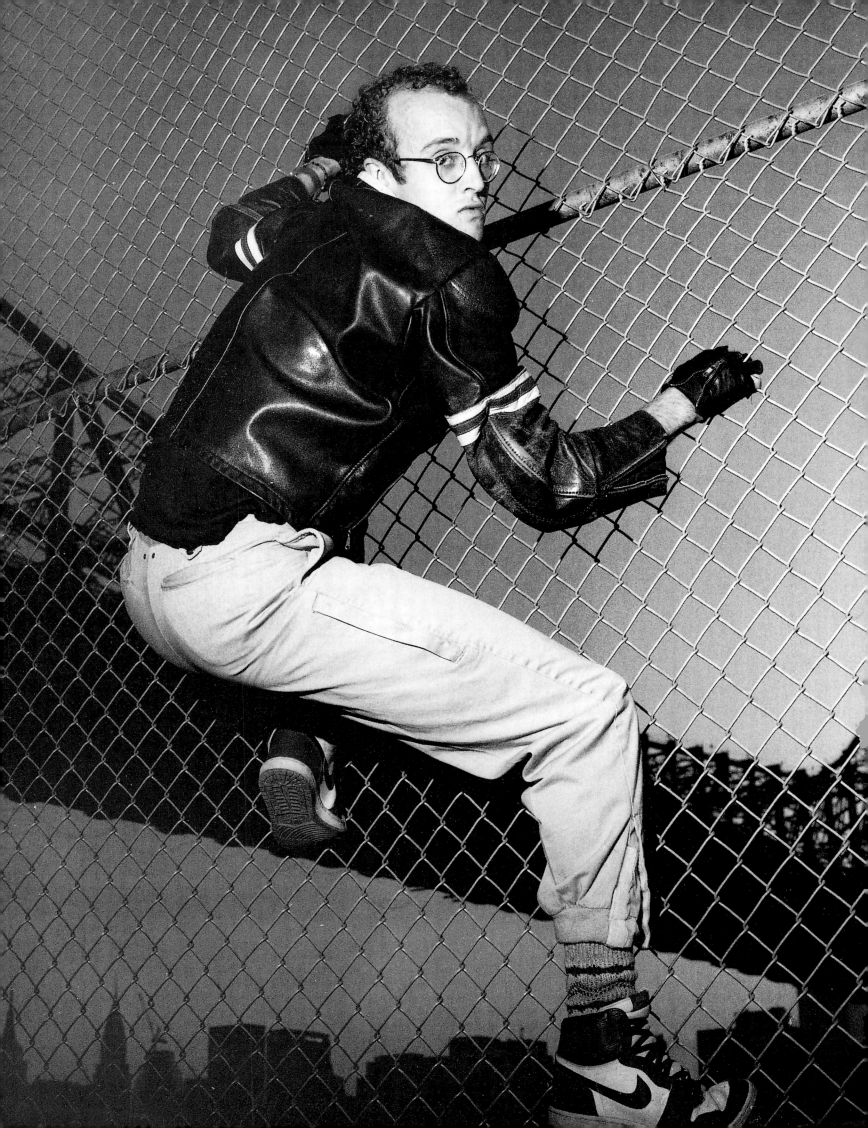

Keith Haring

Edited by Germano Celant

With contributions by Barry Blinderman,
Germano Celant, David Galloway, and Bruce D. Kurtz

Prestel

"Keith Haring: Labyrinths of Life and Death"
translated from the Italian by Joachim Neugroschel

Front cover: *Monkey Puzzle*, 1988 (plate 123)
Back cover: *Untitled*, 1985 (plate 108)
Frontispiece: Keith Haring at Roosevelt Island Park, New York, 1987

Prestel-Verlag
Mandlstrasse 26 · D-80802 Munich, Germany
Tel. (89) 381709-0; Fax (89) 381709-35
and 16 West 22nd Street, New York, NY 10010, USA
Tel. (212) 627-8199; Fax (212) 627-9866

Prestel books are available worldwide.
Please contact your nearest bookseller or write to either of
the above addresses for information concerning your local distributor.

Designed by Heinz Ross, Munich
Typeset by OK Satz GmbH, Gröbenzell
Color separations by C+S Repro, Filderstadt
Printed by and bound by Interdruck Leipzig GmbH, Leipzig

Printed in Germany

ISBN 3-7913-1234-0 (English edition)
ISBN 3-7913-1223-5 (German edition)

Contents

Acknowledgments

Keith Haring had the singular ability to depict the complexity of the present with both its sublime and horrifying aspects as well as its marvelous and monstrous forms. He did so by means of lightness and irony, pleasure and gaiety, inter-woven with an iconographic hardness and an acuteness rooted in the origin of his myth as a both angelic and demonic artist. This myth was fully experienced in Haring's time, which was made up of the computer and the subway, space-ships and television, racial uprisings and ethnic repressions, consumerism and AIDS. Haring, offering a visual and religious, a political and social interpretation, was quite aware that the fundamental meaning of human existence, both per-sonal and collective, is not death, but rebirth. This book tries to grasp the rites of initiation and transmutation with which Haring sought to guarantee rebirth for himself – that is, access to a metahistorical condition: art.

For their kind willingness to attempt a reading of this sacrificial and sac-ralizing ceremony, I am grateful to Barry Blinderman, David Galloway, and Bruce D. Kurtz, whose theoretical contributions have given voice to Haring's individual and public themes, and his formal processes. In preparing this book, I had the good fortune of receiving encouragement and assistance from many quarters. Above all, I have to acknowledge the invaluable help I received from the Estate of Keith Haring and its director, Julia Gruen, assisted by David Stark. Without their valuable advice, sensitivity, and continual availability, this book would not have seen the light of day. I am also grateful to Tony Shafrazi, with his assistant Margaret Poser, for his faith and enthusiasm, which led to the realization of this project: it became my reference point for a deeper knowledge of the oeuvre of an artist and friend, Keith Haring.

I owe special thanks to Pandora Tabatabai Asbaghi; working with her is al-ways a marvelous experience. The selection and volume of material greatly ben-efited from her advice and suggestions, and I am also grateful for her patience and cooperation.

Thanks are further due to the following individuals and institutions: Casino Knokke, Knokke le Zoute, Belgium; Robi Dutta; Galerie Hans Mayer, Düsseldorf; Alfred and Daniel Lippincott; Musée d'Art Contemporain, Bordeaux; and Klaus Richter.

Finally, I would like to express my gratitude to the staff of Prestel in Munich and to Hendrik te Neues for their great professionalism in implementing this publication.

GERMANO CELANT

Keith Haring:
Labyrinths of Life and Death

GERMANO CELANT

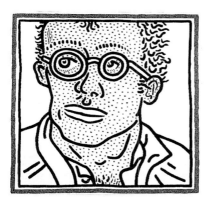

Fig. 1 *Untitled* (Self-Portrait), 1985. Acrylic on canvas, 48 x 48". Private collection

For Keith Haring, painting was a crucible – a site of transformation, of birth and death, a place where objects, lines, colors, and forms went through a creative catharsis and were then transmuted in order to experience a tempest of personal and social, erotic and mystical impulses. This alchemy produced labyrinthal images filled with dreamlike flashes that absorbed the flow of figures and representations – some of them cruel and tragic, some of them playful and happy. Haring's physicalized language and his environmental and material poetry brought forth a network of interweaving signs that could act on the nervous system of a city such as New York, profoundly challenging the encoded and elitist system of art.

Haring's visual tempests emerged from the boundless energy of gestures and movements externalized on city walls, the unceasing vitality of New York's everyday domestic decor, whereby his efforts altered the cityscape with its fantastic lifeblood and its libidinal power, its exciting colors and scenes of desire and collective drama. These teeming, overflowing mosaics of animal and human creatures, giants and monsters copulating, crossbreeding bizarrely, depict infernal scenes, in which the hero, black and homosexual, undergoes torture or submits to the deliriums of a society possessed by the demon of money and TV consumption. It is a wholeness, a fullness that Haring accepted unreservedly, with a kind of mystical participation, as if wanting to take on the job of "representing" a universe in which everything is excrement, sperm, sex, anarchy, cruelty, blood, and death. Resorting to a legacy of symbols and archetypes that lurk in the collective unconscious, Haring introduced a vortex of tremendous disorder, a spasmodic agglomerate of seething images. Latent things awoke, to reveal the authentic matrix of life and existence in a city such as that of New York, which revolves around frenzy, abnormality, and gratuitousness.

Haring's paintings were feverish; they flouted economic laws and became a "gratuitous" energy that defied boundaries. They were conceived elsewhere, in the meanderings of the subway (see plates 6-9, 64, 65) and on the flaking walls of Manhattan (plate 10) as well as on the lithe bodies of performers, from Grace Jones (plates 69, 70, 102) to Bill T. Jones. These paintings were pulverized and then petrified as gadgets, or else turned into cartoons and children's stories. Everything was sacrificed to the maelstrom of an existence that burned airy and

volatile images capable of leaving disquieting imprints in the shadowy world of publicity, television, billboards, theater, and dance.

But what is the visual and subjective matrix of these tangles of highly condensed and feverish signs, these vortices of data figures that can pierce the minds of spectators who, conditioned by the emptiness and mediocrity of everyday images, are fascinated by the existential and erotic fullness of Haring's work? Why do his paintings and sculptures overflow with forms and colors, lines and tissues, and what obsession informs their density and passion? What is Haring's linguistic strategy, a strategy that recruits in an ardent organic atmosphere in which bodies mingle confusedly in an extremely intense and pullulating genital delirium of masturbation and copulation? What hallucinatory and oneiric universe has spawned his demons and angels? What vivifying breath has inspired a continuous formal and iconic creation that spills onto the stage of the world?

Above all, the direct gesture and the fascination with live action were linked to Haring's earliest experiences as a live video and theatrical performer: from 1978 to 1980, he studied at New York's School of Visual Arts and performed at Club 57, identifying physically with his language. In verse and prose, in images and figures, he thereby reintegrated the vital force that circulated in the magma of his drives. Thus were born the tangles of poetry and music read or improvised in the basement on St. Mark's Place or videotaped, when Haring almost pierced the monitor surface with his face and mouth (see Figs. 5 and 6, p. 29). Then, in 1981, it was with the real time of the video that Haring was "reflected" as if in an opaque mirror, discharging his liberating energy on the black, obstructed surfaces of subway billboards. Indeed, it was by means of video or theatrical action or performance – for instance, at the "Acts of Life Art Show" in June 1980 (Fig. 2) – that Haring managed to implement a creative ceremony aimed at the public and to sketch out a *mise-en-scène* of the artistic gesture – in verbal form or as a painting or a piece of sculpture.

By abandoning himself to the TV camera or the Club 57 audience, Haring modified the usual artistic pose in order to externalize unconditionally. He suc-

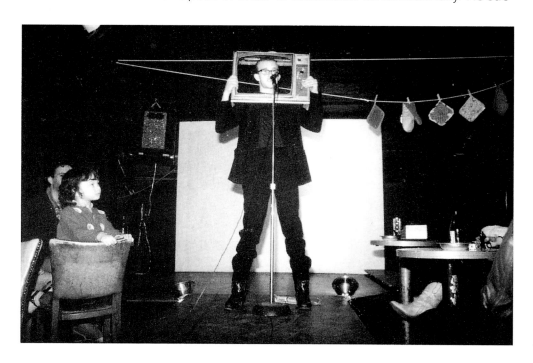

Fig. 2 Haring performing at the "Acts of Life Art Show," Club 57, New York City, June 1980

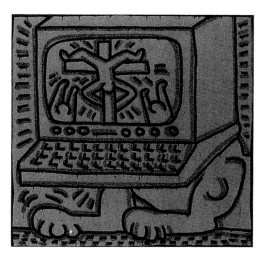

Fig. 3 *Untitled*, 1984. Acrylic on canvas, 94 x 94". Private collection

Fig. 4 *Debbie Dick*, 1984. Acrylic on muslin, 60 x 60". The Estate of Keith Haring

ceeded in furnishing instantaneous information about his own existential and introspective condition, virtually displaying his own processes and creative data as they materialized. This helps us to understand his "live" drawings and paintings of his sensual and sexual, his political and social visions for all kinds of spectators – from subway riders to graffiti artists, from children to other artists. And we can likewise comprehend his chameleonlike adaptation to any type of object or environment – from an amusement park to his Pop Shop, from a theatrical backdrop to a clock, from a vase (see plates 43-49) to a bicycle, from a T-shirt to a screen. Such an ability is typical of the aesthetics of TV and other kinds of spectacle, which aim more at the continuous flow of real time than at a selectivity of subjects.

Furthermore, Haring never seems to stop; he never congeals in a fixed identity drawn from the fluidity of lines and images: he projects himself into an unbroken fullness that swarms with figurative ramifications and carnal hieroglyphics. He virtually yields to a "nuclear" reaction that develops a chain of libidinal and oneiric material or else loads it with its own spatiality and slakes off a new theater of operations without limits or frontiers, times or intervals.

In Haring's paintings and drawings, the continuity is tied to the incessant motion of the line, which runs without caesuras, following its flow of awareness and fancy, developing bends and folds, lending weight and concreteness to labyrinthal conflicts, in eros, with its penetrations and couplings, filling all the gaps, joining and uniting all bodies. It was as if the line were striving to form a Pompeian mosaic of lecherous scenes triggered by a technological consciousness that tends to suggest the telematic constellation of the TV monitor or computer screen.

It is no coincidence that many of Haring's works evoke the iconography of an atomic reaction and the mirror/screen of a TV set, whose neutrality twists and distorts the world. Frequently, this is inserted into, or superimposed upon, the head or bust of a barking dog (see Fig. 3) or a human figure, and the depiction involves maximum information in minimum extension. Haring applies the same concentrative power to his flows of lines and images: with the exuberance of signs, they move from point to point, producing a "flux of visual awareness," which is inscribed in some other flux, such as the New York City subway, or in some other line, such as the Berlin Wall (plate 96).

In this sense, the turbine of his art seems to run uninterruptedly, devoid of memory and planning. Haring entrusts himself to technology, whereby, like a Zen monk, he becomes an instrument and filter of seeing and feeling. His is an open practice capable of mimicking the world. Mimesis is a search for complicity between art and society, and to this end, Haring, like Andy Warhol, moved through the media like a fish through water. He furnished a sufficiently clear image of himself through the repetition of several icons that circulated in the mass media: the radiant child (see plate 3), the barking dog, the dolphin, the pregnant woman, the flying saucer (see plates 18, 21), Debbie Dick (see Fig. 4), the pyramid (see plate 24), and so forth. Each became a logo, a title, a slogan ("Crack Is Wack," plate 95). Here, art was lost, turning into something else through transit: *Art in Transit*.

This principle of transit implies the maximum experience of the present, an identification with the daily process of history. In fact, Haring sided with reality by distributing twenty thousand posters for an antinuclear rally in 1982 and for

a "Free South Africa" campaign in 1985. He also participated in "Art Against AIDS," painting a mural, *Together We Can Stop AIDS*, in Barcelona; and he created an on-site work at the 1985 "Live Aid" concert benefiting African Famine Relief. At the same time, Haring got involved in the open system of the world; he focused on the present, not a future plan or utopia, and opened the Pop Shop in New York and Tokyo. Beginning in 1984, he collaborated with a variety of stars from the worlds of film, art, fashion, dance, and videomusic, including Brooke Shields, Andy Warhol, Jenny Holzer, Bill T. Jones, Grace Jones, and Madonna.

Haring served a public energy that amplified the news, giving it greater resonance. He became a mass-media event, a popular phenomenon of youth culture. His paintings eliminated distinctions between black and white, heterosexual and homosexual, human and animal, natural and artificial. He fed off any subject, immersing himself in its linear and figural universe, devouring it, and then expelling it. The exuberance of his spectacles revealed a certain Situationist spirit, which moved him to give without wanting to receive. He drew thousands of images and stories in subways, and he did hundreds of yards of paintings in New York, Chicago (plate 125), Pisa (plate 127), Sydney, Berlin, Tama City, Atlanta, Barcelona – on the walls of schools, hospitals, and abandoned buildings – without receiving monetary payment. In this way, his discourse was socialized and mediated by children and all social strata. His challenge was a sacrificial one, a self-spectacle, as a moral and mystical alternative to an existence that tends to blur its own subjectivity in favor of a social and collective identity.

Haring transformed his paintings into events, manifesting artistic life, artistic vitality in its pure state – whereby "life" meant nonrepetition and live creation. This led to his religious formation and culture (the adolescent Haring became a Boy Scout, almost a Jesus freak) and to a secret alliance with the notion that history is based on a precise design – that of the godly and the sacred.

These tendencies explain Haring's rhetorical figures of the cross and the radiant aureola, the creature with the hole/soul (see plates 4, 5), the *Ten Commandments* installation (plates 105, 106) at Bordeaux's Musée d'Art Contemporain, the monstrous Saint Sebastian (Fig. 5) pierced not by arrows but by tiny airplanes. Then there was the symbolic force of diabolical numbers, such as 666, and of "maternity," reiterated in the figure of the pregnant woman; there was also the value of love in its associations and/or dialogue, as expressed in the two human figures holding a big, red heart (see plates 23, 64); and finally, the theme of ascent, relating to the symbolism of stairs and the climb to a higher, ethereal and celestial condition (see plate 1).

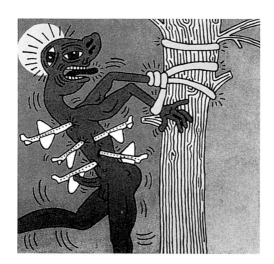

Observers have talked about the decorativeness of Haring's approach. Now the pleasure of decorating is a vital wandering that cannot stop in any projection on a surface or an object; it is a fruitful power that converts into any situation or condition, from a mobile to a mask, from a vase to bicycle wheels. For this reason, Haring's journey was also chaotic, for chaos is life, in which every element of creation opposes and contradicts stasis and definition. The same may be said of Haring's humor, which he applied to the deformities of things and bodies; his humor was meant to reactivate buried energies and to explode the serious fixity and compression of art.

Haring's fluid and situational language passed through the elastic and flexible character of the line and the disarticulation or situational power of the

Fig. 5 *Saint Sebastian*, 1984. Acrylic on muslin, 60 x 60". Private collection

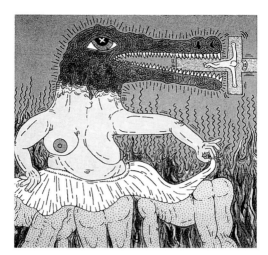

Fig. 6 *Untitled*, 1986. Oil and acrylic on canvas, 96 x 96". Private collection

representation. Self-liquefaction and interweaving were transfused into his iconography. Thus, as of 1981 he painted fantastic figures and creatures, such as a computer with a human head or a face with two eyes and three noses, or an extendible penis and tongue, or a nose transformed into a trunk. And in the animal realm, a dog, a centipede, a snake, a pig are hybrids with multiple faces and monstrous genitals. The result is a contemporary bestiary; unlike the medieval bestiary with its sirens and unicorns, its insect knights and locust warriors, which were also typical of Oriental frescoes and the paintings of Hieronymus Bosch and Pieter Brueghel, Haring's visions introduced new grotesque motifs relating to our present age. His bestiary is tied to the dollar and to the consumerism of gadgets – TVs, radios, microcomputers, clocks, cameras – which, as in *Untitled* (1983; plate 31), form a mountain between two Michelangelesque monsters or, in *Untitled* (1984; plate 71), create an inflow feeding the Great Mother, whose numerous teats nourish many human beings. In *Untitled* of 1986 (Fig. 6) the Great Mother becomes a great whore with a green crocodile head (green is the color of the dollar); immersed in an infernal fire, she devours the crucified Christ. Elsewhere (plate 89), we see a black figure being strangled and chained by "white" giants and a skeleton, handcuffs used on behalf of a phony peace dove and a Christian cross. The torture takes place on a river of blood disgorged by our planet and inundating other figures, white, black, red, and yellow, whose desperate hands lunge out of the bloody wave.

At times, Haring drew the multiple heads of the beast of the Apocalypse, its torso sprouting branches that become animals with monstrous maws. At other times, the animal or human transformation personifies our present-day vices, producing living fruits; or else the evolution of the figurations brings forth a landscape: *Untitled* of 1984 (Fig. 7) is invaded by a legion of demons and dragons with ramified bodies in the shape of bats or serpents, with the claws or tails of reptiles – half-beast, half-human animals with twofold bodies that devour or copulate, killing and castrating other hybrid creatures.

The themes of the double and of eros are mirrorlike. Sex is intermediate between two complementary entities; it guarantees interhuman relationships. Hence, it is a transit, a union, a reconciliation and a harmony between different identities. It participates in the unbroken, unrelenting circular movement that unites the linear routes in Haring's paintings. The penis, for "him," is another intermediary line that closes and concludes, tracing a "life path" and an itinerary for the slaking of desires as well as an allegory of feeling "high," being surrounded by an aureola. The erotic figuration is a further thrust toward unity and the loss of one's own individuality; it is a transmission of insistent and lasting gestures and actions that represent a mystical, cosmic, and orgasmic communication, a uniting through emptiness. It can be a lunge toward sin, evil, profanation; however, it always goes further, expressing a passage of information between two transmitters. It occupies the gaps; it is not a point of arrival so much as an index of movement: love in transit. Haring uses sex as the ultimate metaphor of a flow or transmission between demon and human, beauty and ugliness, nature and artifice. And if the genital organ is a technological instrument for connecting two "terminals," it establishes a coming and going, a to-and-fro in his paintings; the transmission of information and its visualization on a screen becomes erotic. The graffiti in subways or on the wall of the Casino Knokke (1987), the robots and the machines are frequently linked to one an-

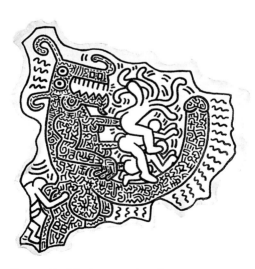

Fig. 7 *Untitled*, 1984. Acrylic on canvas, 72 x 77". The Estate of Keith Haring

other and undergo corporal exchanges, establishing incestuous networks or performing a cannibalistic gesture, thereby approaching creatures and monsters dominated by sex and television, consumerism and religion. In an untitled work of 1985 (plate 72) the *anus dentatus* of the hybrid figure with the five eyes and the framed monitor mouth emits bifurcated tongues/hollows that castrate, imprison, and condition the human being, while at the side a Bible releases snakes and a cross pierces a cerebral mass.

The identification of eros and mass media ultimately reinforces Haring's desire to guarantee worldwide circulation for his art. It is based on the faith that its distribution, duplication, and dislocation seduce and inform an enormous number of people. In these terms, the erotic and telematic relationship is similar to a political relationship – that is, it relates to its own kind. It reveals a desire for a dialogue and for an amorous relationship based on the free circulation of minds and bodies, faiths and beliefs, perversions and corruptions. It is a highly ecumenical process that never demands, asks, claims, or challenges; rather, it favors, fosters, transports – on the supposition that in good or evil, in pleasure or torture, in the marvelous or the horrible, the desire of lover and beloved, of artist and public, are secretly one and the same.

Haring's Place in Homoerotic American Art

BRUCE D. KURTZ

*We have cooperated for a very long time
in the maintenance of our own invisibility.
And now the party is over.*

Vito Russo, *The Celluloid Closet*, 1981

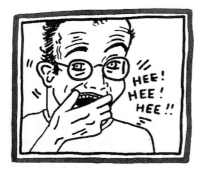

Fig. 1 *Hee! Hee! Hee!!* (Self-Portrait),
1985. Red and black sumi ink on paper,
22 x 30" (sheet). The Estate of Keith
Haring

Keith Haring had very few role models of out-of-the-closet gay American artists to point him toward a way to be gay and an artist in America. Despite the few markers along his route, Haring found the way to make in-your-face, proud-to-be-gay, homoerotically explicit artworks. What he had to work against, how he achieved what he did, and what it has meant to subsequent artists are the subjects of this essay.

Several months before he died of complications due to AIDS in 1990, Haring told me that being mortally ill had given him a new appreciation of life, of its small pleasures, such as the feeling of the sun on his face. Though the HIV virus was destroying his body, he maintained a great appetite for life. The energy of Haring's line – the basis of his art – reflects the artist's gregariousness and eagerness for experience. When he first moved to post-Stonewall New York, he delved into the promiscuous gay sex life that was then taken by gay men to signify their liberated status. In this post-gay liberation, pre-AIDS atmosphere, Haring went as often as twice a week to a gay bathhouse on Second Avenue near Houston Street, in the vicinity of which he had once lived. Haring expressed his status as a liberated gay man – as opposed to Warhol's more closeted gayness of the early 1960s – in sexually explicit, cartoonlike homoerotic images.[1]

Unlike their European confrères, artists in the United States were until very recently required to be heterosexual, or at least to pass as straight. Any expression of gay content implicated the artist as gay and placed both him and his art in the outer regions of acceptability (some say it still does).[2]

Two of the very few American artists to have "implicated" themselves in their art prior to the 1960s were Paul Cadmus (born in 1904) and Marsden Hartley (1877 - 1943). The unflattering depiction of carousing sailors trying to pick up floozies was given as the Navy's reason for removing Cadmus's government-financed *The Fleet's In* (1934) from an exhibition planned for the Corcoran Gallery in Washington, D. C. Did the Navy not mention the gay pickup in progress in the painting because it was too deeply encoded, or because it represented "the love that dare not speak its name"? Cadmus also painted paeans to sensuous young men, often fully or partly nude, as in the locker room scenes *Y.M.C.A. Locker Room* (1933) and *Horseplay* (1935), in *Point O'View* (1945),

Fences (1946), *The Shower* (1943), *Survivor* (1944), *Aviator* (1941), *Playground* (1948), and *The Bath* (1950), as well as in the not so subtly encoded observation of gay lust, *Fantasia on a Theme by Dr. S.* (1946).[3]

The homoerotic content of Cadmus's work is perhaps obvious only to those who respond sexually to its stimulus. Thus, the Navy's (presumably heterosexual) Henry Latrobe Roosevelt may simply not have picked up on the coded image. Art produced on gay themes by in-the-closet gay men prior to gay liberation tends to have two parallel meanings: one that is evident to all viewers, another that is evident only to those who sympathize with the artist's sexual orientation. Vito Russo described the encoding of gay content when he said: "As a gay person, one grows up with the people around you, including your parents, assuming you are straight. At some point of course you know different, and so you acquire a kind of double vision. You are able to see both the truth and the illusion. Growing up with this double vision helps you to practice it on art, on cinema, or in writing, You imagine all sorts of things in order to create a world where you exist."[4]

Marsden Hartley encoded his homoerotic love for a German officer so well within his abstract paintings of 1914 to 1916 than their meaning was not discovered until after his death;[5] it was the German-ness of the images that Americans took Hartley to task for. Even now, his paintings must be perceived with the same "double vision" as their creator's in order to decipher their homoeroticism.

Jackson Pollock is the paradigm of America's insistence on hypervirile, heterosexual masculinity in its art heroes, not only in his art, but in his life as well. A boozing, brawling womanizer, Pollock was an exaggeratedly big bad dude, almost a caricature of American masculinity in the 1940s. Pollock's drip paintings were seen as metaphors for the various psychosexual roles that were then presumed to be the heroic male destiny. Pollock's process of laying his canvas on the floor, then treating it as an "arena in which to act," to quote the art critic Harold Rosenberg,[6] symbolizes frontiersmen in the American West. The "taming" of the West (mother earth), symbolized by the "supine" canvas dominated by the heroic male, who treats it as an "arena in which to act," along with the Indians whom he presumably "conquered" to make the world safe for civilization – these are the myths of the American West and of the white, heterosexual American male. Unspoken are the "tamed," "supine," "acted upon," and "conquered" roles that everyone else was then presumed to play.

The exaggerated masculinity of Pollock's heroic individualism renders virile, in an essentially American way, the more intellectual and less aggressive heroic individualism endemic to modernism and exemplified by the (heterosexual) European artists Marcel Duchamp and Max Ernst, who happened also to be in New York when "Jack the Dripper" let loose. In the land of cowboys and frontiersmen, where being a man of action was all that counted, most American artists before the late 1980s were somewhat defensive about being perceived as "sensitive" or "intellectual" – then code words for "homosexual" – which was then just about the worst thing that could be said about an American man.

The association of culture with femininity and, by warped extension, with homosexuality extends from nineteenth-century America right through to the 1980s. Pollock, Franz Kline, and Syd Solomon articulated this view of American culture when, while relaxing on a beach near East Hampton in the early 1950s,

Fig. 2 *Untitled* (for Bruce), 1986. Black felt-tip pen on paper, 11¼ x 15". Collection Bruce D. Kurtz

Fig. 3 *Untitled*, 1986. Sumi ink on paper, 22¼ x 33". The Estate of Keith Haring

they bemoaned "the lack of interest in art among most Americans." Someone suggested that, if all else failed, they could "just chuck it all and go teach old ladies to do watercolors."[7] As the authors of a recent Pollock biography put it: "Like the other artists of their generation, Pollock, Kline, and Solomon were acutely aware that, for the great majority of Americans, art was old ladies' business. They had inherited an aesthetic world shaped by Victorian sentimentality and administered, almost exclusively, by women. Men who strayed into that world were considered, at best, unproductive, at worst, homosexual, by those outside it."[8]

Pollock had become the dominant heroic figure in American art by the early 1950s. Though some observers perceived him to have sold out when his paintings started showing up in Connecticut summer homes and in the pages of *Life* magazine, Pollock narrowly rescued his heroic status by crashing into a tree, in female company, during a drunken binge. Death brought transfiguration and apotheosis. For artists, Pollock became not only the hero-artist, but the hero-role model as well. Contemporary artists had to be not only poor, misunderstood, antisocial loners, but also big bad dudes, hypermasculine, virile, and heterosexual.

Enter Andy Warhol, America's first flaming homo artist, who knew that he had a lot going against him. "Believe me," Warhol said, "I've made a career out of being the right thing in the wrong space and the wrong thing in the right space. That's one thing I really do know about."[9] As Dave Hickey put it: "Andy Warhol was no theorist, but he was a *great* problem solver and his problem with American culture in the late 1950s was that a hugely successful, gay commercial illustrator who wanted to be a hugely successful 'fine artist' hadn't a snowball's chance in hell of becoming one – because any image that he made would be defined by his 'commerciality,' his 'success,' and his 'gayness.' And these were 'bad' words at that time."[10]

Fig. 4 *Untitled*, 1983. Sumi ink and acrylic on paper, 72 x 69¼". The Estate of Keith Haring

As it happens, Warhol's gayness was the last of the "bad" words he overtly let out of the closet in his art. Anyone capable of reading the gay "double vision" – or, as Edmund White has termed it, the gay "oblique angle of vision"[11] – of Warhol's tabloid pages, Campbell's Soup Cans, Marilyns, Lizes, Elvises, Marlons, Warrens (Beatty), and Troys (Donahue) understood that they were Camp, the sensibility defined by Susan Sontag's 1964 essay "Notes on Camp." "Camp," she wrote, "is a vision of the world in terms of style – but a particular kind of style. It is the love of the exaggerated, the 'off,' of things-being-what-they-are-not."[12] Cases in point are Warhol's "being the wrong thing in the right space" and the "double vision." Camp, too, are Warhol's androgyny, his role-playing, his love of dramatic females, his practice of putting images in quotation marks, and his dethroning of the serious.[13] "Homosexuals, by and large, constitute the vanguard – and the most articulate audience – of Camp," Sontag wrote.[14] Anyway, no hypervirile, masculine, heterosexual, male artist would dream of making paintings out of pinups from fanzines, especially pinups of handsome young *male* stars.

But Warhol really came out of the gay closet with his movies *Blow-Job* (1963), *The Thirteen Most Beautiful Boys* (1964), *My Hustler* and *Camp* (both 1965), *The Chelsea Girls* (1966), *I, A Man* and *Lonesome Cowboys* (both 1967), not to mention the films featuring transvestites – a liking for whom no Pollock emulator would have admitted to in the 1960s – or the later Paul Morrissey films,

such as *Flesh* (1968), *Trash* (1970), *Woman in Revolt* and *Heat* (both 1972). If anyone had any remaining doubts about Warhol expressing his gayness in his art, in 1977, using some of the hundreds of Polaroids he had exposed of handsome nude young men, Warhol produced a series of paintings titled "Torsos." The following year he made prints, titled *Sex Parts* and *Fellatio*, explicitly depicting homosexual sex acts.

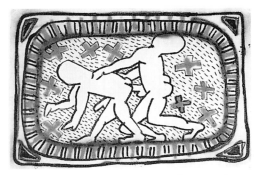

Fig. 5 *Untitled*, 1980. Spraypaint, sumi ink, and acrylic on paper, 48 x 69½". The Estate of Keith Haring

In my view, the stranglehold that the Pollock mythos had formerly had on contemporary gay artists in America was broken by Warhol and Haring more than by any other artists. Haring was a twenty-year-old student at the School of Visual Arts in New York City in 1978 when Warhol made *Sex Parts* and *Fellatio*. He had seen his first Warhol works – a group of "Marilyns" – at the Hirshhorn Museum in Washington, D. C., on a church-organized trip during high school.[15] Having grown up in a small Pennsylvania town – Kutztown – followed by a brief stint in Pittsburgh, Haring sought the artistically and sexually liberating milieu of New York. As a highly inquisitive young gay man, he had certainly tuned in to the "double vision" of Warhol's earlier work, and probably knew of the films and of the later, sexually explicit paintings, if not in 1978, then at least by 1983, when he met Warhol and the two artists became close friends.

The conditions that Haring (1958-1990) faced in making a place for himself in the world were different from those of the older Warhol (1928-1987). The year 1969, the date of the Stonewall Riots, is generally stated as the beginning of "gay liberation" – of "coming out of the closet," of gays demanding equal rights, of "gay pride," even of the widespread use of the term "gay" instead of "homosexual" or any of a number of terms of abuse. Many of the images expressing Warhol's gayness date from before then. Haring's coming out and coming of age took place well after the establishment of gay liberation – not that it was any easier to be gay in the 1980s than in the 1960s, or now; it was simply different.

One difference was that, in the 1960s, Warhol had almost single-handedly, and against great odds, established that it was possible to make and show art in America that expressed the artist's gayness – no mean feat. The only other living contemporary gay artist role models at the time were Cadmus, then existing in relative obscurity, and David Hockney (born in 1937), the young, eccentric British comer who made paintings with such titles as *The Most Beautiful Boy in the World* (1961), *Two Men in a Shower* (1962), *Man Taking a Shower in Beverly Hills* (1964), *Boy About to Take a Shower* (1964), *Man Taking Shower* (1965), *Two Boys in a Pool* (1965) – you get the idea – along with other tender and affectionate depictions of young male nudes. The British have always evinced tolerance of eccentricity, but Hockney went far beyond any other contemporary British artist, being, in fact, one of the few artists in the world – together with Cadmus and Warhol – to dare to be overtly gay in the 1960s.

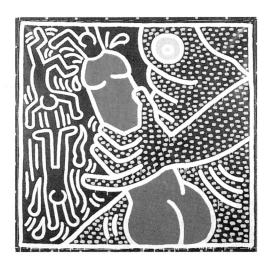

Fig. 6 *Untitled*, 1984. Vinyl paint on vinyl tarpaulin, 96 x 96". The Estate of Keith Haring

It is hard to imagine that, when Haring started making his cartoonlike homoerotic images in the late 1970s, only a handful of contemporary artists had risked such subject matter, and even fewer as explicitly as he. One of the latter was Robert Mapplethorpe (1946-1989), the cancellation of whose exhibition "The Perfect Moment" – which included homoerotic photographs – at the Corcoran Gallery in 1989 recalled the removal of Cadmus's *The Fleet's In* from the exhibition at the same museum in 1934. The well-known cancellation of the Mapplethorpe show, the brouhaha in the U.S. Congress over the National

Endowment for the Arts, the subsequent obscenity suit against another exhibiting institution (the Contemporary Arts Center in Cincinnati), and the jury's verdict of not guilty are all watersheds in the history of American art, of homophobia, and of oppression. Mapplethorpe began making and exhibiting his homoerotic photographs, of which nearly every gay artist was aware, in the early 1970s. Haring knew of, and admired, them.

At the time of his death, Haring's library contained books about the erotic art of Japan and Africa, of the artists Hieronymus Bosch, Aubrey Beardsley, Jean Cocteau, and Pablo Picasso, along with the writings of William S. Burroughs (with whom Haring collaborated by illustrating both *Apocalypse* and *The Valley*), Oscar Wilde, Jean Genet, André Gide, and Roland Barthes, as well as volumes on Warhol, Hockney, and Mapplethorpe.

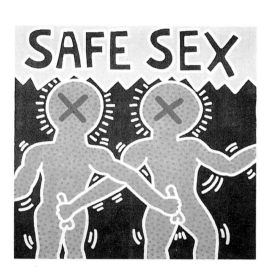

Fig. 7 *Safe Sex*, 1985. Acrylic and silver paint on canvas, 120 x 120". The Estate of Keith Haring

The large body of sexually explicit homoerotic drawings and paintings that Haring produced, beginning in the late 1970s and continuing until his death in 1990, is unprecedented in American art. These works carried further the legacies of Cadmus, Warhol, Hockney, and Mapplethorpe, as well as tying in both with the popular arts of soft- and hardcore pornography and with the sexually explicit nature of some graffiti.[16] What is most troublesome to some cognoscenti – and to not a few of the uninitiated – about Haring's homoerotic images is that many are as explicit as pornography. Yet their sexual explicitness is one of their most significant features.

While many people may feel that *any* explicit homoerotic image is pornographic, pornography's sole intent is sexual stimulation, and Haring's homoerotic images are more than mere sexual stimulation, achieving social and artistic significance not only through their subject matter, but for the same reason that his other art is significant: it crosses the boundaries between fine art, popular art, and folk art, occupying a territory between all three with greater authority and conviction than the art of any other artist who has attempted such a crossover.[17] Haring's homosexuality is only one of the many facets of his art. That he so successfully integrated his entire being – including his homosexuality – into his art is one of the many reasons why he has been taken as a role model by subsequent artists, especially gay ones.

In a book about gay and lesbian video and film titled *How Do I Look?* the editors wrote: "Pornography's place in gay men's self-representation has a complex history. On the one hand, its centrality is in part determined by the fact that *any* image of homosexuality is thought by many to be inherently pornographic; on the other hand, pornographic images are the one type of representation that is made explicitly for, and often by, gay men, and therefore has offered a measure of self-determination."[18]

Offering a measure of self-determination is the legacy and significance of Haring's homoerotic images. After him, a deluge of artists, from Robert Gober to David Wojnarowicz, Nayland Blake, Donald Moffet, Cary Leibowitz, Jack Pierson, and McDermott and McGough, among others, have proudly and powerfully expressed their gayness in their art, without the Camp, the "double vision," or the "oblique angle of vision" of earlier generations.

Notes

1 I have written elsewhere about the foundation of Haring's art in cartooning and in line. See Bruce D.Kurtz, "The Radiant Child (Keith Haring)," in idem (ed.), *Keith Haring, Andy Warhol, and Walt Disney* (Munich: Prestel-Verlag, and Phoenix, Arizona: Phoenix Art Museum, 1992), pp.143-51.

2 I use the pronoun "he" rather than "he or she" because the term "gay" refers to male homosexuals.

3 Painted in a stylized form of hyperrealism, Cadmus's work was both formally and thematically out of sync with mainstream American art, resulting in belated recognition of the artist. Only in the 1980s, when tolerance toward gay imagery started to increase – thanks, in part, to Haring's work in this vein – did Cadmus's career begin to emerge from the gay pall that had been cast over it. No doubt the reemergence of narrative, figurative painting in the 1980s also furthered Cadmus's recognition. In 1934 the balance in American art was tipped more toward abstraction than representation, with the explosion of Abstract Expressionism not far off.

4 "Extended Sensibilities: The Impact of Homosexual Sensibilities on Contemporary Culture" (a panel discussion between Arthur Bell, Jim Fouratt, Kate Millett, Vito Russo, Jeff Weinstein, Edmund White, and Bertha Harris), in Russell Ferguson, William Olander, Marcia Tucker, and Karen Fiss (eds.), *Discourses: Conversations in Postmodern Art and Culture* (New York: The New Museum of Contemporary Art, and Cambridge, Mass.: The MIT Press, 1990), p. 136.

5 Barbara Haskell, *Marsden Hartley* (New York: Whitney Museum of American Art, 1980), p. 43.

6 Harold Rosenberg, "The American Action Painters," in Henry Geldzahler, *New York Painting and Sculpture: 1940-1970* (New York: E. P. Dutton and Company, 1969), p. 342.

7 Steven Naifeh and Gregory White Smith, *Jackson Pollock: An American Saga* (New York: Clarkson N. Potter, Inc., 1989), p. 169.

8 Ibid.

9 Andy Warhol, *The Philosophy of Andy Warhol (From A to B and Back Again)* (New York: Harcourt Brace Jovanovich, 1975), p. 158.

10 Dave Hickey, "Andy's Enterprise: Nothing Special," in Kurtz (ed.), *Keith Haring, Andy Warhol, and Walt Disney*, p. 89.

11 "Extended Sensibilities," p. 131.

12 Susan Sontag, "Notes on Camp," in *A Susan Sontag Reader*, intro. Elizabeth Hardwick (New York: Farrar, Straus, Giroux, 1982), p. 108.

13 Ibid. Regarding androgyny: "The androgyne is certainly one of the great images of Camp sensibility" (p. 108). Regarding putting things in quotation marks and role-playing: "Camp sees everything in quotation marks. It's not a lamp, but a 'lamp;' not a woman, but a 'woman.' To perceive Camp in objects and persons is to understand Being-as-Playing-a-Role" (p. 115). Regarding dramatic females: "Allied to the Camp taste for the androgynous is something that seems quite different but isn't: a relish for the exaggeration of sexual characteristics and personality mannerisms. For obvious reasons, the best examples that can be cited are movie stars. The great stylists of temperament and mannerism, like Bette Davis, Barbara Stanwyck, Tallulah Bankhead, Edwige Feuillere" (pp. 108-9).

14 Ibid., p. 117.

15 John Gruen, *Keith Haring: The Authorized Biography* (New York: Prentice Hall Press, 1991), p. 18.

16 As I have written elsewhere, Haring never was a graffiti artist, but he admired the grass-roots expression of graffiti for its visual wit and sophistication, and the artists for their ingenuity in putting art before the public without going through galleries and museums.

17 See Kurtz, "The Radiant Child," passim.

18 Bad Object-Choices (eds.), *How Do I Look?* (Seattle: Bay Press, 1991), p. 27.

A Quest for Immortality:
The Sculptures of Keith Haring

DAVID GALLOWAY

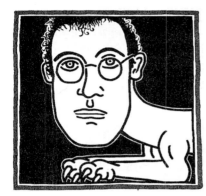

Fig. 1 *Untitled* (Self-Portrait), 1984. Acrylic on canvas, 60 x 60". The Estate of Keith Haring

Keith Haring's official debut as a sculptor came on October 26, 1985, when a series of free-standing figures, cut from steel and brightly lacquered, went on view at Leo Castelli's Green Street gallery in New York. The hundred-foot side walls were covered with a frieze of cartoon characters that, to Castelli's astonishment, Haring completed in a single day. The artist's aim was to create "the atmosphere of a wild playground," and he encouraged school groups to visit the show, insisting that "the kids be allowed to climb all over the sculptures."[1] That playful note, so consistent with Haring's belief in the communal, even "tribal" function of art, may in part account for the failure of serious criticism to credit his precocious grasp of this new medium. When three of the sculptures shown by Castelli were erected in Dag Hammarskjöld Plaza (see plate 108), it was a media event of the sort Haring loved and could skillfully exploit, but it was far from the considered appraisal for which he yearned.

Nonetheless, during the next five years he would greatly extend his sculptural repertoire, revealing waxing confidence and an eagerness to experiment with three-dimensional forms. In this sense, his sculptural apprenticeship had begun well before the Castelli premiere, with the decoration of *objets trouvés*, which prompted him to think of space as volume and not merely as a flat field for graphic activity. Such objects were regularly shown as complements to his works on canvas or paper, just as wall drawings provided a context for Castelli's presentation of the first fabricated sculptures. It was Haring's own gallerist, Tony Shafrazi, who initially suggested, "Put your alphabet in the landscape, out there in the real world." He also arranged financing for the first series and persuaded Leo Castelli to present the results, with a parallel show of new paintings at Shafrazi's space in Mercer Street. The following year Haring agreed to collaborate with Hans Mayer on the production of a German series.[2] The first work of this group, still relatively modest in scale but a major factor in establishing the artist's European reputation, was shown as one of Münster's "Sculpture Projects" in 1987.

Kasper König's second presentation of public sculpture in Münster, which he curated with Klaus Bussmann, proved an unqualified critical success; many visitors felt that Münster offered a professionalism and international scope that surpassed "documenta 8," which was running concurrently in Kassel. For

Haring, often viewed in his own country as some whimsical by-product of the graffiti craze, being placed on common ground with the likes of Richard Serra, Sol LeWitt, Per Kirkeby, and Ulrich Rückriem was not without consequence.

Like the other Münster participants, Haring had been asked to create a work for a particular site of his own choosing. The resultant *Red Dog for Landois* (Fig. 2) was one of his very few works, before the late *King and Queen*, to carry a formal title, and it made clear the degree to which the artist sought to accommodate his idiom to local history. The park in which the work was installed was once part of a much larger complex that held Münster's zoological garden, founded in 1875 by Professor Hermann Landois and destroyed in the late 1960s to make way for a bank building. "*The Red Dog*," Haring explained, "is the spirit of the zoo and the spirit of Landois himself, pulling themselves out of the ground to bark a protest to the new building *The Red Dog for Landois* is a monument to the imagination and a protest against blind progress."[3] Thus, the commencement of the European phase of Haring's sculptural work reveals the instinct for social causes that recurs like a leitmotiv throughout his career.

Nonetheless, the medium was radically different from the chalk drawings in which his barking dog first took subversive shape. Even more than the paintings which gave ideograms that had originated in the subway a new, fine-arts context, this translation into cut steel added a new dimension of reality. In Haring's own words:

A painting, to a degree, is still an illusion of a material. But once you cut this thing out of steel and put it up, it is a real thing, I mean it could kill you. If it falls, it will kill you. It has a kind of power that a painting doesn't have. You can't burn it. It would survive a nuclear blast probably. It has this permanent, real feeling that will exist much much much longer than I will ever exist, so it's a kind of immortality. All of it I guess, to a degree, is like that . . . All of the things that you make are a kind of quest for immortality.[4]

The last sculptures produced in Germany – several of them completed only after the artist's death – lent such ambitions an unmistakably heroic scale: ranging to

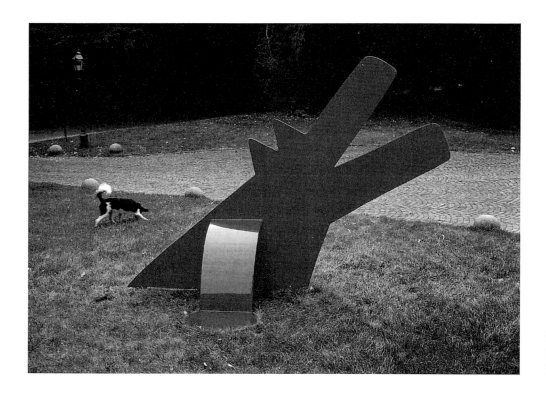

Fig. 2 *The Red Dog for Landois*, 1987. Lacquered steel, approx. 72 x 78 x 84". Private collection, Baden-Baden, Germany

more than seven meters in height, they have the commanding presence of ancient steles or monoliths, yet never lose their lyric air of delicacy and poise.

This purity of line was the quality that Haring admired in both the drawings and the sculptural works of Alexander Calder; Jean Tinguely, Jean Dubuffet, and Claes Oldenburg also offered him inspiration. Haring came to know Oldenburg personally while working at Lippincott, where Haring's large-scale American sculptures were fabricated. Works by Calder are sometimes repaired there, so that Haring developed a more intimate view of the achievements of a sculptor who had fascinated him even as a boy. What he admired was the "simple, clear, poetic quality to which anyone can respond. Kids like him, too, because the work has spirit, comes from the spirit." Haring made similar remarks about Tinguely's bizarre assemblages and about Vito Acconci's plans for a playground with oversized athletic equipment painted in shocking pink. (Haring himself had designed a playground even before his first outdoor sculptures were produced.)

Haring often visited the site in Riverside Park where two of his earliest works were temporarily installed (see ill., p. 120), to observe how people reacted to the pieces – "how they use them," in his words. Even on the rare occasions when no children were playing there, he could judge their activity by patterns in the grass, worn away at all the points from which they could clamber up. Hence, he insisted that the edges of his pieces be carefully smoothed and rounded, to prevent injuries. The resulting softening of the forms, closer to a chalked line than to cut steel, was complemented by their coloration. "Painted," as Haring noted, "they no longer look like metal but like bright, shiny toys that should be played with." Such remarks suggest that, for all his talk of "immortality," the artist was not merely seeking to plant monuments in the landscape; in that case, maximum visibility would have been his primary concern. "If a work is going to be public," he insisted, "it has to harmonize both with the location and with the people who use it." Hence, though he expressed high regard for the work of Richard Serra and protested the dismantling of the latter's *Tilted Arc* in 1989, he also felt instinctive sympathy for its "philistine" opponents, who found the piece intrusive.

Because his own works were rarely site-specific (even if, like *The Red Dog for Landois*, they were inspired by a particular site), Haring confronted none of the controversies that regularly plague the commissioned public sculpture. Furthermore, the works installed in the pastoral setting of Riverside Park had looked equally good beside a cluttered intersection on New York's 47th Street or in the restrained elegance of Leo Castelli's downtown gallery (Fig. 3). *The Red Dog*, furthermore, exists in different formats and locations; the two-meter version now installed in a private garden in southern Germany is no less effective than the larger prototype in Münster (which may eventually be removed by the private collector who financed its production). It is not sufficient to account for this versatility on the basic of comic-style simplicity or lollipop coloration. The fact is that, from the beginning of his spectacular carrer, Haring showed a continuous interest in three-dimensional forms and, in the last years of his life, evolved a sure and subtly expressive sculptural idiom.

The sensitivity revealed here, on the other hand, differs considerably from that which produced elaborate decorations on furniture or vases. If those experiments marked the real beginning of Haring's sculptural apprenticeship, they remained a kind of allover drawing laid onto the available surface. The band of

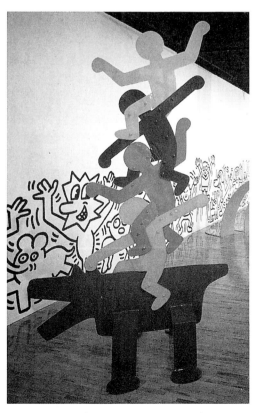

Fig. 3 View of Haring's one-man show at Leo Castelli Gallery, New York, 1985

images on a vase, for instance, might easily be flattened into a frieze and lose nothing of its graphic coherence. Such surface enrichment has much in common with the efforts of so-called "primitive" peoples to beautify both everyday tools or weapons and ritual objects with drawn, carved, or painted motifs, but it also has roots in American folk art, which in rural Pennsylvania evolved into a richly distinctive idiom. Pennsylvania-born Haring had great admiration for such artifacts – above all, for their mingling of a spontaneous, childlike freshness with a highly structured sense of design. The Michael Rockefeller Collection of Primitive Art at New York's Metropolitan Museum of Art was one of his favorite haunts.

Haring's seminal position in the primitivist tradition pioneered by Picasso, Braque, and Brancusi has yet to be adequately appraised, though from the *Totem* of 1983 to the metal masks of 1987 (plates 111-18) the artist often commented with witty directness on his antecedents. Even found objects, such as the baby crib he painted in 1983 (plate 14), revealed the impulse to beautify quotidian surfaces and endow them with his own coded language. Such works were formally different from, but in no way inferior to, the large public sculptures that came later, though some of the overpainted figures – the *Venus de Milo*, Michelangelo's *David* (plate 55), even the *Statue of Liberty* – are uncomfortably like jokes that start by revealing the punch line.

This cannot be said of the vases that Haring began to decorate as early as 1980 (see plates 43-49). Simple, classic, neutral forms, they submitted readily to the medicine man's charm. These are not sculptural works, however, but simply an uncommon surface, in our time, for the painter. (Not surprisingly, before visiting the Rockefeller wing at the Metropolitan Museum, Haring regularly viewed the museum's superb collection of Greek vases.) Nonetheless, the experience of working on found objects, including most of the furniture in his first New York apartment, helped develop the feeling for forms in space that would lead in time to full-fledged sculptural statements. This involvement may, in turn, account for the visual depth present in some of the late paintings or, more dramatically, in the *Apocalypse* and *The Valley* lithographs that he produced with William S. Burroughs.

Earlier, Haring's drawings had communicated depth, volume, and motion through graphic suggestion, with figures shown twisting, turning, somersaulting through space. Comiclike directional lines – short, brisk strokes beneath the feet of a jogger, for example – sometimes accentuate the sense of movement, but the true dynamic is to be found in the outline of the figure. Indeed, Haring's strength as a sculptor would ironically derive from his deceptively reductionist graphic style, but in order to realize its potential he had to proceed beyond the facile silhouettes that first brought him widespread popularity.

A closer look at the late sculptures offers an important clue to this development, revealing that the abstract ideology of Haring's student days continued to inform his aesthetic and helped him move beyond the merely illustrative. In developing a new, volumetric approach to the figure, the artist did not abandon earlier techniques but augmented and enriched them. He continued to work, as well, in the "totemic" style that treated any available surface – whether the Berlin Wall (plate 96), the body of Grace Jones (plates 69, 70, 102), Sean Lennon's favorite guitar, or the pseudo-African masks produced in 1987 – as a field for graphic activity. Here, the decoration typically took the form of ornate abstract

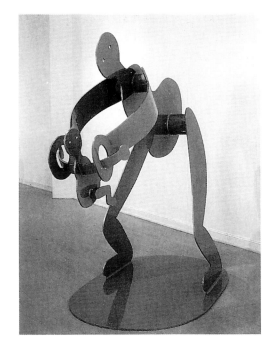

Fig. 4 *Mother and Child*, 1987. Silver metallic Dupont enamel paint on aluminum, 91 x 89 x 48". Courtesy Tony Shafrazi Gallery, New York

patterns. The fabricated sculptures, while employing recognizable human and animal forms, often have a nonfigurative essence or inner life: a concern with stress and repose, substance and void, balance, arrested motion, horizontal versus vertical thrust. Hence, at the formal level, Haring drew closer to the idiom of Calder – to the extent of creating a "mobile" mother and child (Fig. 4).

Translating his familiar ideograms into three-dimensional forms often involved an entire battery of high-tech aids, which in turn extended the artist's field for performance. The process began when the complex mechanisms of a foundry such as Lippincott were set in motion, and continued through transport and installation. "This is the comedy and pathos of turning line drawings into monuments," Tony Shafrazi once observed. Sometimes the transformation started with simple cardboard models that were freely "sculpted" with a pair of scissors, a process of creative play that particularly suited the artist's temperament. At other times, plastic or wooden maquettes were built from drawings. At Lippincott, Haring occasionally intervened in the process of construction to draw forms directly on a sheet of steel or to alter the positioning of elements. This direct involvement was characteristic of all his work; he regularly gessoed his own canvases and rarely accepted assistance for the most routine of studio tasks. "Hands-on is crucial for me," he explained. "It's all part of a ritual process with a distinct beginning, a distinct end." Workers at Lippincott were amazed by the newcomer's rapid grasp of new techniques and the self-assurance with which he treated the foundry as "an extension of his own atelier."

As the sculptures grew larger, the hands-on process inevitably became somewhat diluted. Transforming even the most precise model into a 7.5 meter-high structure involves a meticulous reckoning of statics, load-thrust, tensile strength – even of the reaction to high winds and freezing weathers. For the largest pieces, all of which were produced in Germany, the process was complicated by the fact that much of the work was done in Haring's absence. Attempts to enlarge his drawings with the aid of a computer were only marginally successful, for curved lines acquired saw-toothed "pixel" contours. Later, with the aid of industrial photocopiers, one-to-one drawings were produced for each sculptural element. The planning and production was supervised by Düsseldorf artist Klaus Richter, whose own idiom has numerous affinities with Haring's. During the fabrication phase the two were in continuous contact, and Haring made regular visits to inspect the works and order alterations. A curve that appears right in a knee-high model may look conspicuously wrong when looming overhead.

The long-distance procedure had disadvantages, yet it also compelled the artist to think systematically and to anticipate problems before they occurred. What resulted was less a dilution than a concentration of creative energy, as can be seen in the formal confidence and technical bravura of the last pieces. If the first large-scale works seemed variations on the graphic idiom – enlarged cutouts of line drawings – these are clearly autonomous creations. For the entwined figures titled *King and Queen* (Fig. 5), Haring even decided to dispense with color and employ Cor-Ten steel, whose rust-colored patina lends the composition an archaic aura. It was a further sign of the growing confidence he felt in the medium. Furthermore, and despite its figurative allusions, *King and Queen* recalls a phrase that Haring used in reference to the works of Calder: "a fluid poetry."

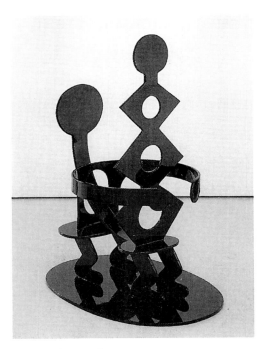

Fig. 5 *King and Queen*, 1987-88. Cor-Ten steel, 49½ x 27½ x 24". Private collection

"Much of what I do is chance," Haring insisted. "I don't really invent figures so much as I tap into a common image bank." Yet chance, as Louis Pasteur stressed (and the artist was fond of repeating), always favors the prepared mind. In that sense, Haring's entire career – from his childhood cartoons to abstract paintings, subway drawings, painted *objets trouvés*, totems, and masks – seemed to funnel toward these three-dimensional encounters. Viewed in the context of landscape or cityscape, they extended the dialogue begun by the altered advertisements and faked headlines with which Haring once plastered the streets of Manhattan. The sprightly air of the sculptures, however, can be deceiving: they address formal issues of increasing complexity, and many allude to themes of aggression, eroticism, and pain that are not the conventional furniture of neighborhood playgrounds.

Even before he learned of his own fatal illness, Haring's vision was rarely so blithe and never so simplistic as his detractors are still wont to suggest. The "simple ritualistic, iconic experience" that was the goal of his work never excluded an awareness of fear and aggression and death – elements frequently represented and thereby exorcized in "primitive" art. Haring argued that "the contemporary artist has a responsibility to continue celebrating humanity,"[5] but celebration does not merely imply a carefree festival; it is also, as in the eucharistic rites, a solemn and reflective occasion. That implicit duality, present in Haring's work from the start, is the reason we look again, with a kind of shock of recognition, at even his simplest ideograms. The seemingly universal chord that they strike found its most consistent expression in the artist's achievements as a sculptor.

Notes

Unless otherwise identified, statements by Keith Haring derive from conversations with the artist in Paris (June 9 - 10, 1989), New York (July 27, 1989), and Düsseldorf (November 17, 1989). An interview with Tony Shafrazi (July 28, 1989) is the source of quotations by the gallerist.

1 John Gruen, *Keith Haring: The Authorized Biography* (New York: Prentice Hall Press, 1991), p. 133.

2 A total of five individual motifs were realized in varying sizes. In each case a two-meter model was produced in an edition of three, plus one copy for the artist; two motifs were executed with a height of four meters; all were enlarged to heights ranging from 5 to 7.5 meters. A second American series, based on maquettes produced in 1986, was in production at Lippincott when Haring died. He had personally supervised the technical drawings, cutting of the templates, and selection of materials and colors. Each of three motifs was produced in formats ranging from 46 centimeters to 3.7 meters. Completed posthumously, the sculptures were first exhibited in November 1990 at the Tony Shafrazi Gallery.

3 Klaus Bussmann and Kasper König (eds.), *Skulptur Projekte in Münster*, exhibition catalogue (Cologne: DuMont, 1987), p. 118.

4 Daniel Drenger, "Art and Life: An Interview with Keith Haring," *Columbia Art Review* (Spring 1988), p. 45.

5 Ibid., p. 53.

And We All Shine On

BARRY BLINDERMAN

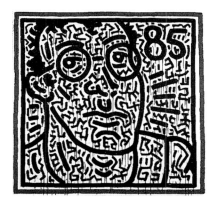

Fig. 1 *Untitled* (Self-Portrait), 1985. Acrylic on canvas, 48 x 48". Private collection

Art when really understood is the province of every human being.

Robert Henri, *The Art Spirit*, 1923

When I paint, it is an experience that, at its best, is transcending reality. When it is working, you completely go to another place, you're tapping into things that are totally universal, of the total consciousness, completely beyond your ego and your own self.

Keith Haring, *Rolling Stone* interview, 1989

Although it has been over two years since Keith Haring made his last line, currents of the energy and spirit that he embodied for such a brief time are readily detectable and will undoubtedly intensify over time. It is as though his pulsating images have already danced their way into the atavistic chambers of the collective mind, as if his characters are now somehow imprinted on ribbons of DNA to be transmitted genetically to future generations. In less metaphysical terms, it has become increasingly apparent to me that his line lives on: Adolescents in Japan draw Haringese on subway station walls. Haring imagery turns up in clothing shops in Australia, on "help the homeless" signs posted at Orly airport,

Fig. 2 Chopsticks wrapper (detail) for ISO restaurant, New York City, undated. Offset ink on paper, 4 x 1"

in greeting card stores in San Francisco, on chopsticks wrappers at a Manhattan restaurant (Fig. 2), on innumerable ads for charities and other causes. His images have been reabsorbed by the world culture that inspired them. The other day I asked my five-year-old son what the lines emanating from one of the "machines" he was drawing meant. He looked at me as if I had asked the silliest of questions and replied: "They're Keith's feeling rays."

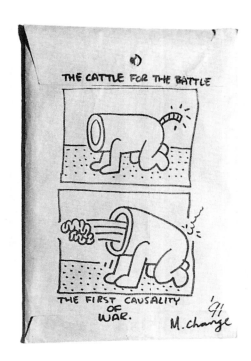

In the Cybernetic Age the professional assignment of the performing philosopher is to produce new paradigms which will inspire and encourage others to think for themselves.
<div align="right">Timothy Leary, Neuropolitique, 1988</div>

I started doing drawings every night that were almost exactly like Keith's I feel he created a language, and it seemed foolish not to speak this language simply because he *spoke it.*
<div align="right">Michael(CHANGE)Maier, letter to the author, 1991</div>

Some artists leave behind a style, others a memorable subject or two. A select few, more ambitious, like Picasso, leave us with a vocabulary that can be adapted to a multitude of new expressions. Haring's legacy is a model universe, a lexicon of signs and symbols reflective of anxiety, euphoria, desire, oppression, and hope in an age of digital magic and massive communications breakdown. Timothy Leary has called Haring a performing philosopher, and it is certain that a truer understanding of Haring's mission to "liberate the soul, provoke the imagination, and oppose the dehumanization of our culture" will emerge along with our attunement to the radical blurring of boundaries between science, ecology, art, and theology in the last years of this century.

Fig. 3 Michael (CHANGE) Maier. *Untitled*, 1991. Felt-tip pen on manila envelope, 6 x 9". Collection Barry Blinderman

A new mythology is possible in the Space Age, where we will have heroes and villains, as regards intentions towards this planet. I feel that the future of writing is in Space, not Time.
<div align="right">William S. Burroughs, The Future of the Novel, 1962</div>

The so-called new paradigm is really a recovery of our most ancient intuition.
<div align="right">David Steindl-Rast, Belonging to the Universe, 1991</div>

Drawn with urgency, clarity, and brazen simplicity, Haring's characters whisk us from the mysteries of ancient ritual to the hallucinatory interface of biology and technology in our cybernetic futurenow. Examples: **1981:** A flying saucer beams its rays at a four-legged creature who is in turn worshiped by a mass of copulating figures. The flying saucer, turned on its side, becomes a gaping orifice. **1983:** Figures brandishing power rods ride upon a giant caterpillar whose computer-screen head projects the image of a glowing brain. **1985:** A computer-headed larva monster grabs and swallows a human through an orifice appearing on the computer screen (Fig. 4). Passing through the birth canal of an electronic matrix, the figure "jacks in" to cyberspace.

Haring was a loner in the midst of an eighties artworld obsessed with irony, appropriation, and deconstructed meaning. A rare modern believer in the potential magic of graven images, he made a strong and consistent case for the relevance of mythology in the post-Christian era. For it is in ancient myth, be it

Fig. 4 *Untitled*, 1985. Subway drawing

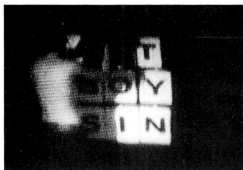

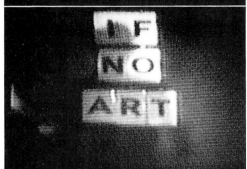

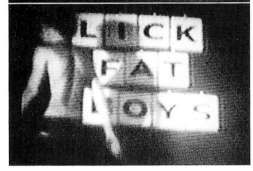

Fig. 5 Stills from *Art Boy Sin*, ca. 1979. Black and white video

Greek, African, or Native American, that we find the prototypes for fantastic couplings between god/animals and humans, animals as ancestral spirits, and the constant struggle between good and evil that are visible in nearly every Haring composition.

Though usually cited as a "neo-expressionist," in opposition to the acknowledged conceptual school of the eighties, Haring's work from the beginning addressed the parameters of images, speech, and words as interchangeable and manipulable signifiers. His little-known video art from 1979 and 1980 consists of absurd signboard word scrabble ("ART BOY SIN . . . SIN AS IF . . . IF NO ART . . . ART IF LICK . . . LICK FAT BOYS"; Fig. 5), flashcard phonetics lessons with sound/word dislocations, and the artist's frenzied vocalizations of electronic chatter. In a color video titled *Machines* (1980), produced shortly after studying semiotics with Joseph Kosuth and Keith Sonnier at the School of Visual Arts in New York, Haring robotically utters phrases such as "'It's evolution,' he said, 'We don't need you any more,' he said, 'Now it's all machines; it's bigger than both of us, and it's better than both of us,' she said." His mouth, nearly touching the lens of the camera, takes up the entire screen, and the lascivious coupling of mouth and tongue movements with a stuttering FutureShock tone poem bears witness to the artist's careerlong obsession with technology as a potential evolutionary nightmare. The disruptive editing and use of tape loop repetitions in *Machines* points also to Haring's discovery at this time of William S. Burroughs's "cut-up" word technique.

Tape for My Father (Fig. 6) concerns similar semiotic emissions, in this case a Minimalist score consisting of random-sequence vocalizations of Morse code "Dit" and "Dah" ("Da-Da-DIT-it"), mitigated only by brief monologues about his childhood ambivalence toward his father's ham radio hobby. His face eerily distorted by the fisheye effect of the lens, Haring's urgent oral telegraphy foreshadows the expediency with which he later created and combined modular characters to form his chimerical pictograms.

I like the idea that my art could be on a floppy disk and you could send the floppy disk back and forth or even send the information by telephone. If I had a bank of images on tape or floppy disk, someone could take those images as a starting point, the raw material, and do whatever they want with them and take the head off one thing and put it on something else and change the color.

Keith Haring, *MacWEEK* interview, 1989

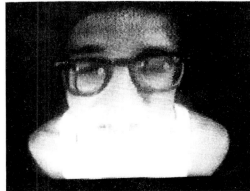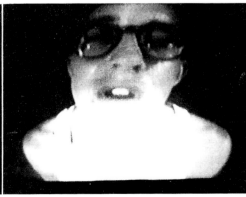

Fig. 6 Stills from *Tape for My Father*, ca. 1979. Black and white video

While on the subject of telegraphy ("writing from a distance"), drawing a brief parallel between Haring's contribution and that of the nineteenth-century artist/inventor Samuel F. B. Morse may provide fields of investigation more fertile than any produced by formal art analysis. Morse introduced the concept of transmitter and receiver, which was later refined by the inventors of the telephone, radio, and television. In an analogous manner, Haring devised a visual code that could be amplified through the greater communicational spectrum of printed and electronic media. But to be a good transmitter, one must first be a good receiver – and Haring had particularly long antennae. He viewed himself as a vehicle through which ideas that emanated from some other source could be disseminated to a vast number of people. With his supple line and hyperactive imagination, Haring broadcast political, poetical, and spiritual messages to a nonelite, multicultural, and international audience. Whether on T-shirts, posters, subway walls, buttons, or even refrigerator magnets, Haring's thought-images got across to a larger and more diverse public than the work of any other contemporary artist. His expanded view of staging an exhibition dissolved boundaries between high and low art, between handball court wall and pristine gallery wall, between museum and store.

The reality of art begins in the eyes of the beholder and gains power through imagination, invention, and confrontation.
Keith Haring, *Art in Transit*, 1984

To overlook the direct interaction with the public involved in the subway drawings and outdoor murals (see Fig. 7) is to miss one of the most salient qualities of Haring's work. Rather than trying to bring people to his art, he realized the beauty of bringing his art to the people. He did nearly all the subway drawings during the day, often at peak traffic times, and was as intent on sharing the act of artmaking with his audience as he was on leaving behind lasting artworks in the material sense. The ease and speed with which he drew on surfaces ranging from hospital walls to the Berlin Wall (plate 96) was matched only by his unfailing ability to draw a crowd. Not only was Keith's medium the message – Keith was also the medium.

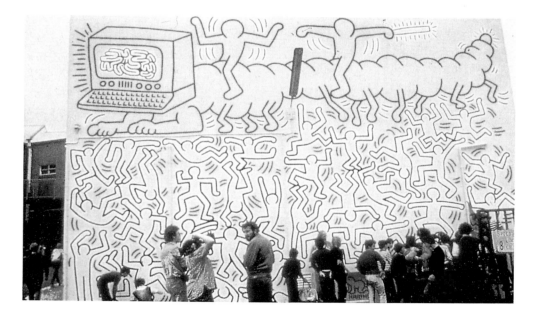

Fig. 7 Mural, Collingwood Technical School, Melbourne, Australia, 1984

These drawings just happened, and once it happens you build on it. It's what some people call coincidence and others call fate. It doesn't surprise me anymore that these things happen.
Keith Haring, interview with the author, 1981

Haring's commitment to public performance was backed by his absolute embrace of chance and spontaneity. He was inspired in equal parts by the automatism inherent in Jackson Pollock and Mark Tobey's painting process, the assuredness of Oriental calligraphers, and the sheer abandon of graffiti writers "bombing" trains. He was also fond of quoting Louis Pasteur's aphorism "Chance favors the prepared mind." Haring did not believe in mistakes; like a trapeze artist without a net, he knew there was no turning back once he began a subway drawing, a sumi ink painting, or a fifty-foot mural.

The line between inner and outer landscape is breaking down. . . . The whole random universe of the industrial age is breaking down into cryptic fragments.
William S. Burroughs, foreword to J. G. Ballard's *The Atrocity Exhibition*, 1990

In Haring's pictorial realm there is little distinction between foreground and background, between inner and outer. No matter how complex the composition is in a work of his, all the action is compressed into a depthless television nonspace. In many large paintings and tarpaulins done between 1981 and 1986, figures, objects, and the areas between them are filled in with broken lines, zigzags, or squiggles (see plate 100). Like fragmented characters in search of a language they had lost along the way, these more abstract elements cannot quite be deciphered.

Although a narrative is implied in nearly every piece Haring produced, the "story" has no ending or beginning. Much like the random-access capability of computers, the viewer/operator can "track" one of Haring's more detailed works at any point. Except for an occasional block-lettered year, a winged clockface, or a cartoonlike sequence of panels, no time is evident in Haring's limbo world. Everythingishappeningeverywhereatonce. There is neither day nor night, sun nor moon – only the pervasive schematic glow of UFOs, pyramids, light bulbs, and atomic clouds.

I don't want to say this across the board, but the flying saucers in the drawings are God-figures – the ultimate power. . . . An earthly god gains power from the UFOs. It's not about a specific God as much as a God-force.
Keith Haring, interview with the author, 1981

The most crucial implications of new-paradigm thinking for politics today, and for society at large, concern the notion of interconnectedness, this sense of belonging, which we understand as the heart of religious experience.
Fritjof Capra, *Belonging to the Universe*, 1991

Haring's sign system bespeaks animism, the primitive concept that spirit inhabits all things and, therefore, all things are interconnected in spirit. The modular nature of Haring's vocabulary of symbols facilitates a particularly important aspect of this interrelationship: With the addition and changing of a few lines, a

Fig. 8 *Flash Art* (March 1984), cover

barking dog merges with a TV set to form a broadcasting TV-dog, a paradigm for the interchangeability of corporeal/neural and electronic impulses.

When poet Rene Ricard dubbed Haring's omnipresent crawling figure (see plate 3) "the radiant child" he really hit upon the central and most exhilarating message of Haring's work: God-energy, like electromagnetic radiation, is the unifying force that courses through all beings and things, endlessly transmitted, transferred, and transformed. Perhaps, for Keith, this radiance symbolized our spiritual potential for triumph over the evil represented by the demonic mutant beings that populated his later work. In any case, his radiant child compressed a few thousand years of religious imagery through a cartoon distillery and gave us the first believable twentieth-century halo.

Plates

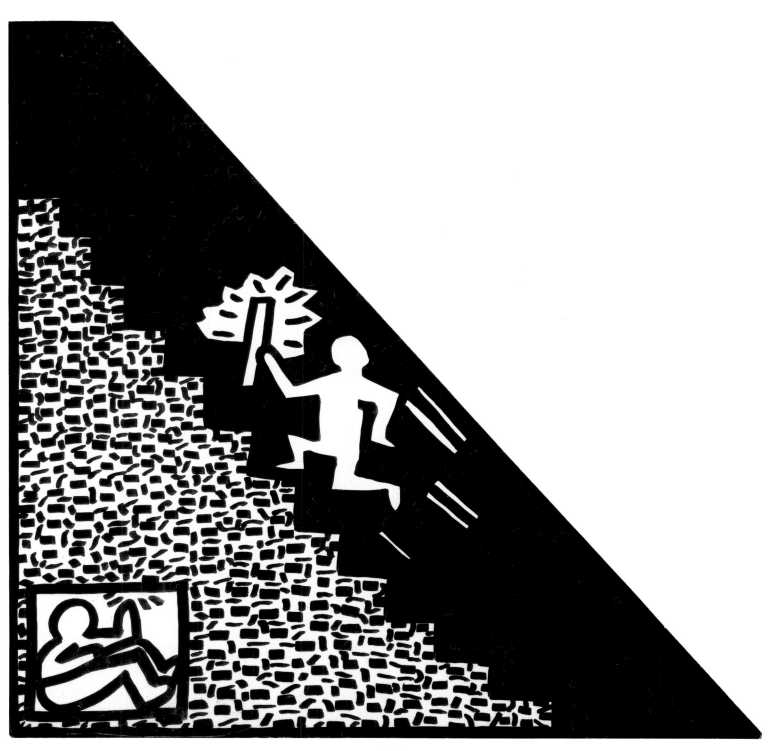

1 *Untitled,* 1981

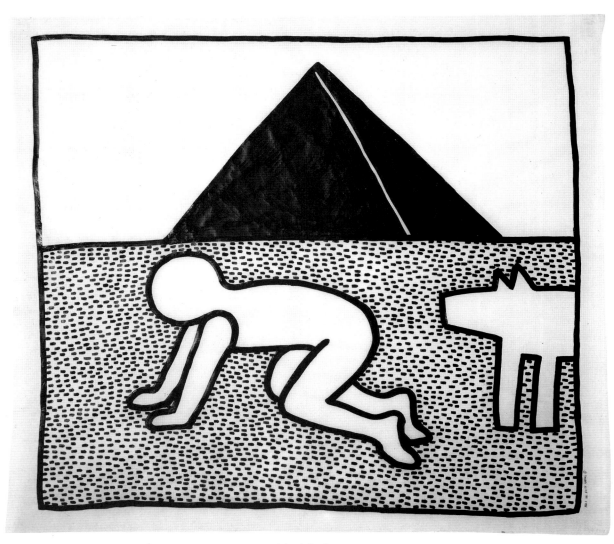

2 *Untitled*, 1981

3 "Times Square Show," New York, 1980

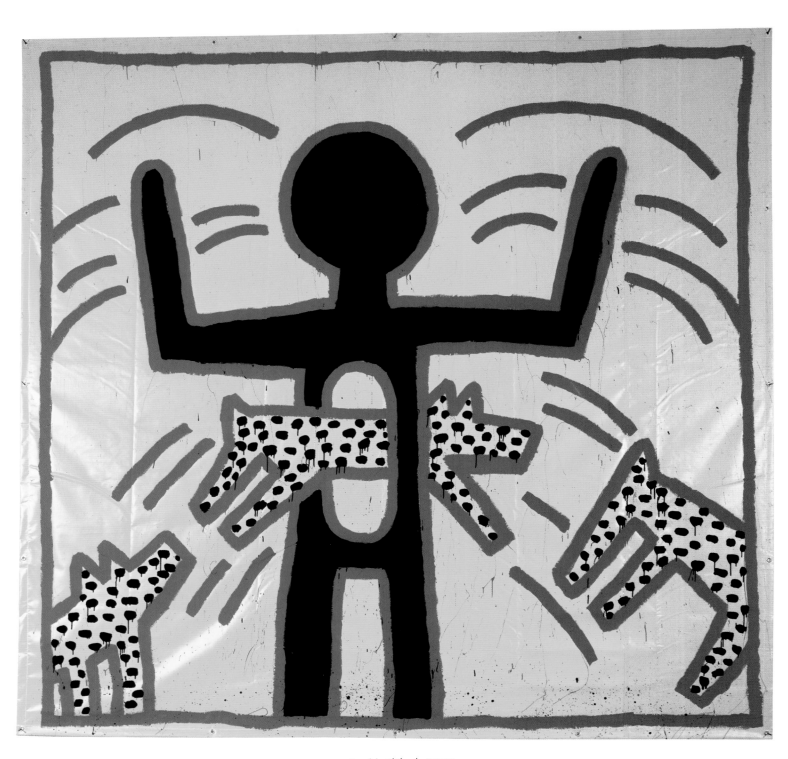

4 *Untitled*, 1982

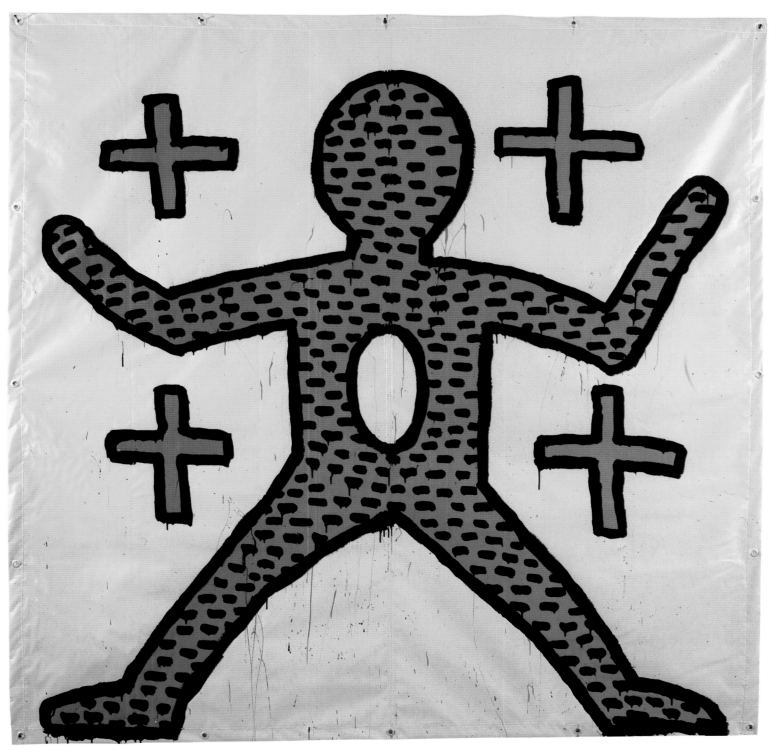

5 *Untitled,* 1981

Following pages:

6-9 Drawings in the New York City subway, 1983, 1982, 1984, and 1985

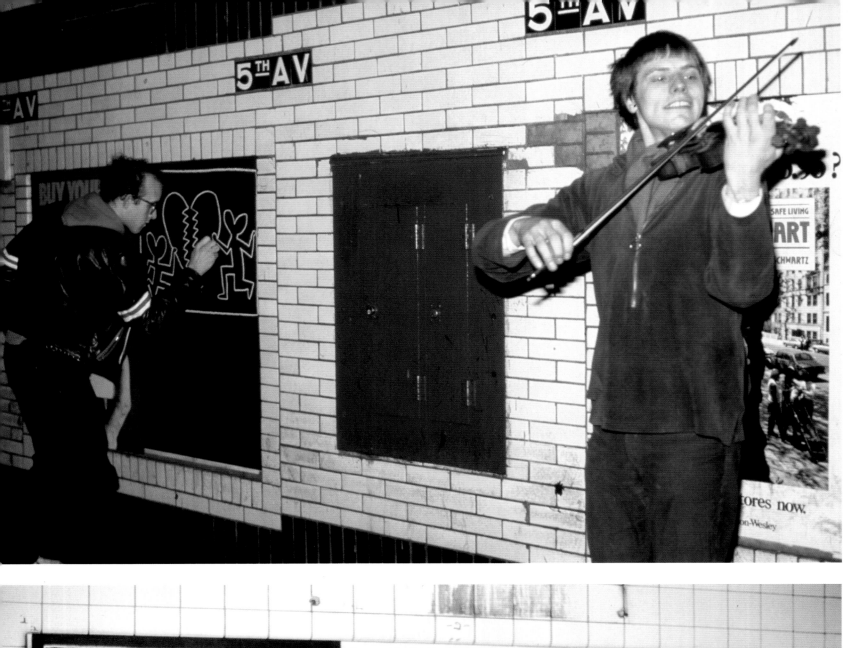

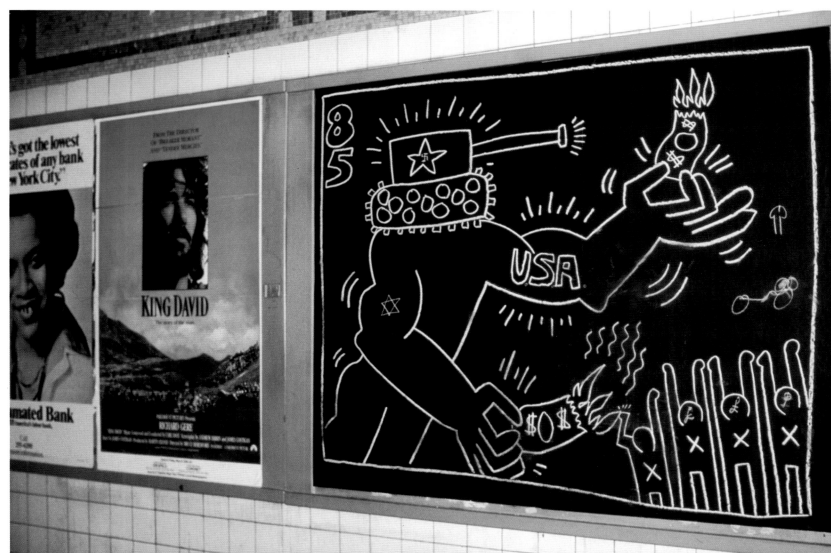

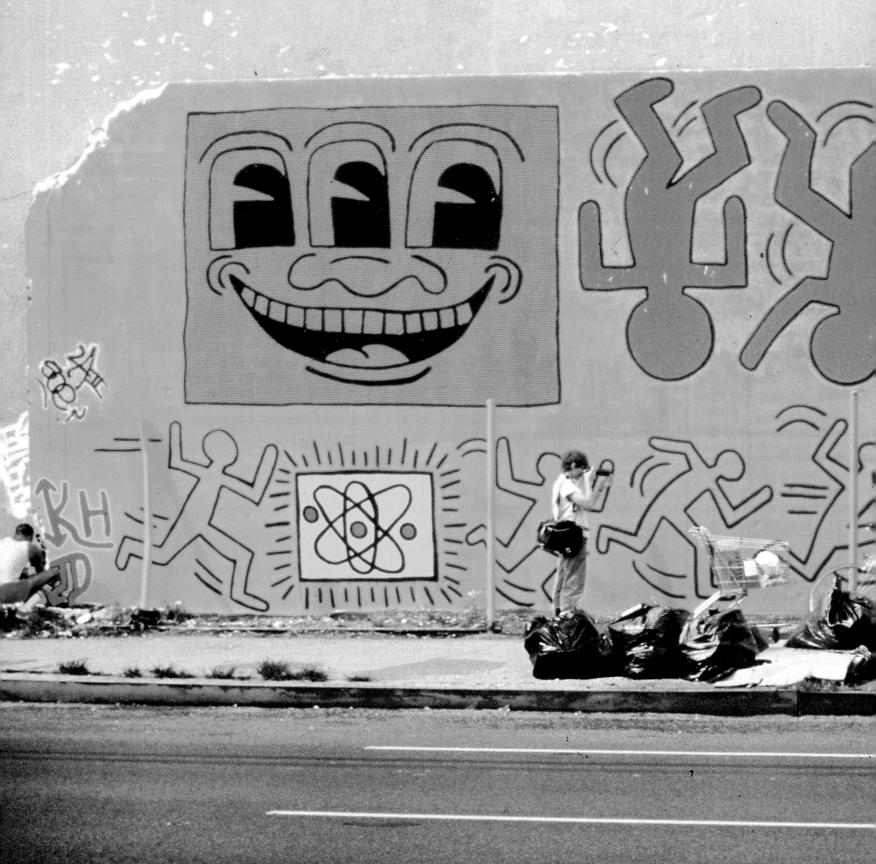

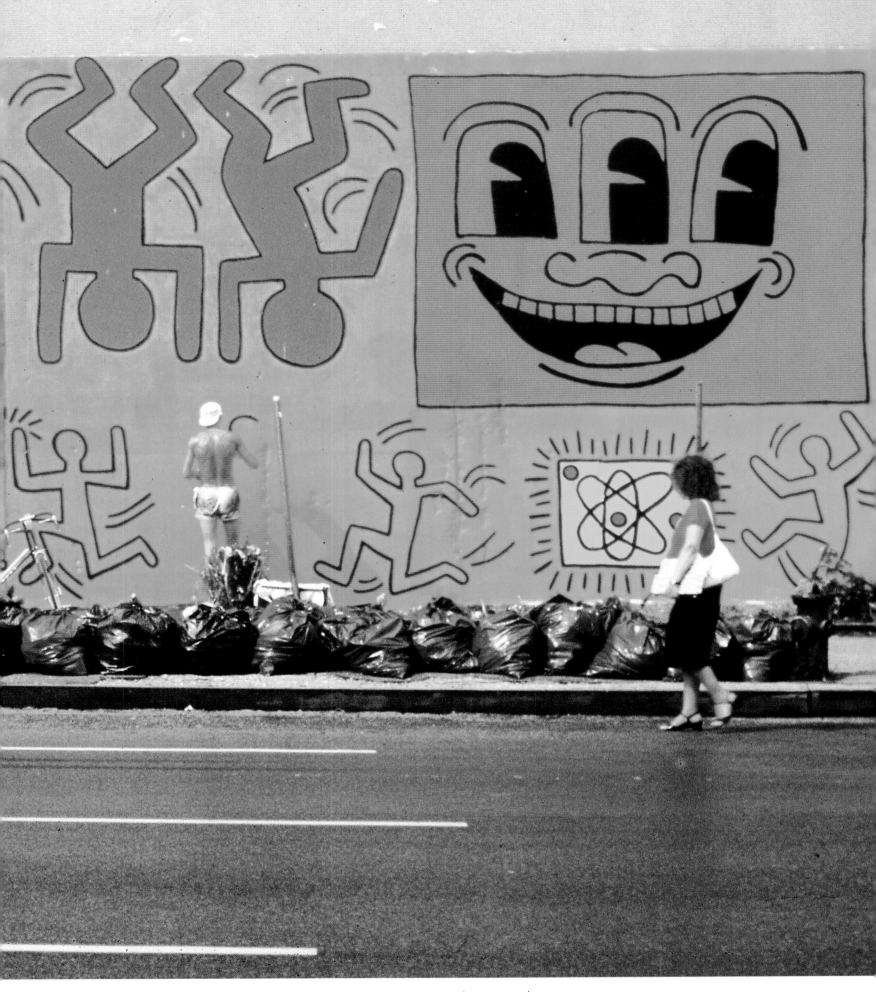

10 Houston Street mural, New York, 1982

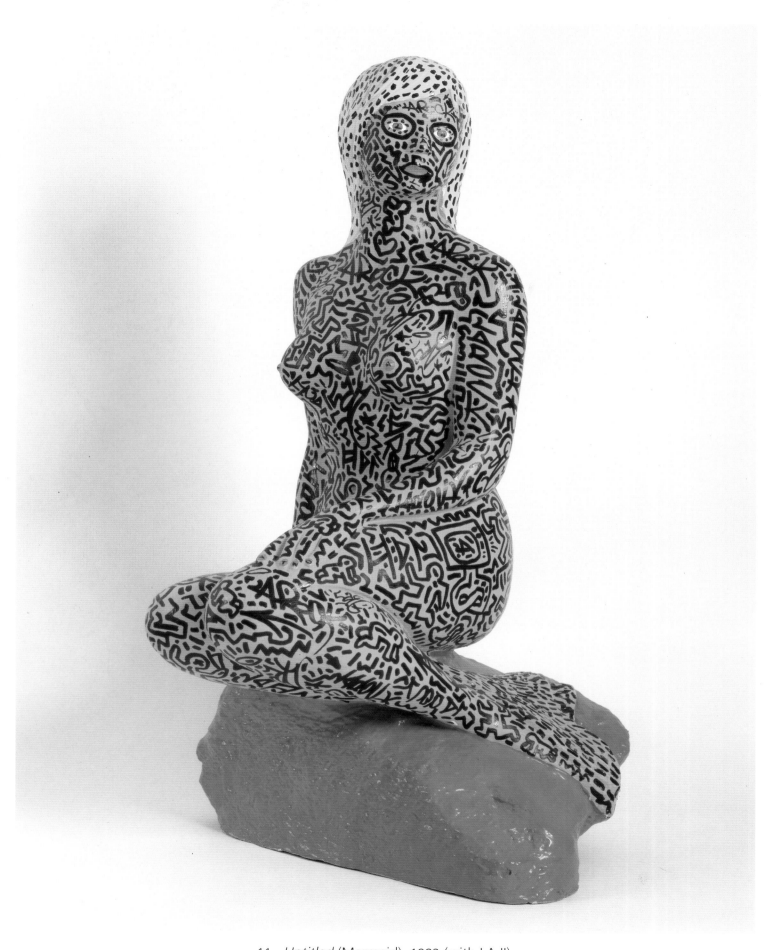

11 *Untitled* (Mermaid), 1982 (with LA II)

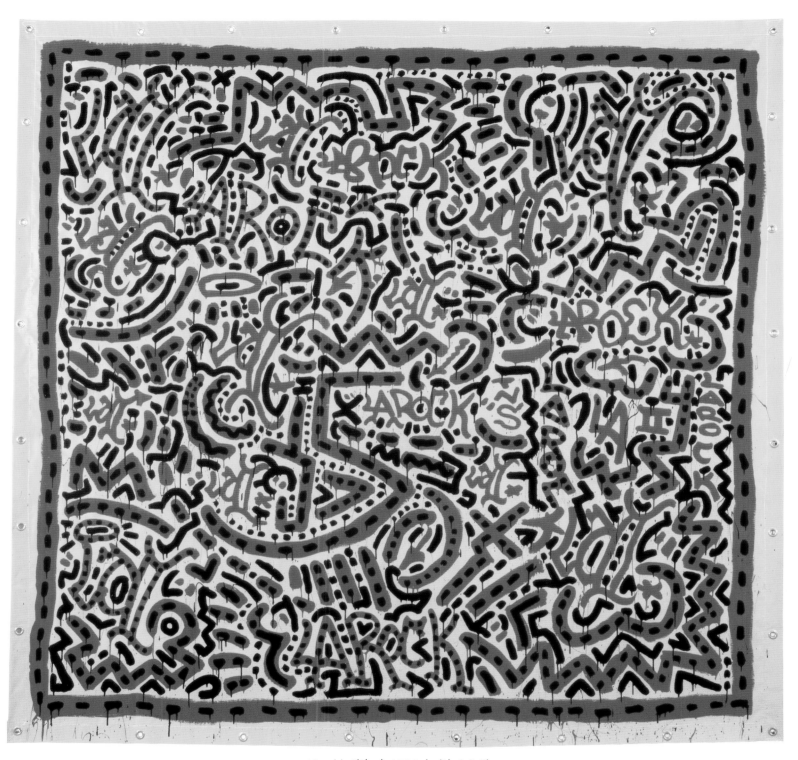

12 *Untitled,* 1982 (with LA II)

13 *Untitled,* 1981 (with LA II)

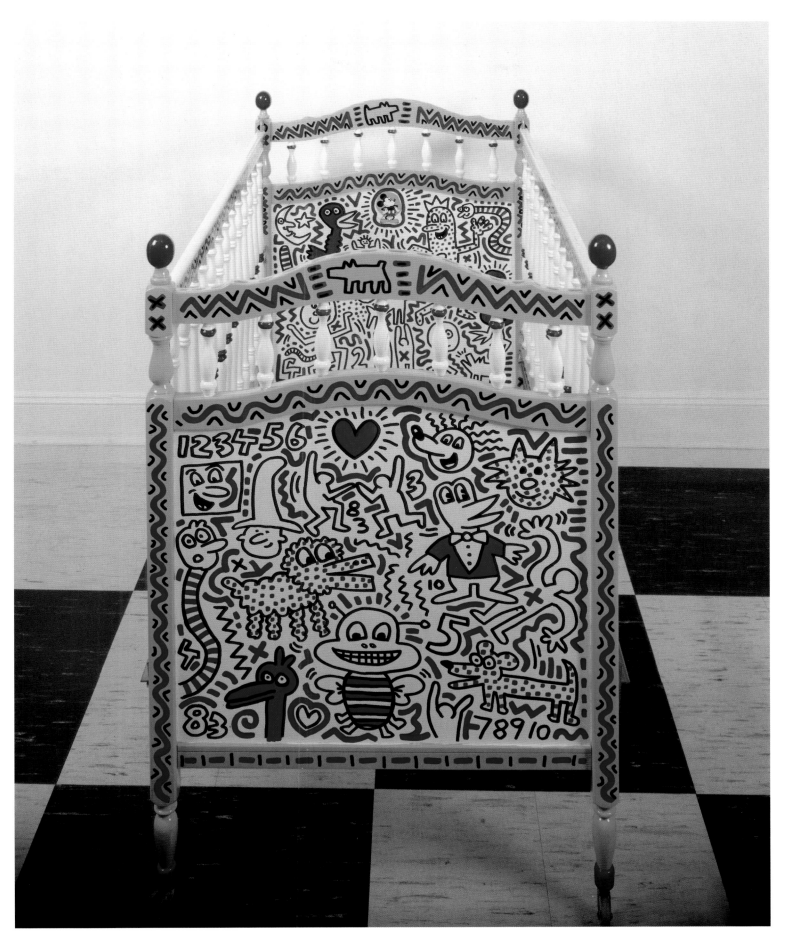

14 *Untitled,* 1983

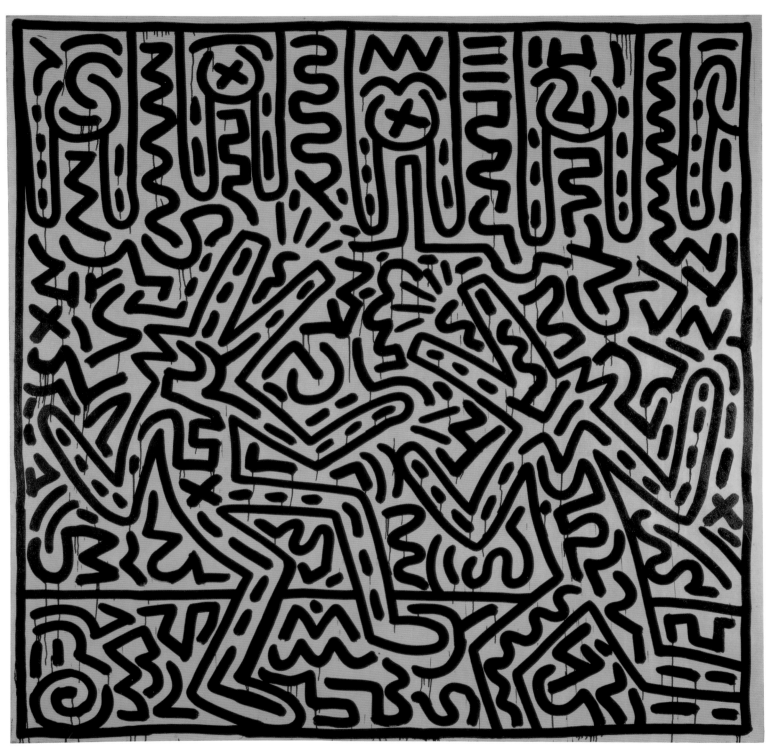

15 *Untitled*, 1982

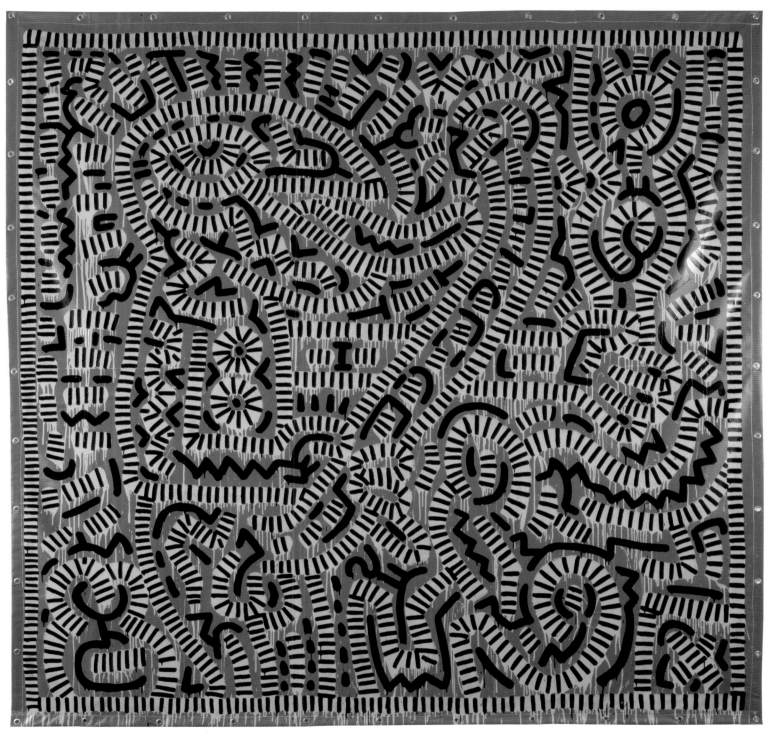

16 *Untitled,* 1983

"A real artist is only a vehicle"

Keith Haring on the Creative Process and the Role of the Artist

Often when I am drawing in the subway in New York City an observer will patiently stand by and watch until I have finished drawing and then, quickly, as I attempt to walk away, will shout out, "But what does it mean?" I usually answer: "That's your part, I only do the drawings."

So, when I was asked to write something for *Flash Art*, I found myself in a similar situation. I still maintain that an artist is not the best spokesman for his work. For myself, I find that my attitude towards, and understanding of my work is in a constant state of flux. I am continually learning more of what my work is about from other people and other sources. An actively working artist is usually (hopefully) so involved in what he is doing that there isn't a chance to get outside of the work and look at it with any real perspective. A real artist is only a vehicle for those things that are passing through him. Sometimes the sources of information can be revealed and sometimes the effects can be located, but the desired state is one of total commitment and abandon that requires only confidence and not definition. The explanation is left to the observer (and supposedly the critics). However, in the past two years I have done dozens of interviews and frequently talk about what I think I am doing. Still, I have read very little real critical inquiry into my work, besides the ongoing obsession with the phenomena of money and success. For this reason I decided to note a few of the things that nobody ever talks about, but which are central (I feel) to my work.

One of the things I have been most interested in is the role of chance in situations – letting things happen by themselves. My drawings are never pre-planned. I never sketch a plan for a drawing, even for huge wall murals. My early drawings, which were always abstract, were filled with references to images, but never had specific images. They are more like automatic writing or gestural abstraction. This was my prime attraction to the Cobra group (primarily Pierre Alechinsky) and Eastern calligraphy.

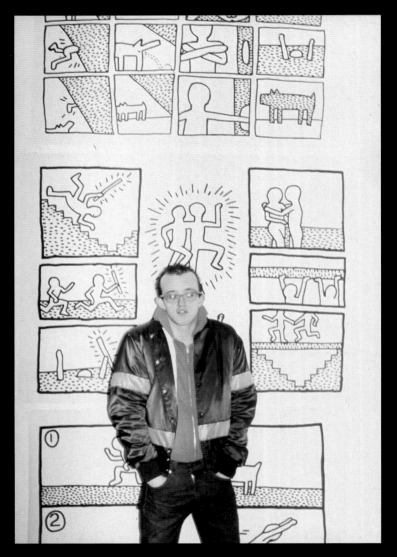

Keith Haring in his studio, 1981

Total control with no control at all. The work of William Burroughs and Brian Gysin (*The Third Mind*) came the closest in literature to what I saw as the artistic vision in painting. The artist becomes a vessel to let the world pour through him. We only get glimpses of this art spirit in the physical results laid down in paint.

This openness to "chance" situations necessitates a level of performance in the artist. The artist, if he is a vessel, is also a performer. I find the most interesting situation for me is when there is no turning back. Many times I put myself in situations where I am drawing in public. Whatever marks I make are immediately recorded and immediately on view. There are no "mistakes" because nothing can be erased. Similar to the graffiti "tags" on the insides of subway cars and the brush paintings of Japanese masters, the image comes directly from the mind to the hand. The expression exists only in that moment. The artist's performance is supreme.

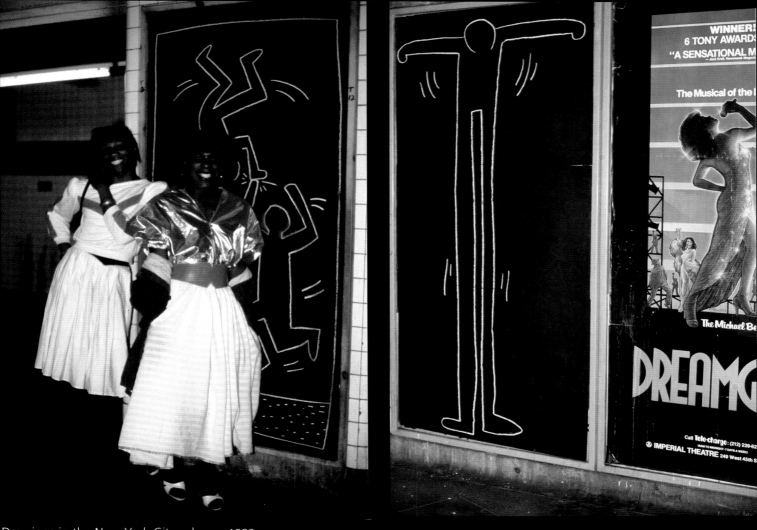

Drawings in the New York City subway, 1982

Keith Haring drawing in the New York City subway, 1981

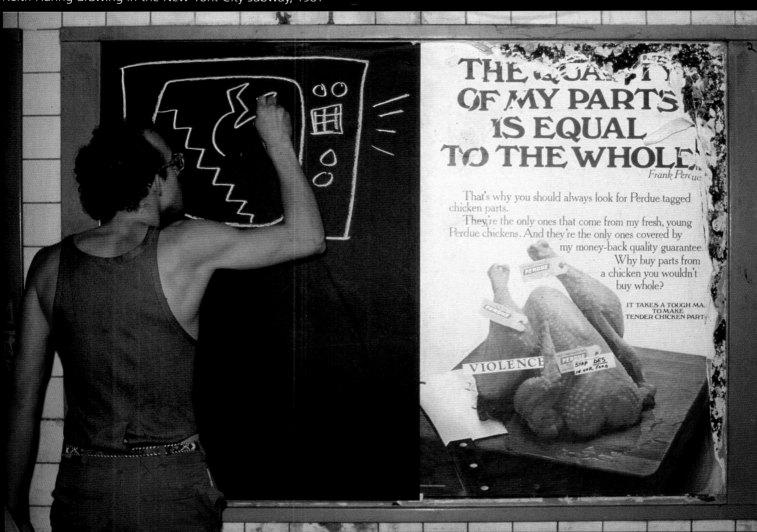

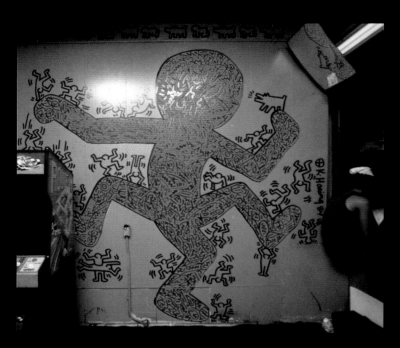

This attitude toward working seems particularly relevant in a world increasingly dominated by purely rational thought and money-motivated action. The rise of technology has necessitated a return to ritual. Computers and word processors operate only in the world of numbers and rationality. The human experience is basically irrational.

In 1978 I came to New York City and attended the School of Visual Arts. I was keeping a diary when I first got to New York and was surprised when, rereading it recently, I came across various notations about a conflict I was having over the role of the contemporary artist. It seemed to me that with minimal and conceptual art the role of the artist was increasingly helping to usher in the acceptance of the cooly-calculated, verifiable, computer-dominated, plastic "reality." A comparison between a human worker and a computer would inevitably prove that (from an efficiency standpoint) the human was being surpassed and maybe even replaced by the capabilities of the microchip. The possibility of evolution evolving beyond the human level was a frightening realization. Artists making art that consisted solely of information and concepts were supported by corporations and museums. It appeared to be right in line with the ideologies of corporations motivated by profit instead of human needs.

Although this is exaggerated, I think the contemporary artist has a responsibility to humanity to continue celebrating humanity and opposing the dehumanization of our culture. This doesn't mean that technology shouldn't be utilized by the artist, only that it should be at the service of humanity and not vice versa.

I think any artist working now has to take advantage of the technological advances of the past hundred years and use them creatively. Andy Warhol said he wanted to be a machine, but what kind of machine?

Living in 1984, the role of the artist has to be different from what it was fifty, or even twenty years ago. I am continually amazed at the number of artists who continue working as if the camera were never invented, as if Andy Warhol never existed, as if airplanes and computers and videotape were never heard of.

Think of the responsibility of an artist now who is thrust into an international culture and expected to have exhibitions in every country in the world. It is impossible to go backwards. It is imperative that an artist now, if he wants to communicate to the world, be capable of being interviewed, photographed, and videotaped at ease. The graphic arts of reproduction have to be utilized. It is physically impossible to be in more than one place at one time (at least for the moment). The artist has his own image as well as the image he creates. It is important that through all these permutations the artist retains a vision which is true to the world he lives in, as well as to the world his imagination lives in.

This delicate balance between ritual and technology is applied to every aspect of my work. Whether I draw with a stick in the sand or use animated computer graphics, the same level of concentration exists. There is no difference for me between a drawing I do in the subway and a piece to be sold for thousands of dollars. There are obvious differences in context and medium, but the intention remains the same. The structure of the art "market" was established long before I was involved in it. It is my least favorite aspect of the role of the contemporary artist; however, it cannot be ignored. The use of galleries and commercial projects has enabled me to reach millions of people whom I would not have reached by remaining an unknown artist. I assumed, after all, that the point of making art was to communicate and contribute to a culture.

Art lives through the imaginations of the people who are seeing it. Without that contact, there is no art. I have made myself a role as an image-maker of the twentieth century and I daily try to understand the responsibilities and implications of that position. It has become increasingly clear to me that art is not an elitist activity reserved for the appreciation of a few, but for everyone, and that is the end toward which I will continue to work.

First published in *Flash Art* (March 1984), pp. 20-24

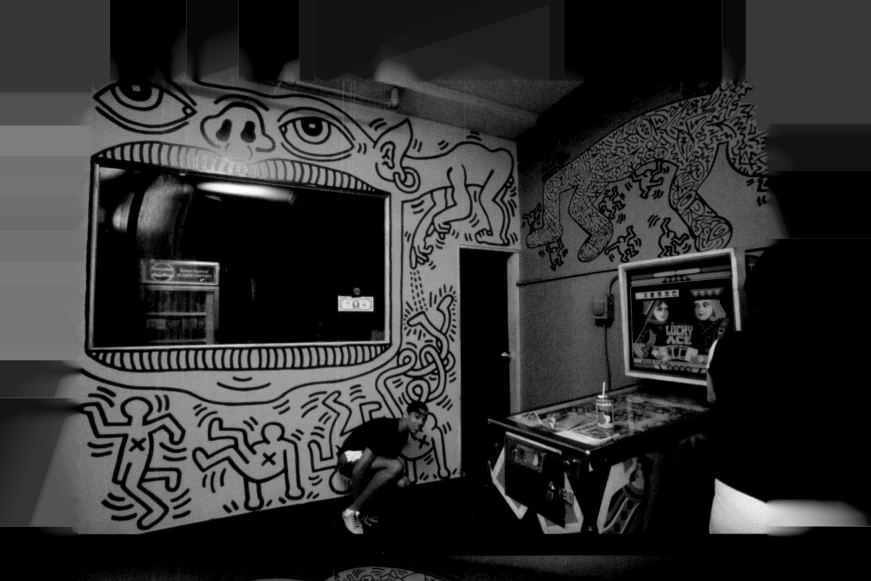

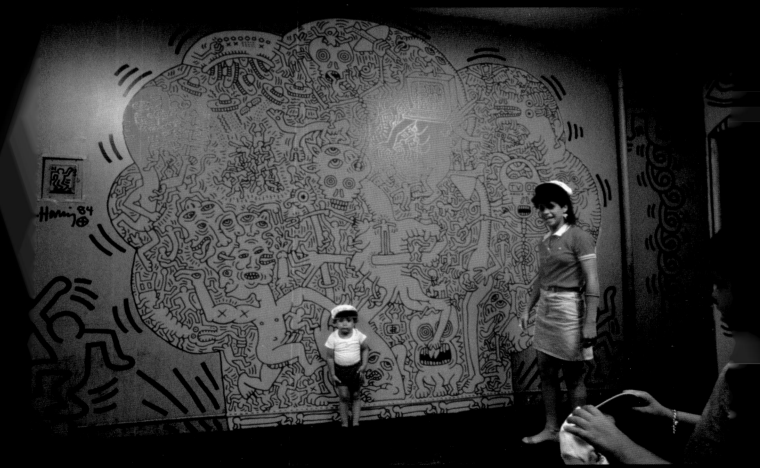

17 *Untitled,* 1980

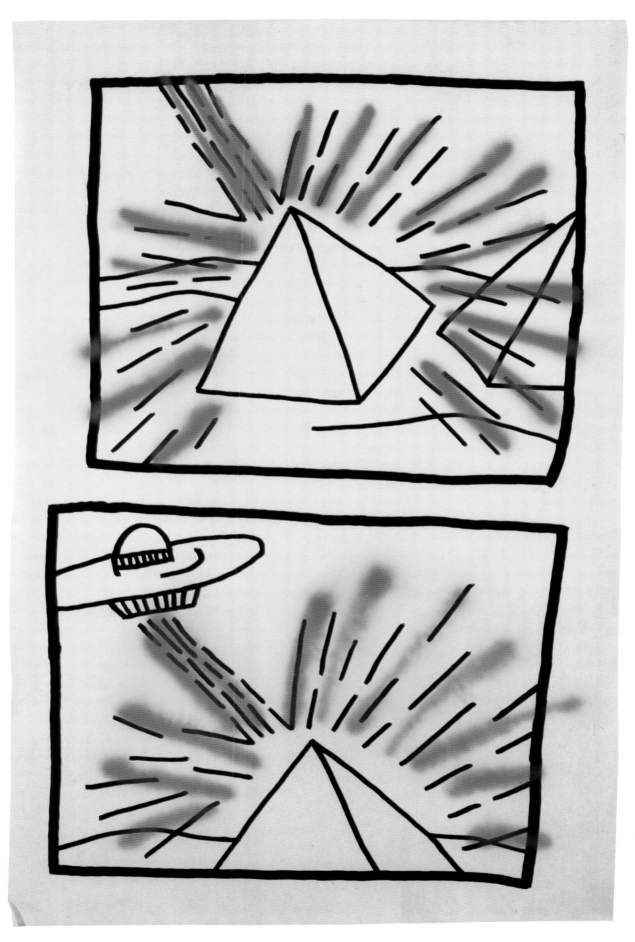

18 *Untitled,* 1980

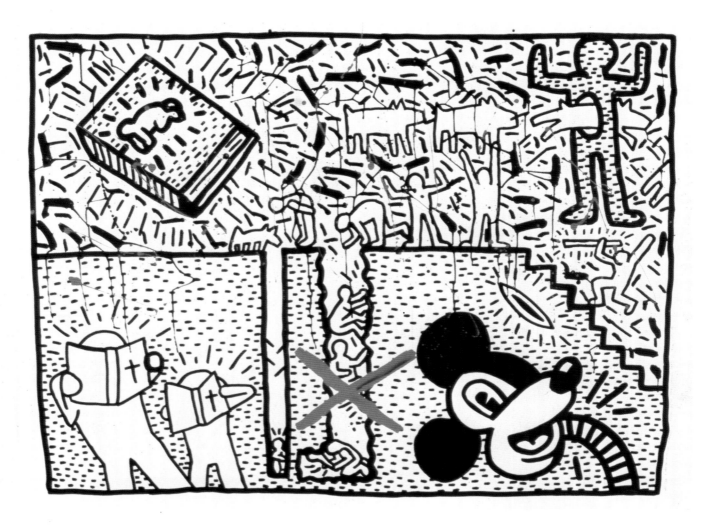

19 *Three Men Die in Rescue Attempt Six Months After John Lennon's Death,* 1981

20 *Untitled,* 1981

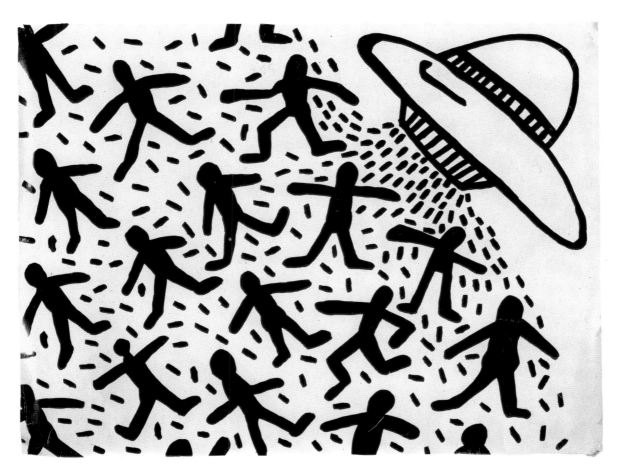

21 *Untitled,* 1980

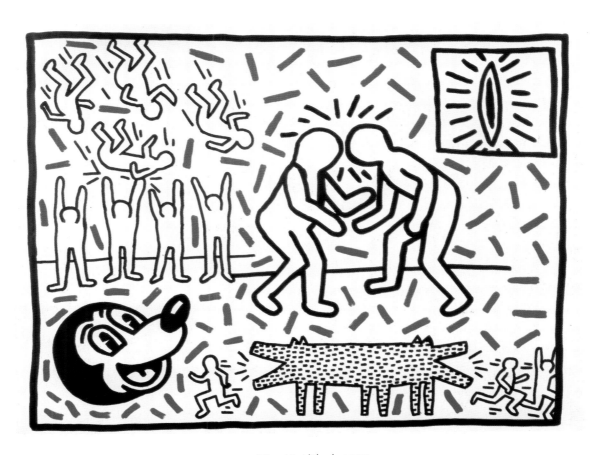

22 *Untitled,* 1981

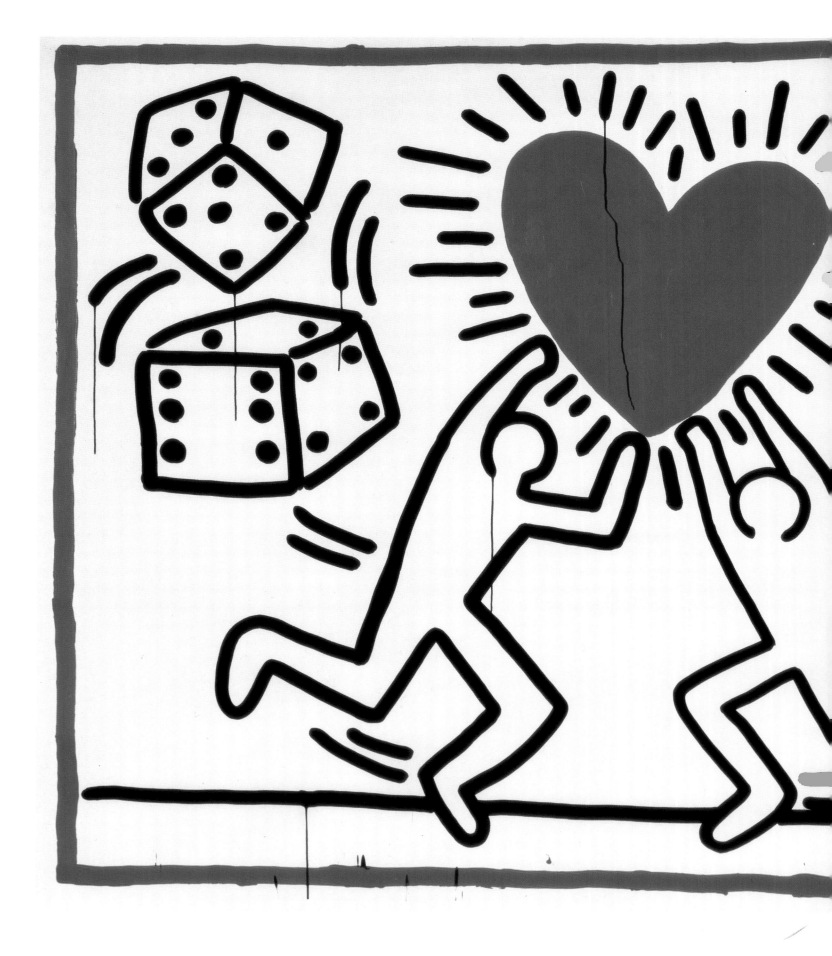

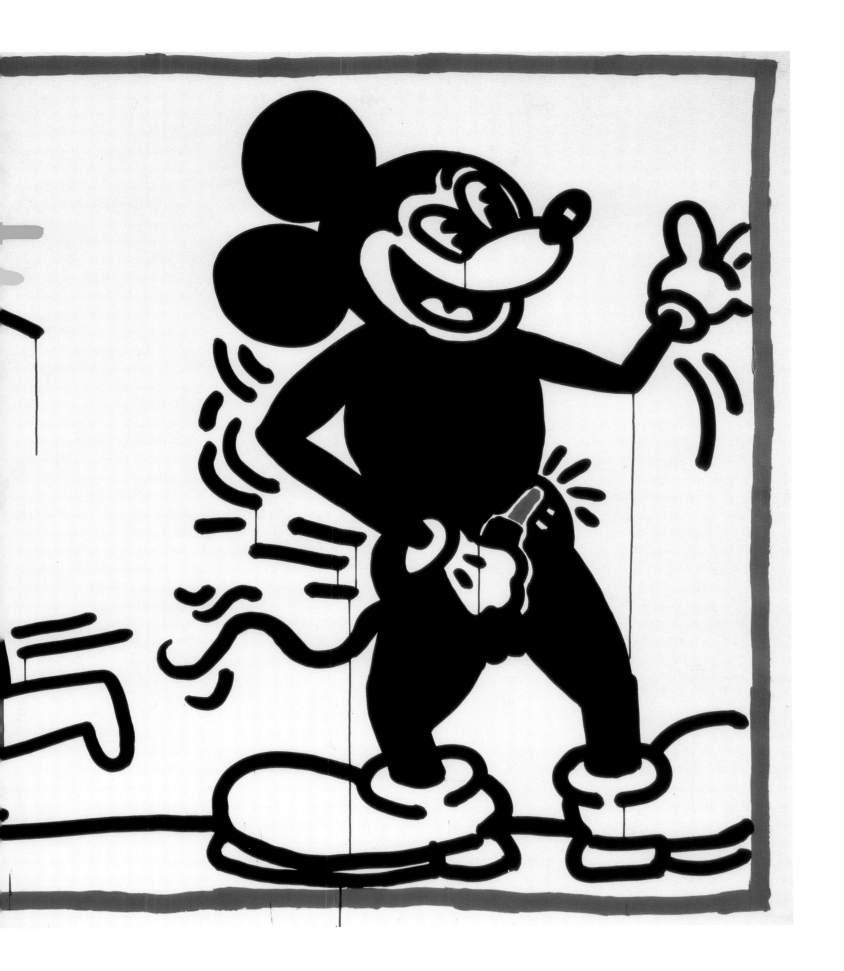

23 *Untitled*, 1982

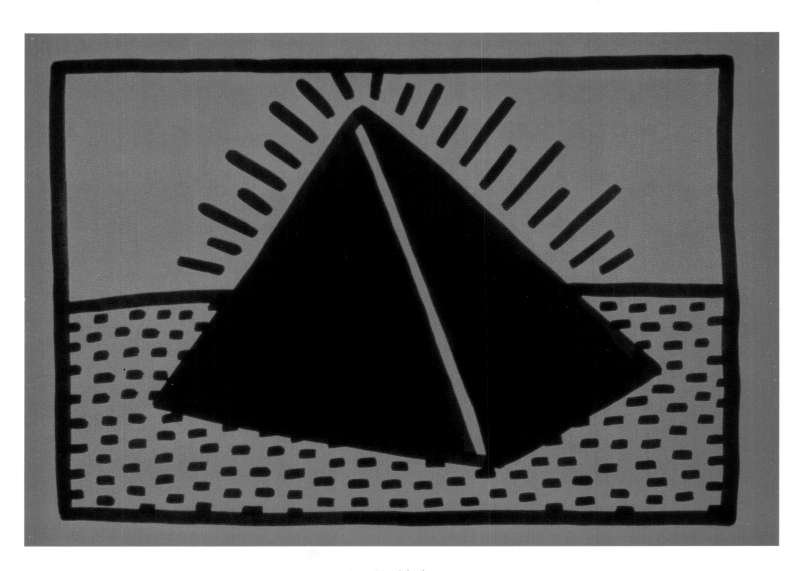

24 *Untitled*, 1982

25 *Untitled*, 1982

26 *Untitled*, 1982

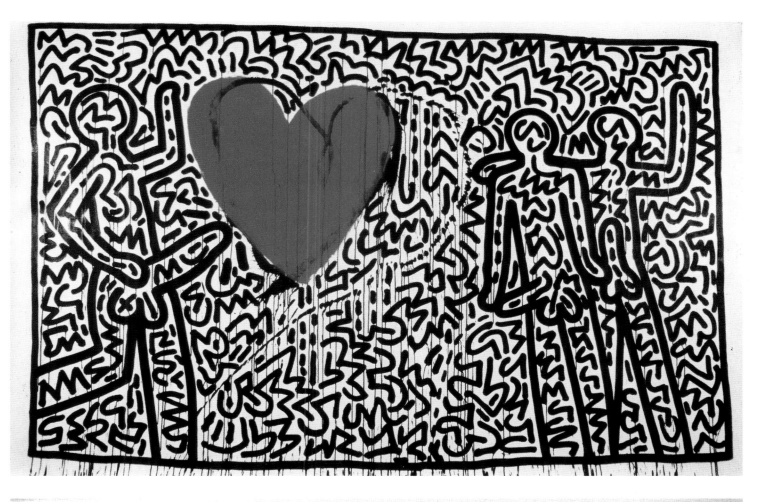

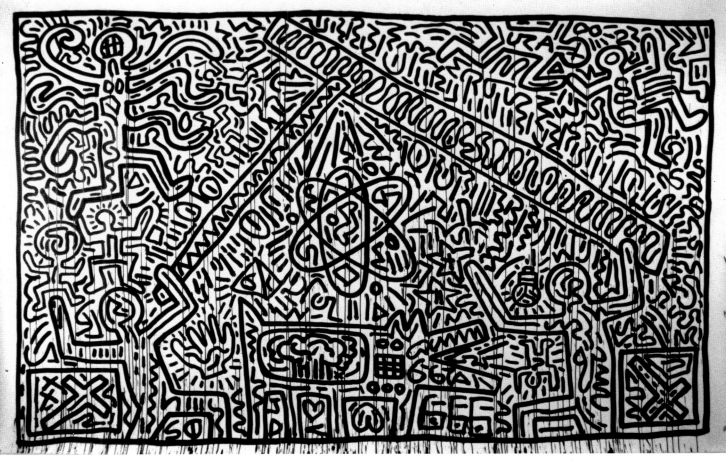

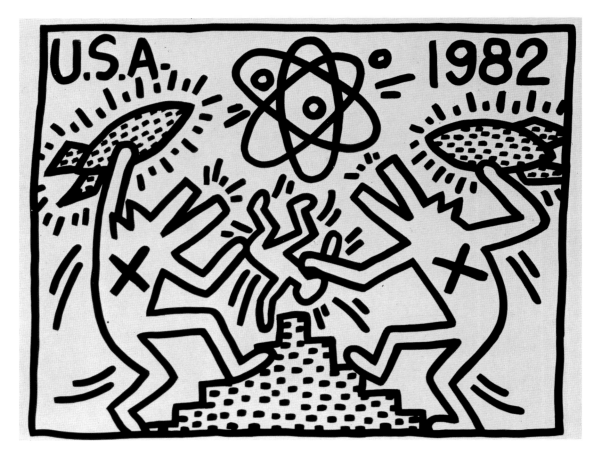

27 *Untitled,* 1982

28 *Untitled,* 1983

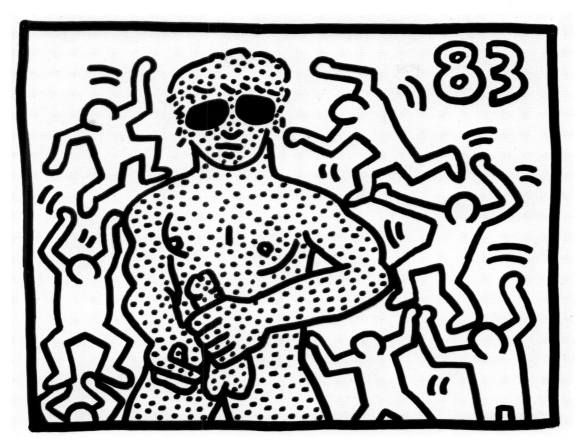

29 *Untitled,* 1983

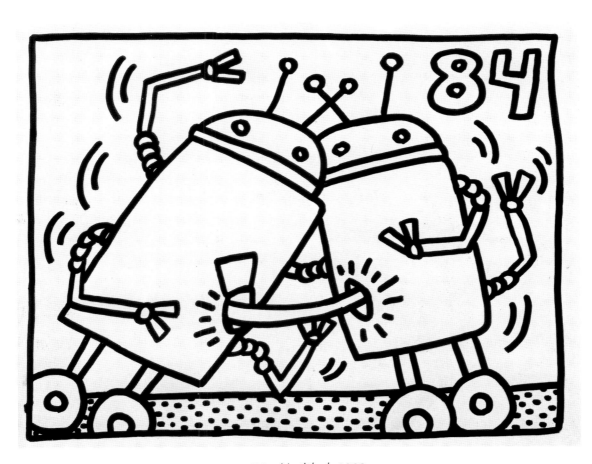

30 *Untitled,* 1983

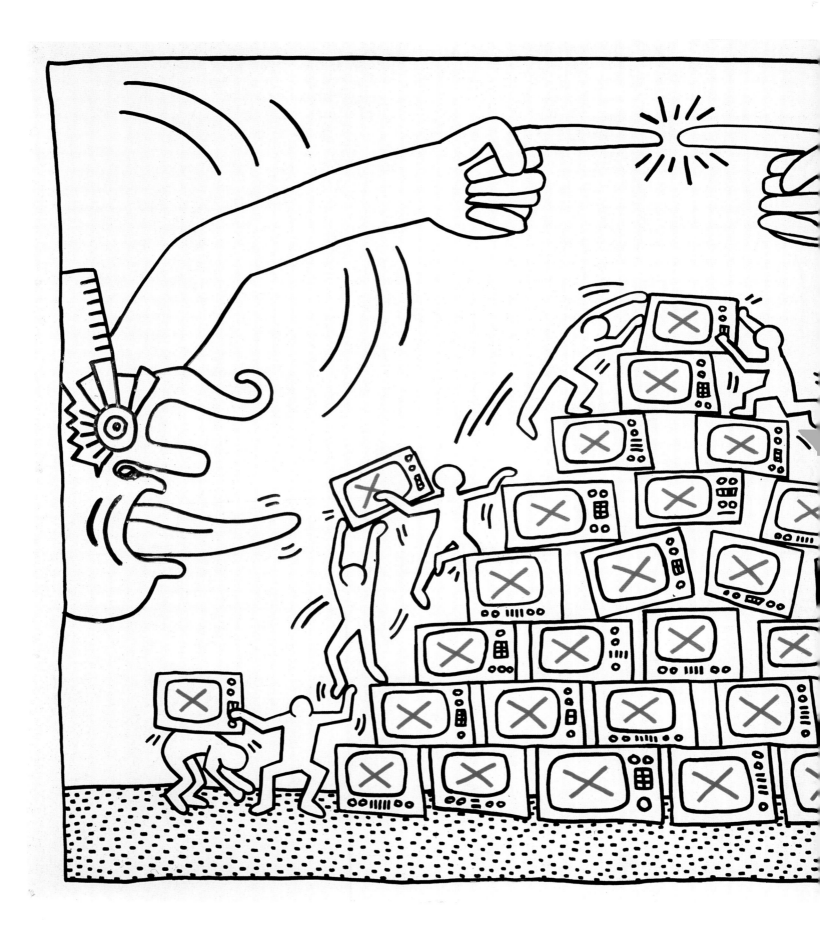

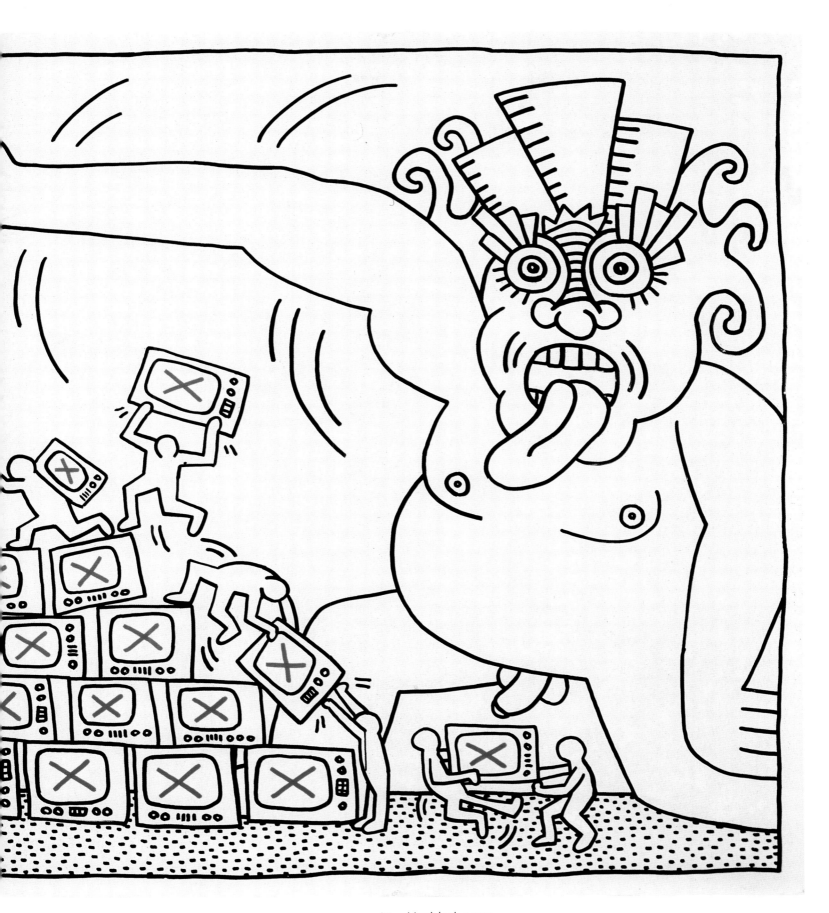

31 *Untitled,* 1983

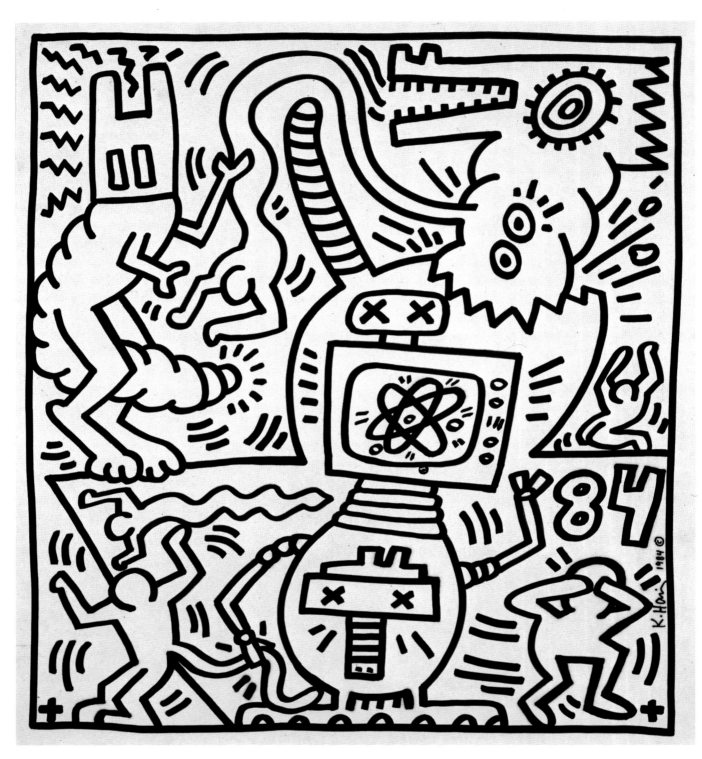

32 *Untitled,* 1984

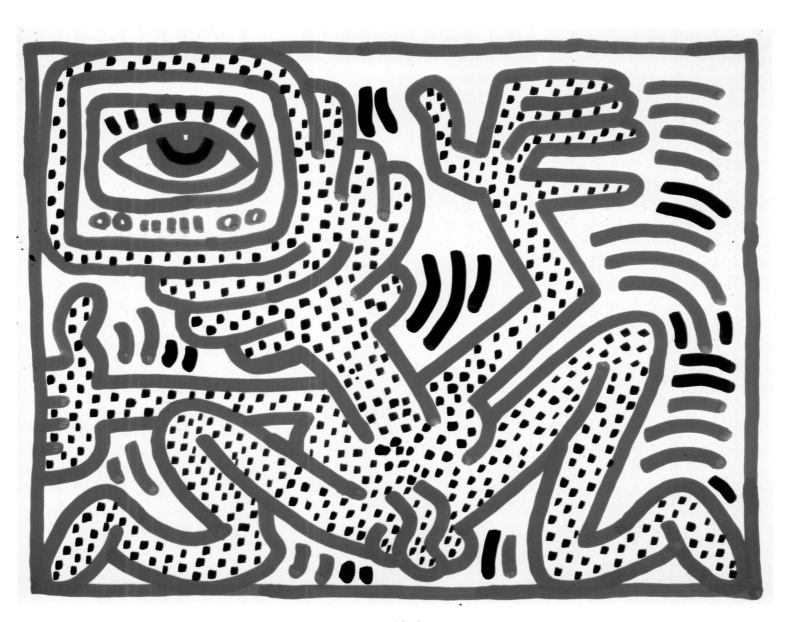

33 *Untitled,* 1983

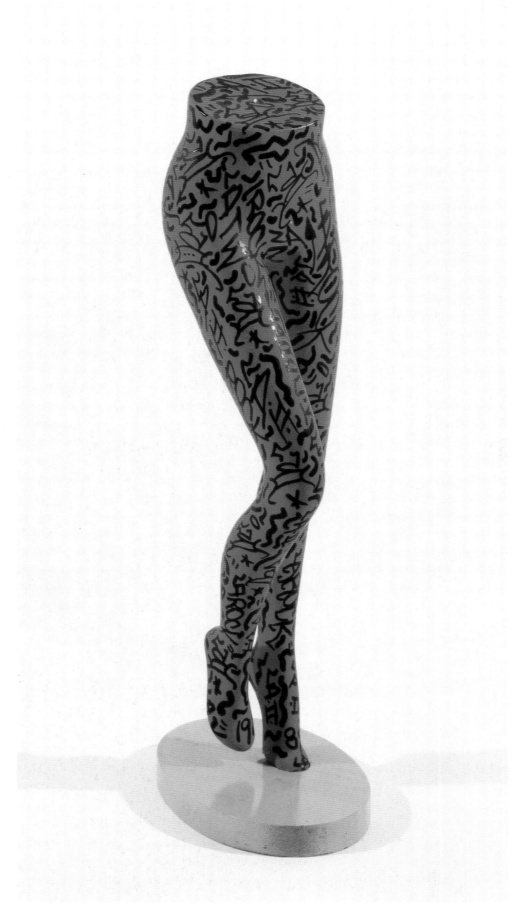

34 *Untitled,* 1982 (with LA II)

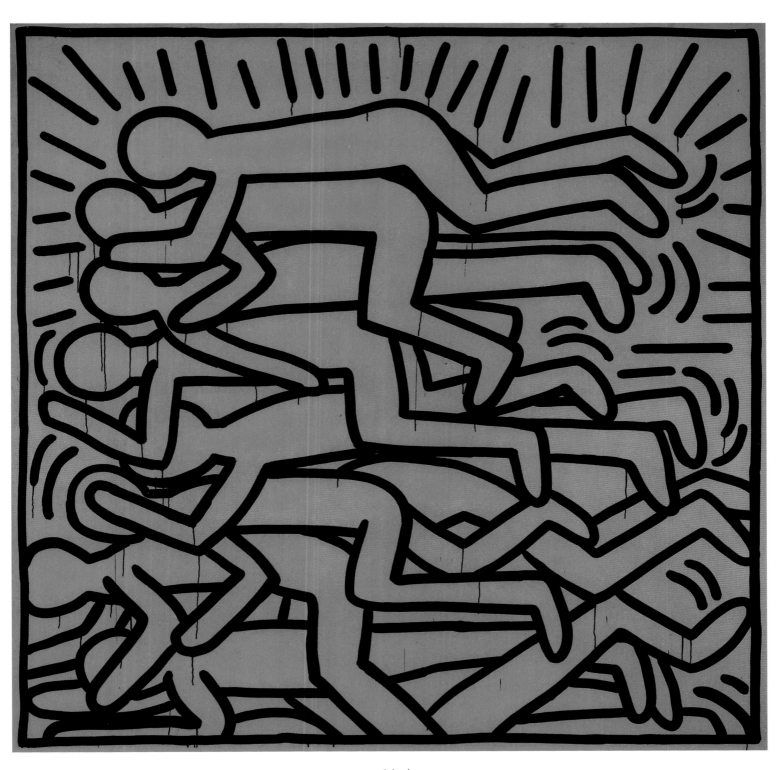

35 *Untitled*, 1982

36 *Untitled,* 1983

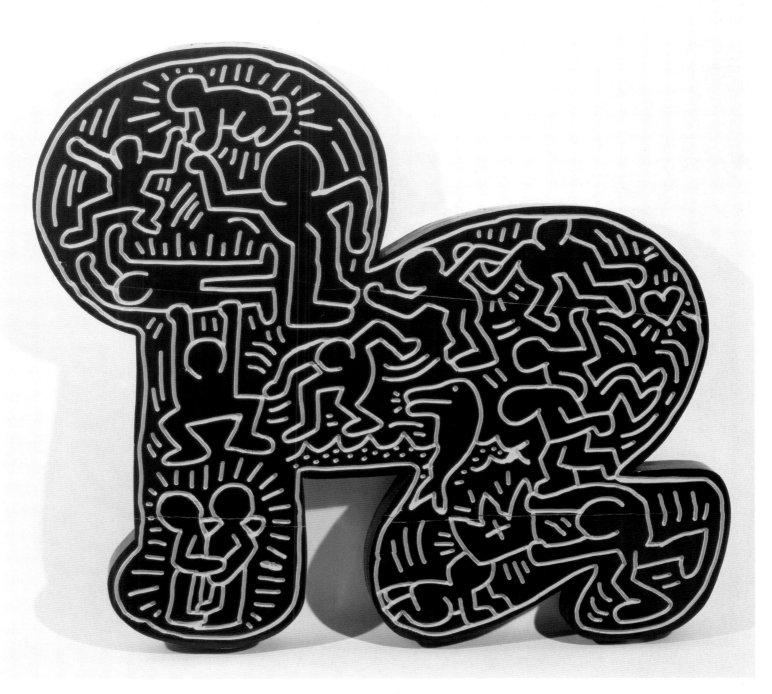

37 *Untitled*, 1983

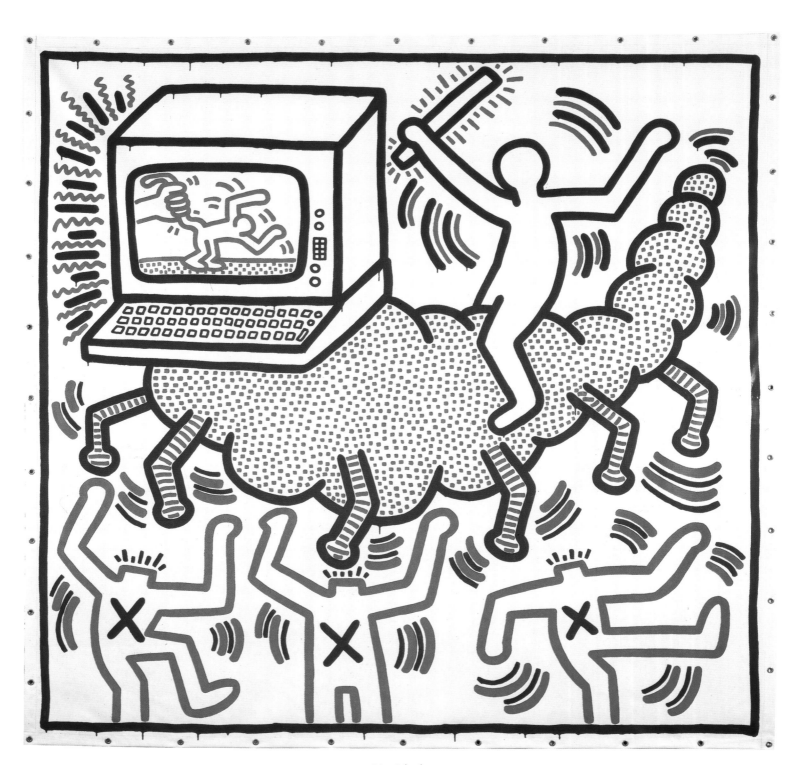

38 *Untitled*, 1983

39 *Untitled*, 1983

Overleaf:

40 Installation view of sarcophagus and screen, 1983 (with LA II)

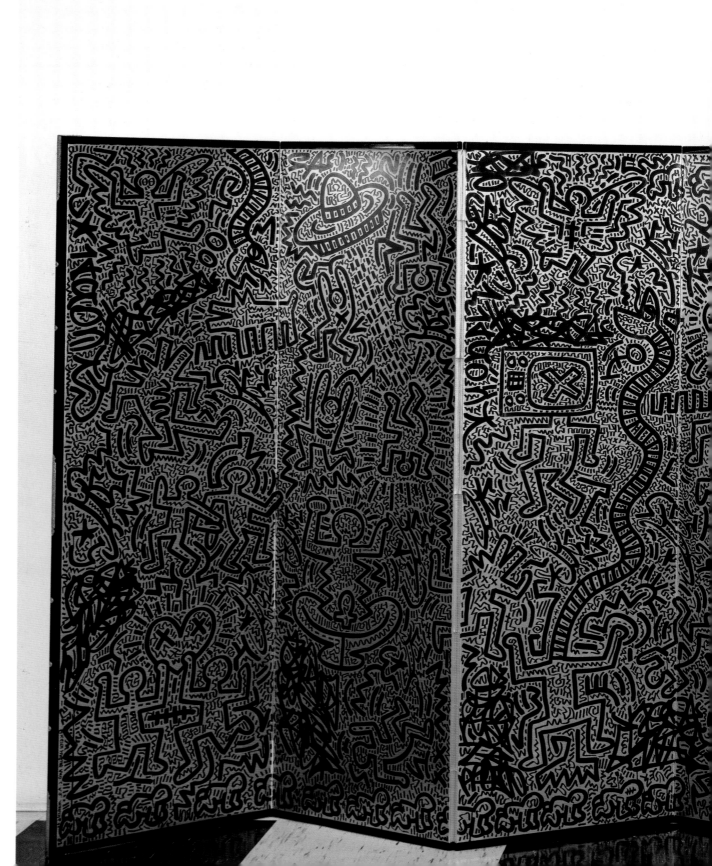

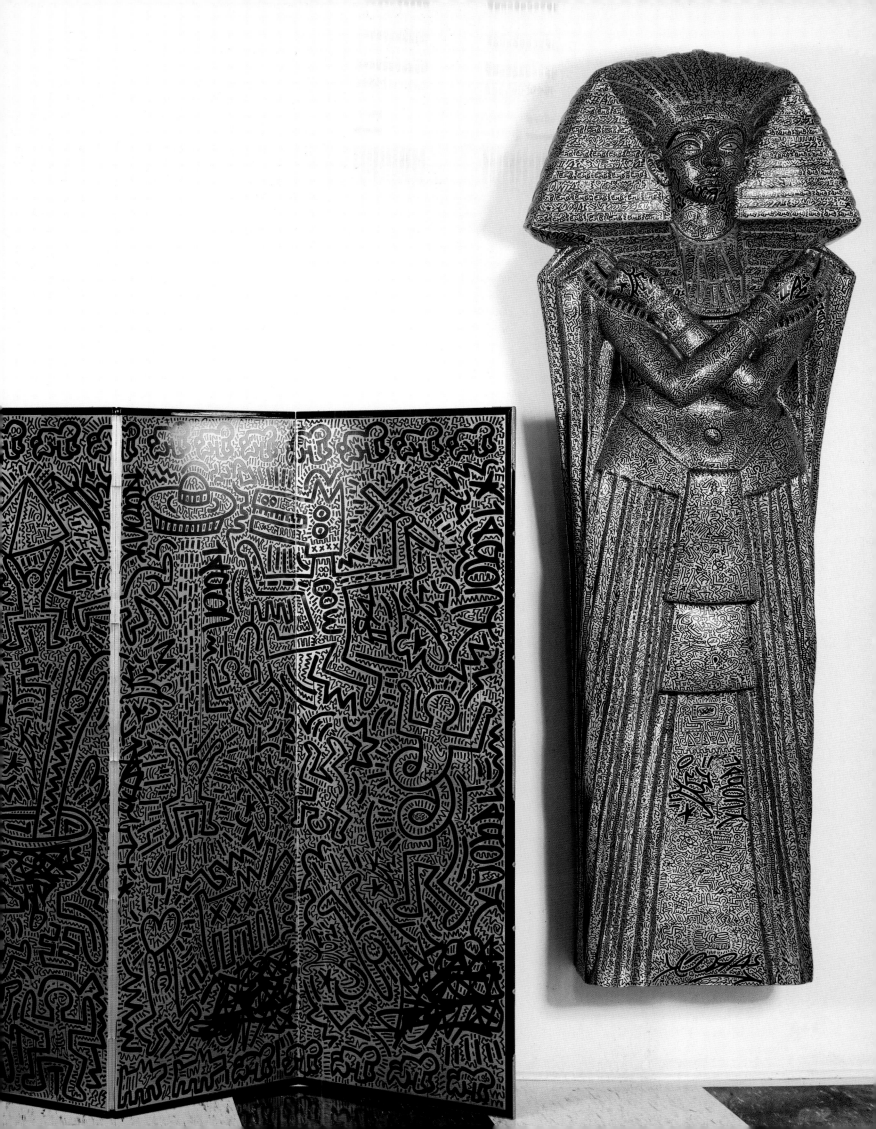

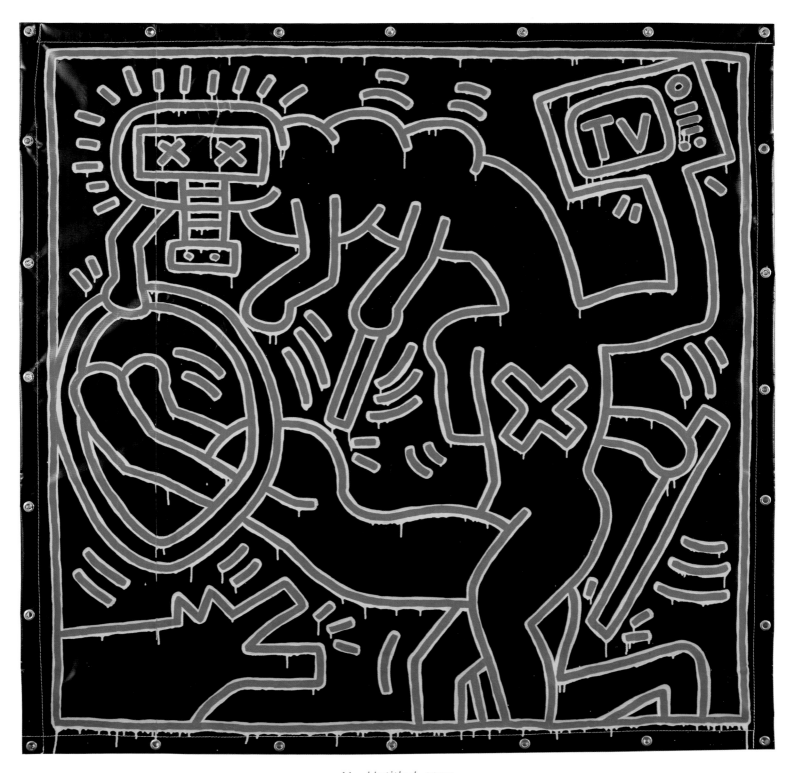

41 *Untitled,* 1983

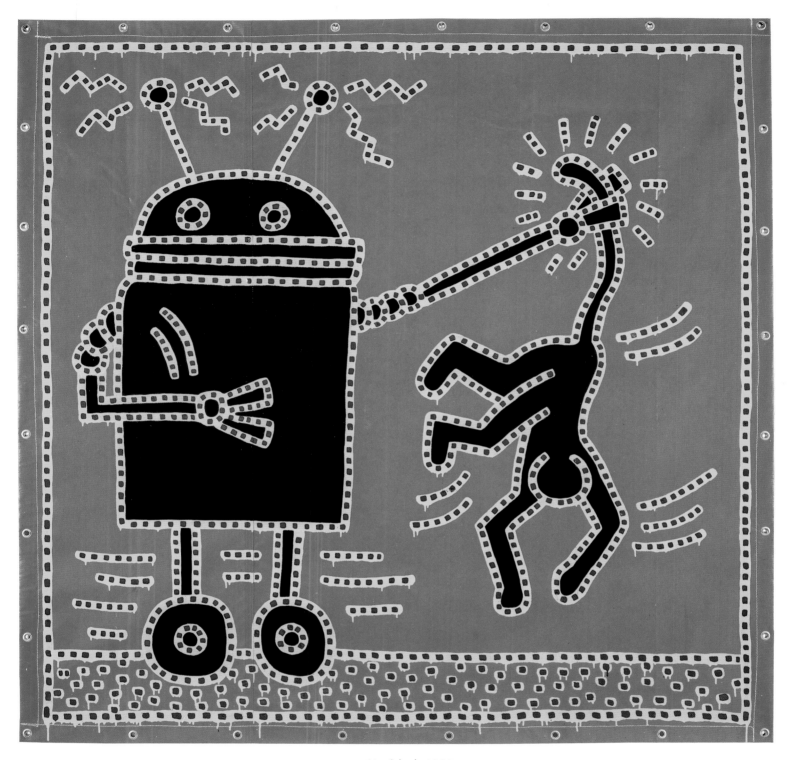

42 *Untitled*, 1983

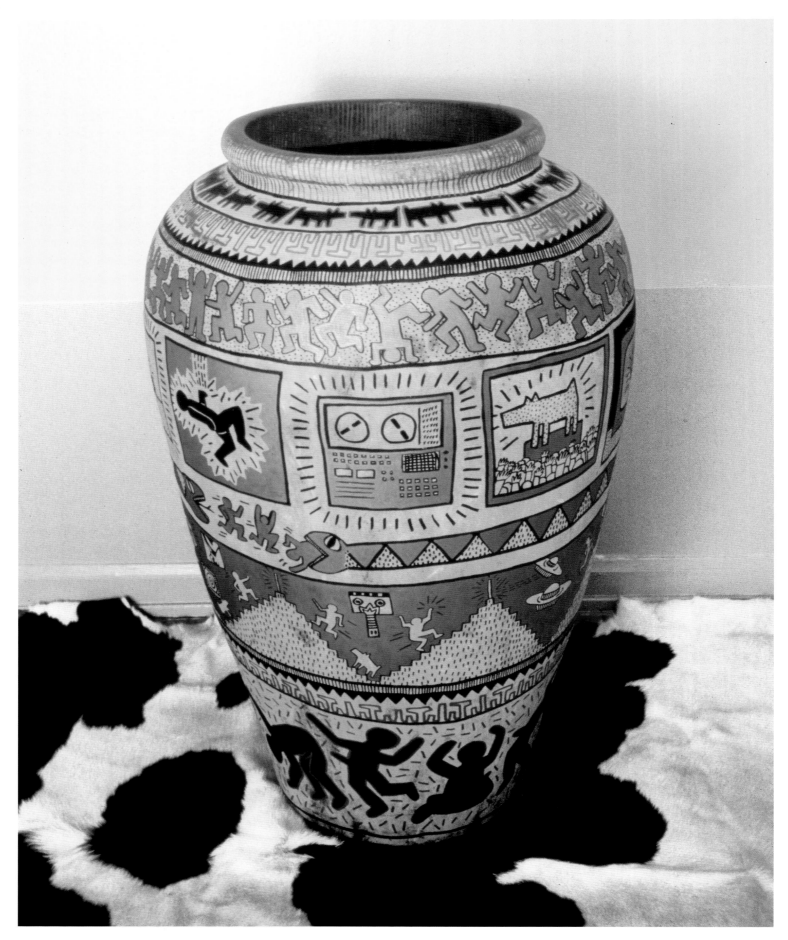

43 *Untitled,* 1981

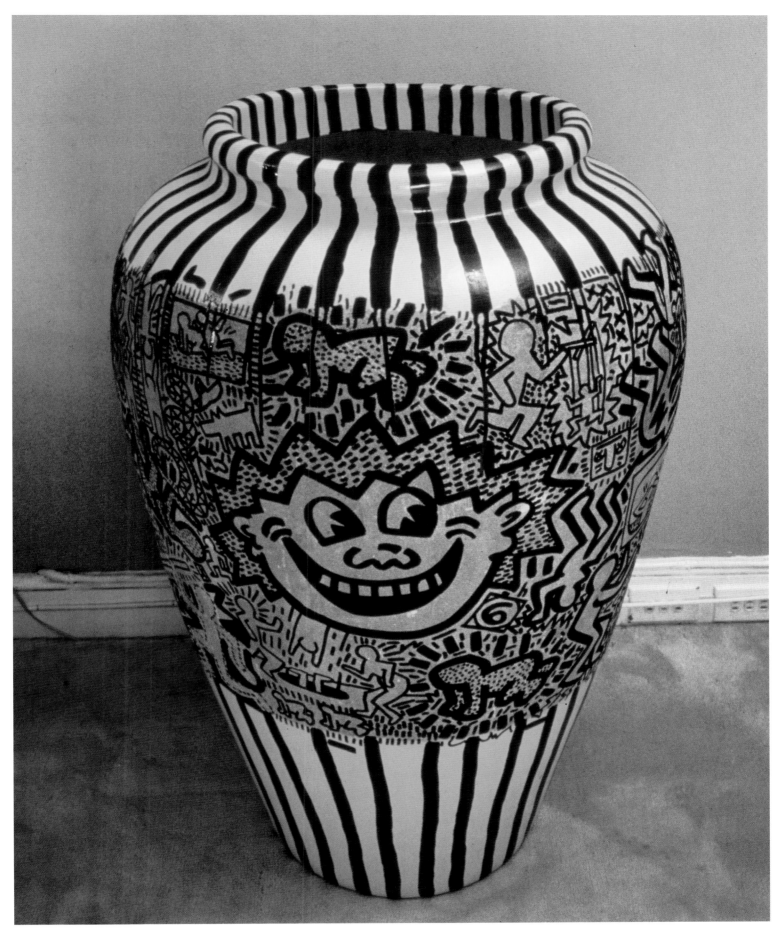

44 *Untitled,* 1981

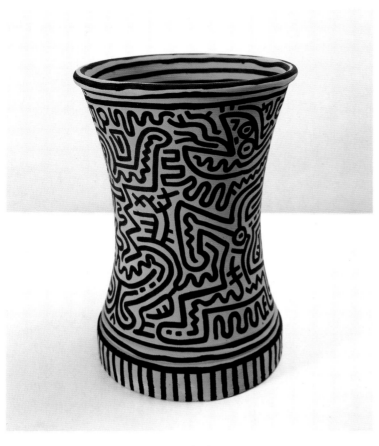

45 *Untitled*, 1984

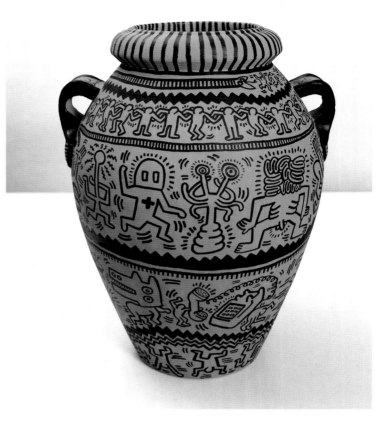

46 *Untitled*, 1984

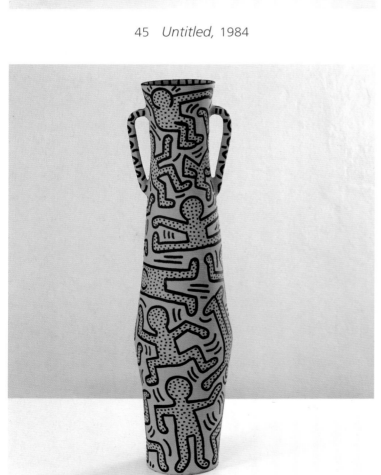

47 *Untitled*, 1984

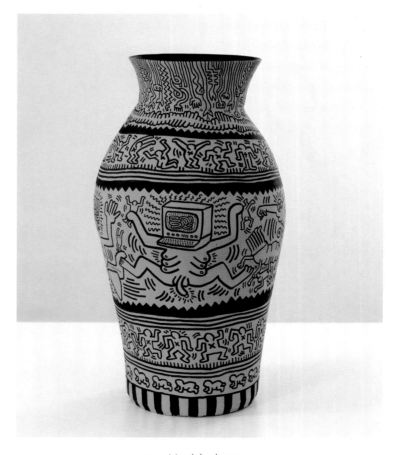

48 *Untitled*, 1984

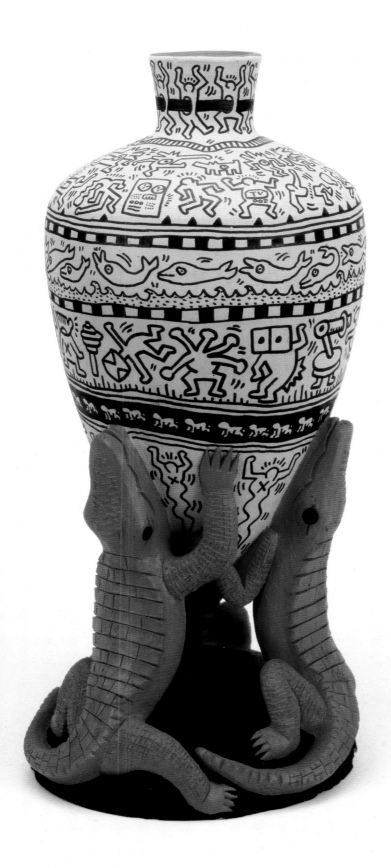

49 *Untitled,* 1990

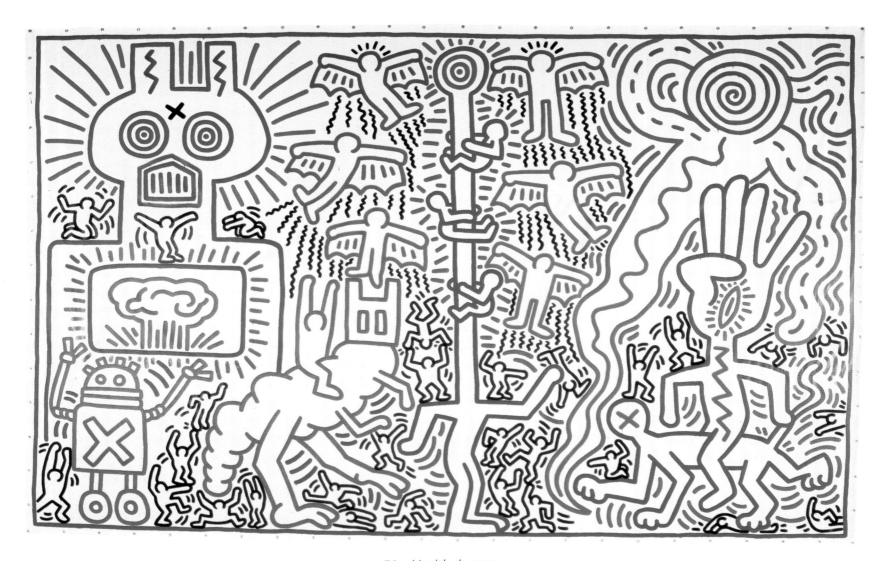

50 *Untitled,* 1983

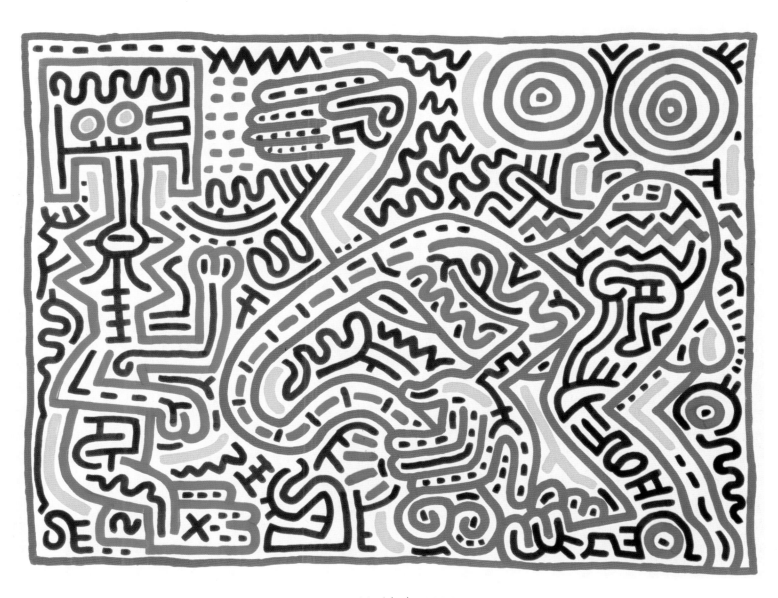

51 *Untitled*, 1984

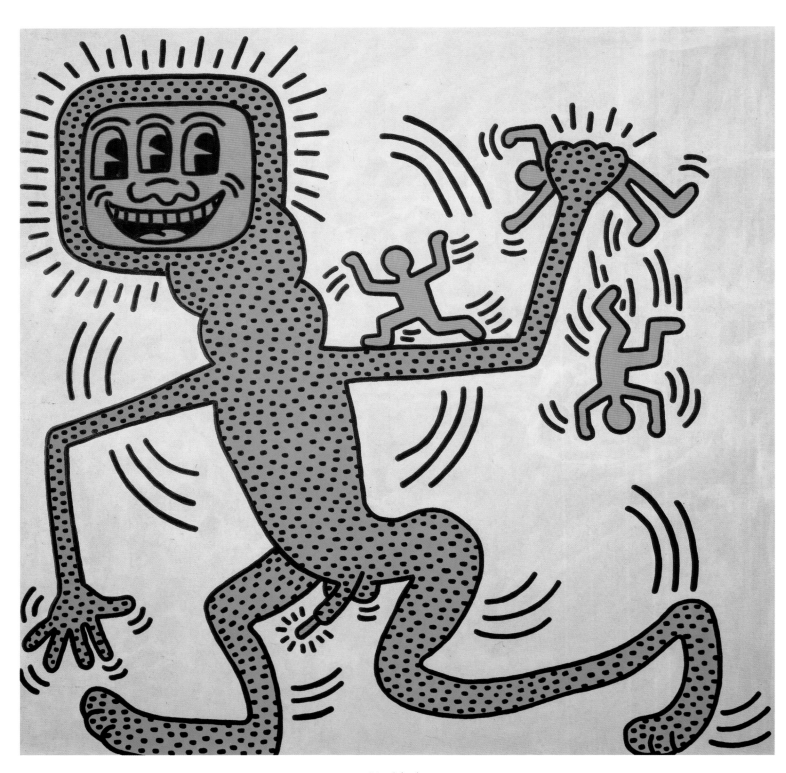

52 *Untitled*, 1984

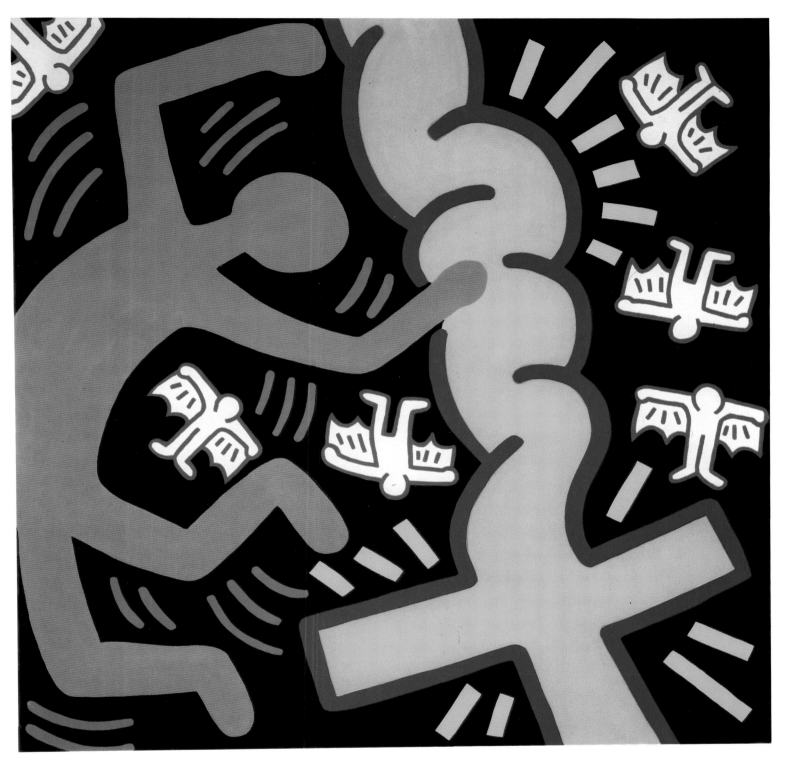

53 *Untitled,* 1984

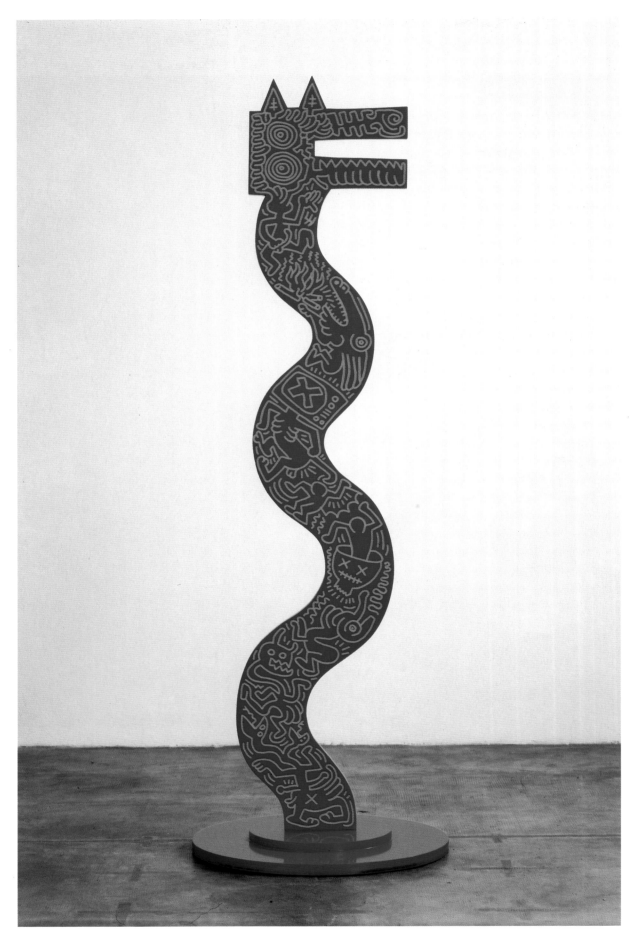

54 *Untitled,* 1984

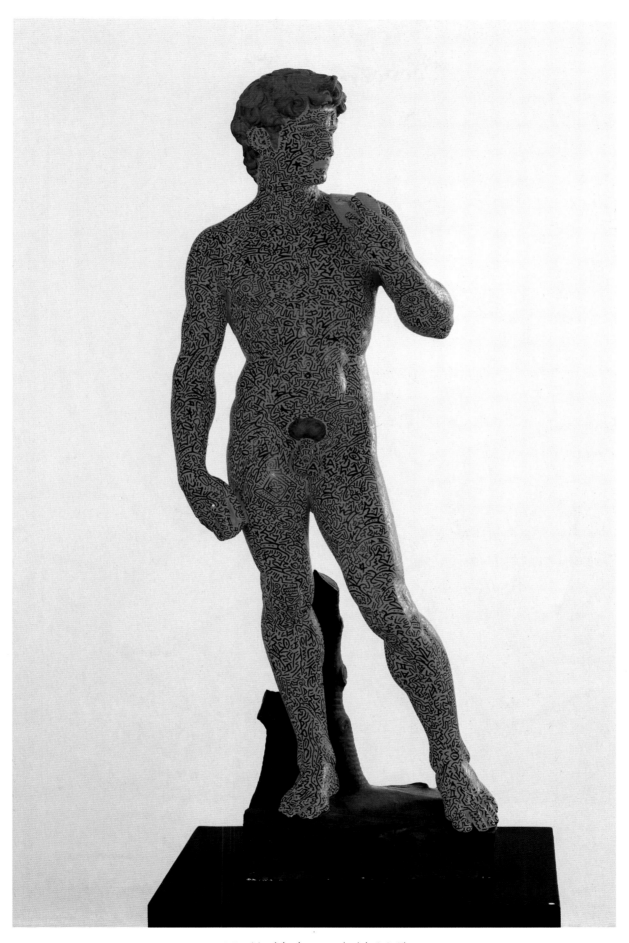

55 *Untitled*, 1984 (with LA II)

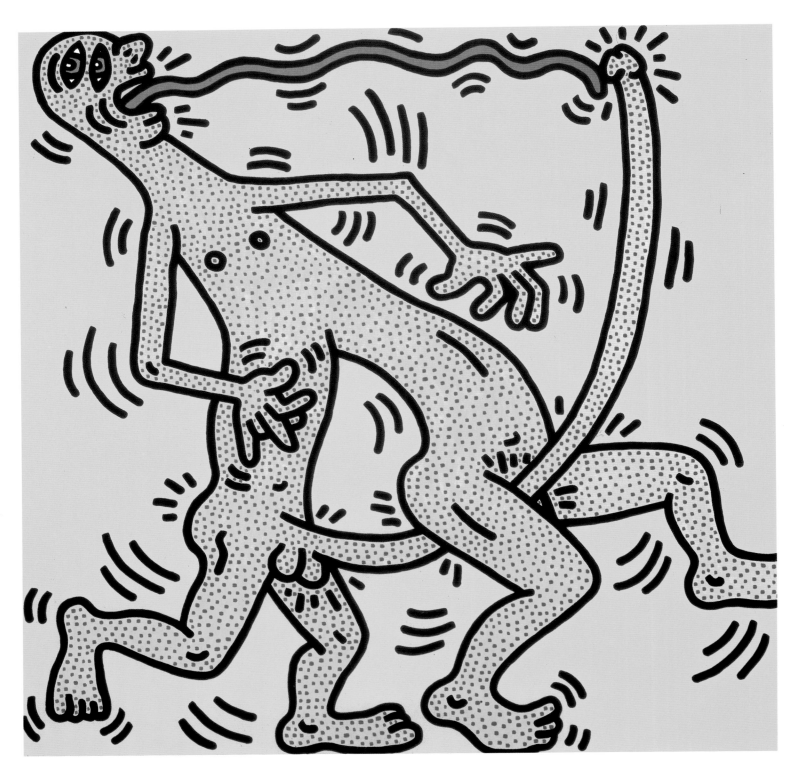

56 *Untitled*, 1984

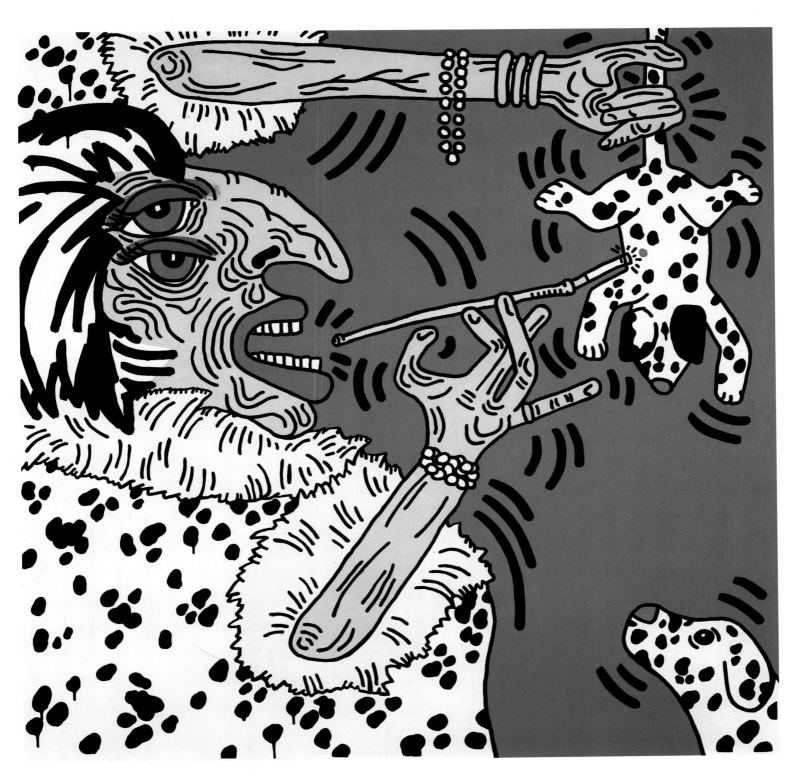

57 *Cruella Deville*, 1984

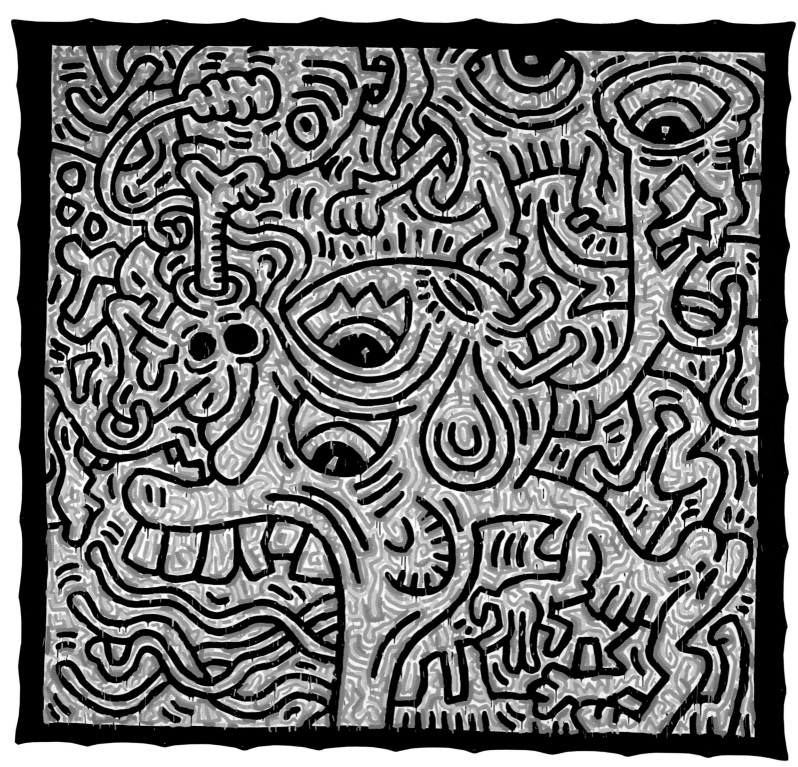

58 *Untitled*, 1984

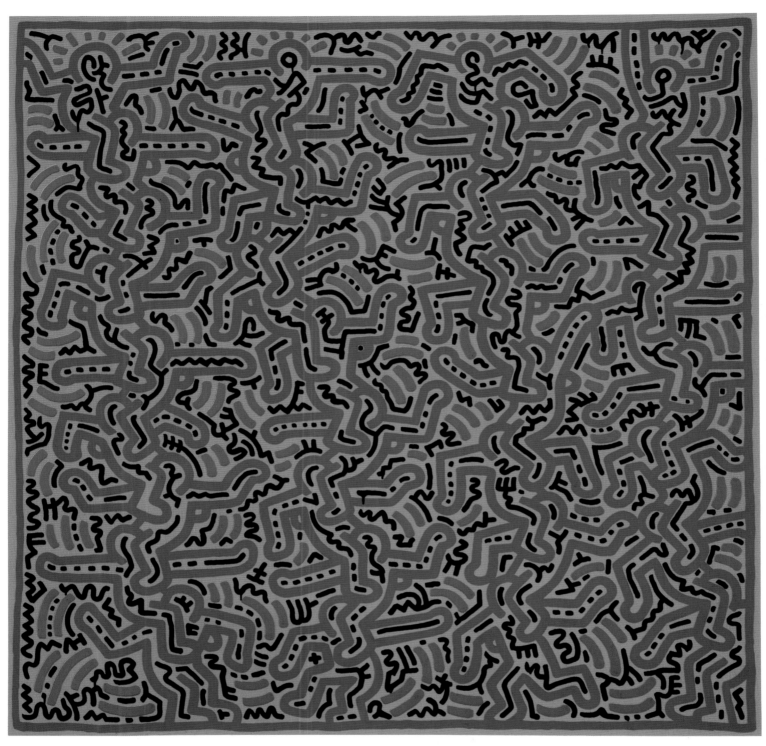

59 *Untitled*, 1984

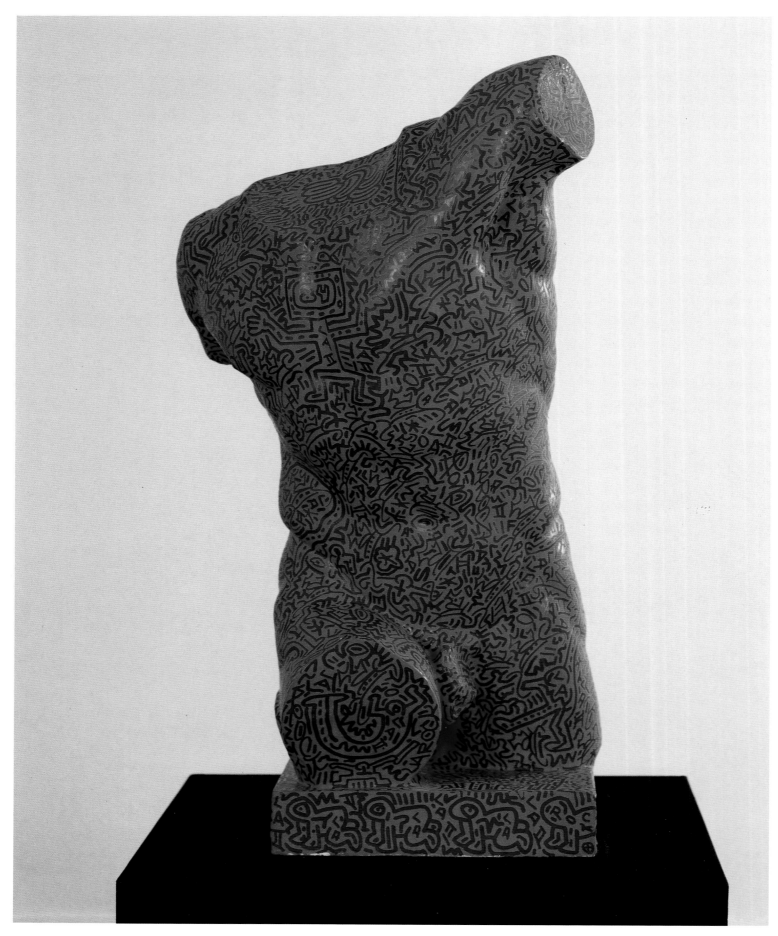

60 *Untitled,* 1984

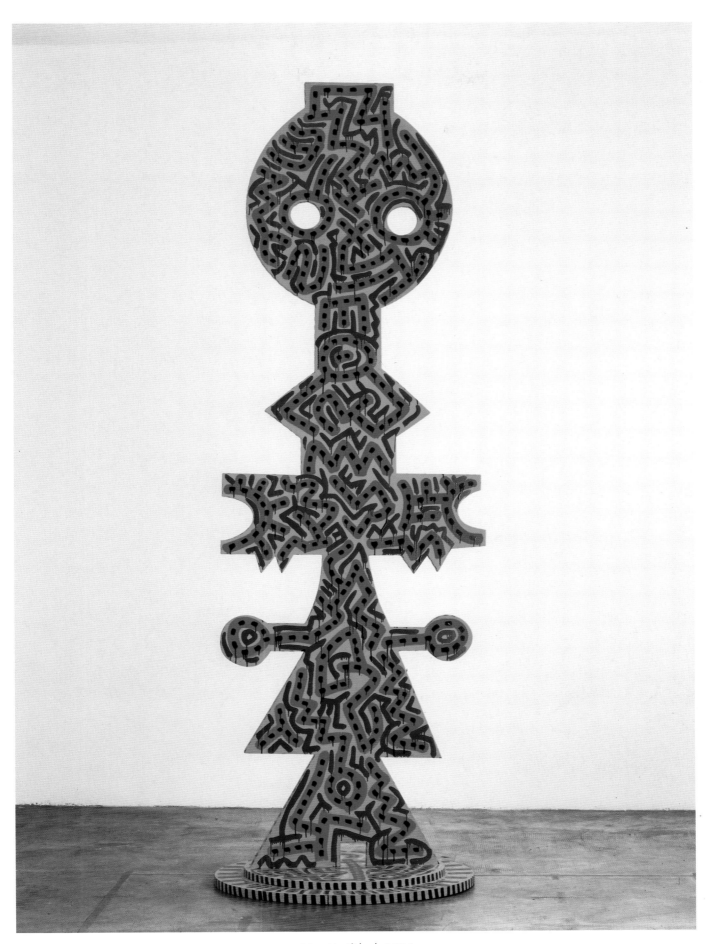

61 *Untitled,* 1984

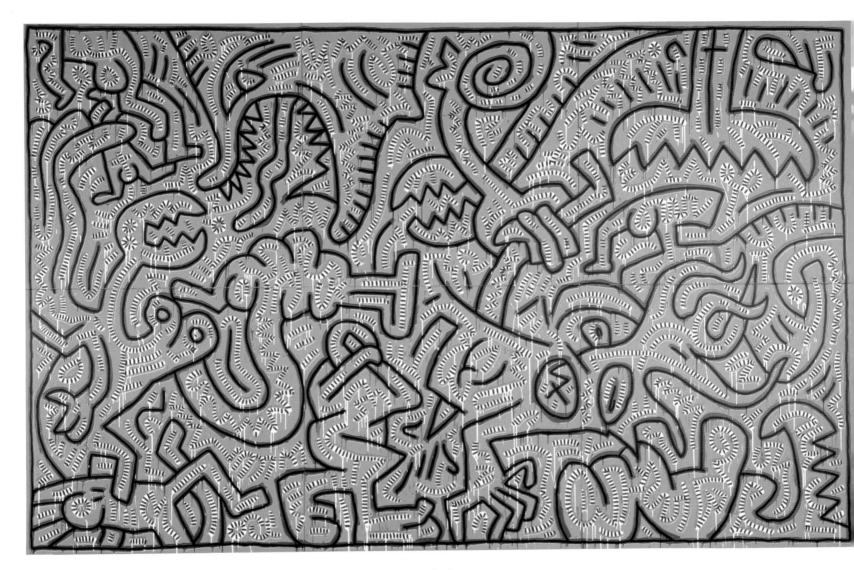

62 *Untitled,* 1984

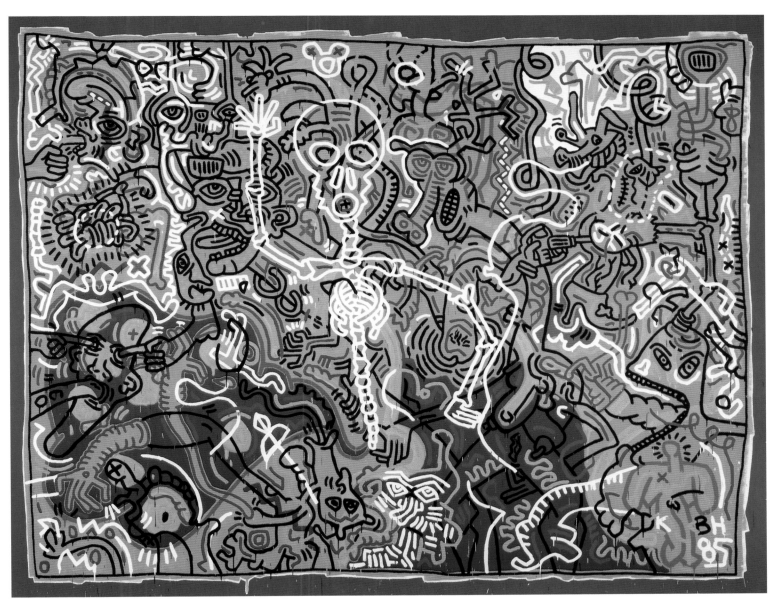

63 *Untitled*, 1984

Following pages:

64, 65 Drawings in the New York City subway, 1985, 1983

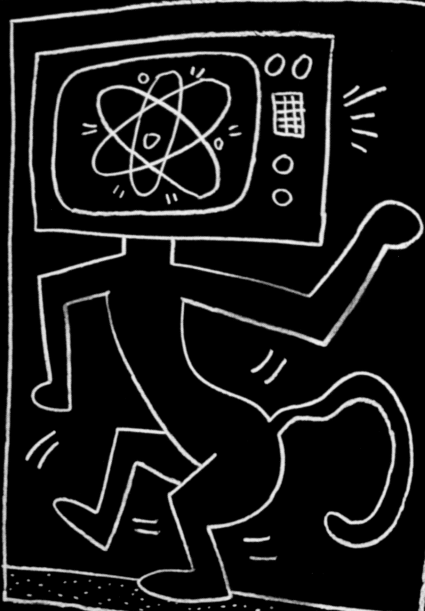

5TH AV.

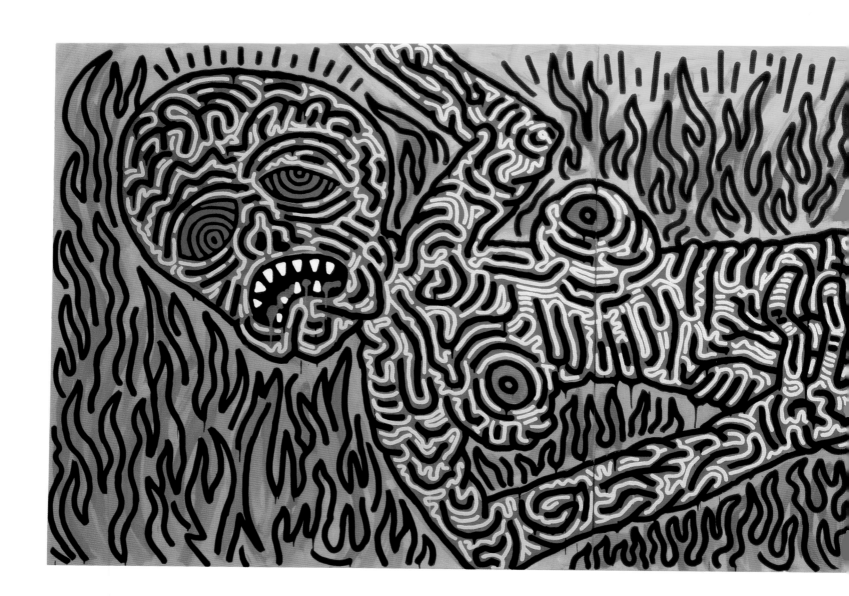

66 *Untitled,* 1984

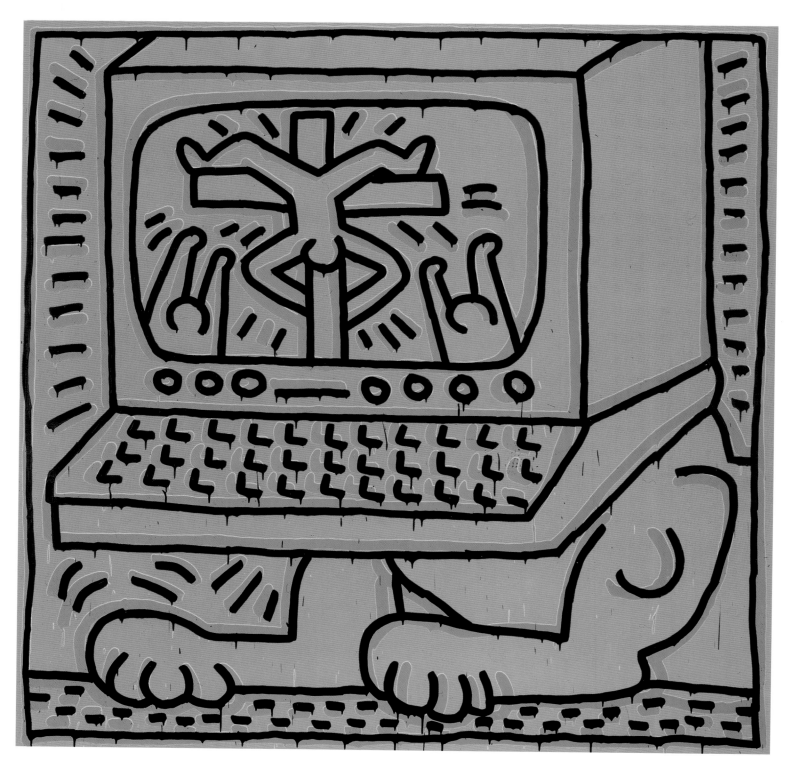

67 *Untitled,* 1984

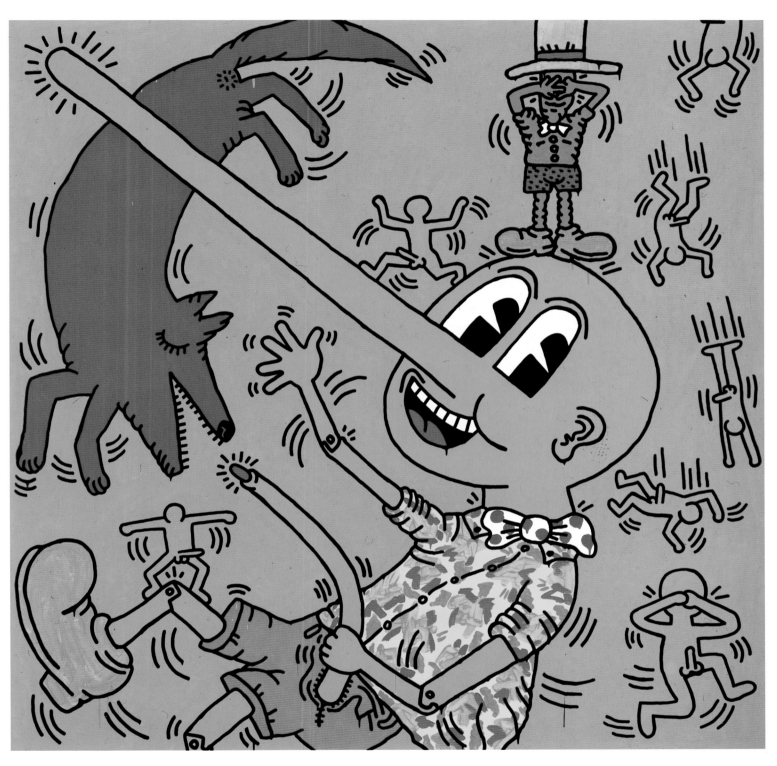

68 *Untitled,* 1984

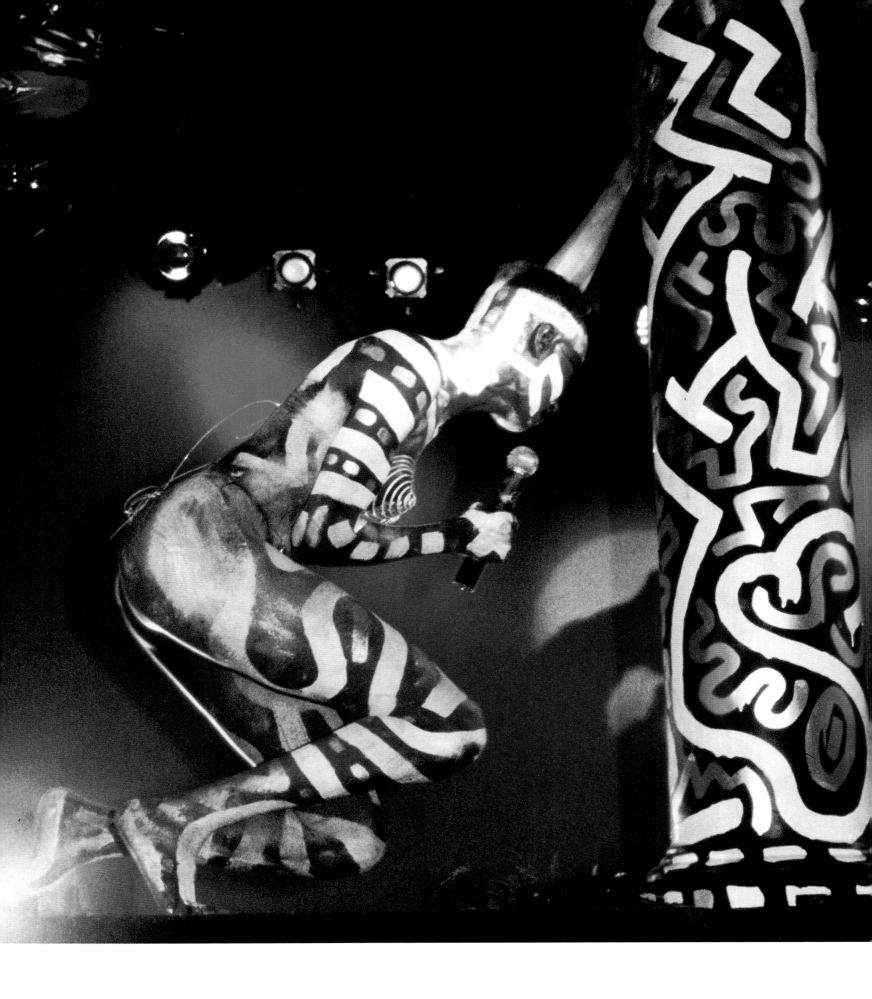

69, 70 Painted body of Grace Jones and stage set for performance at the Paradise Garage, 1984

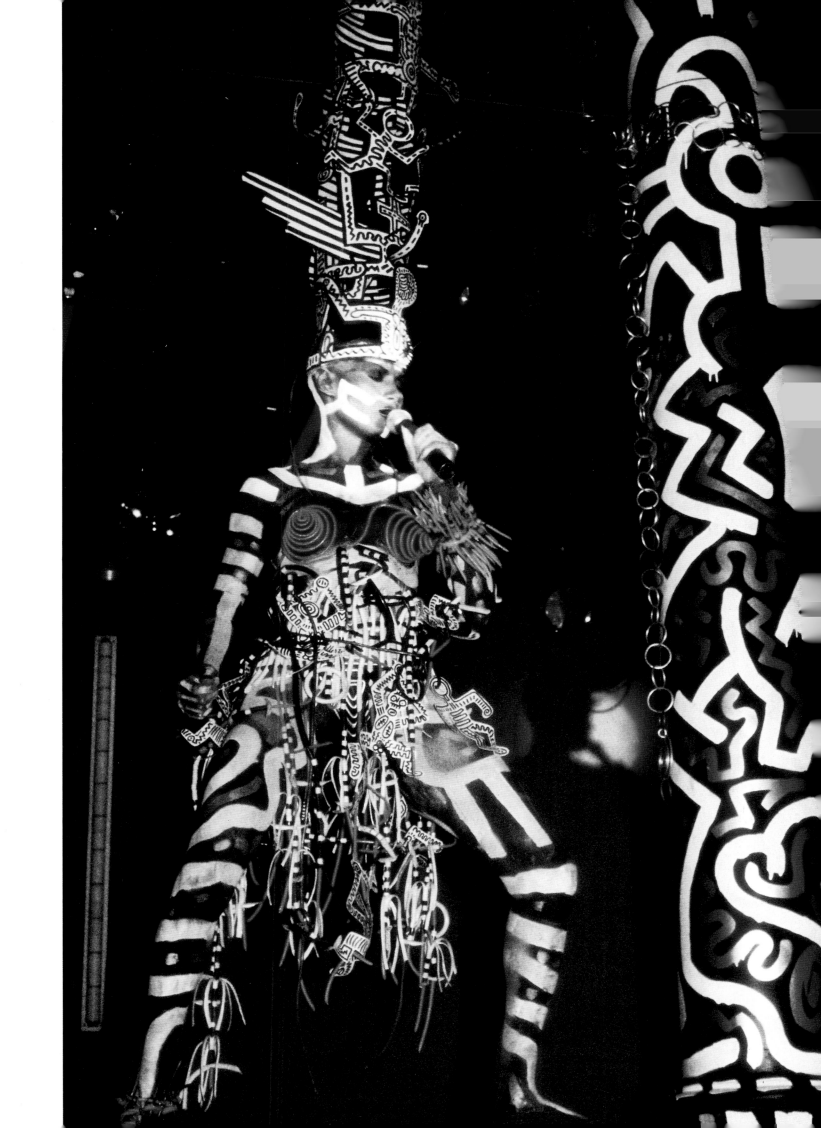

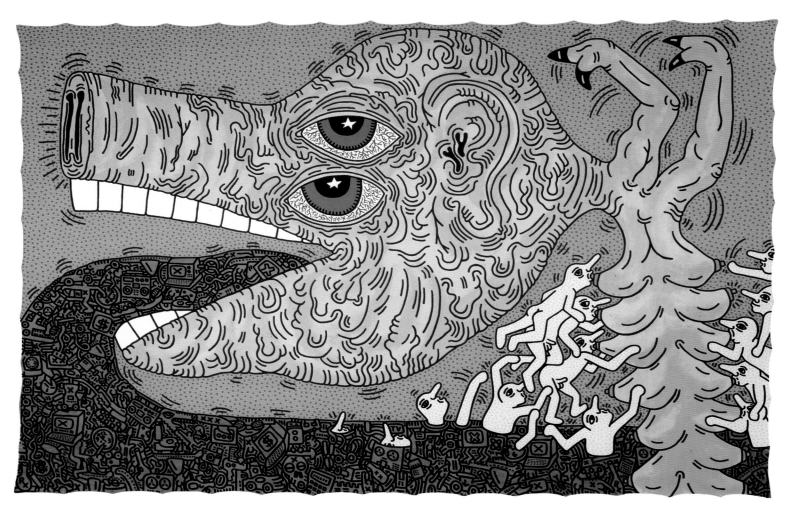

71 *Untitled,* 1984

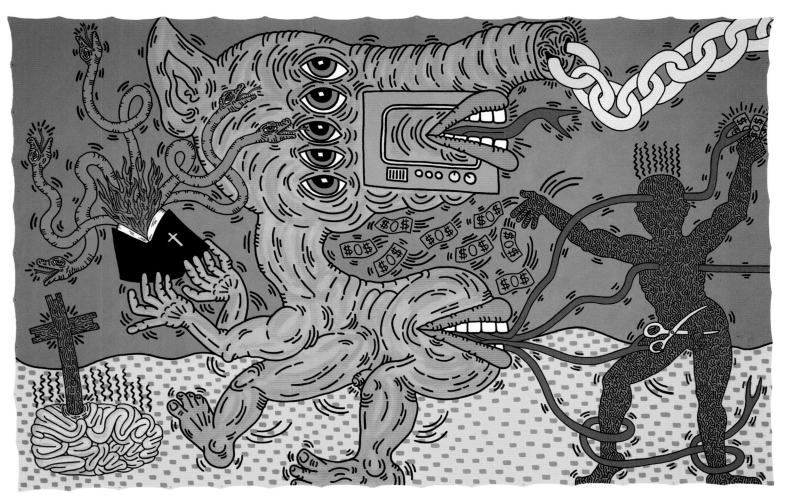

72 *Untitled,* 1985

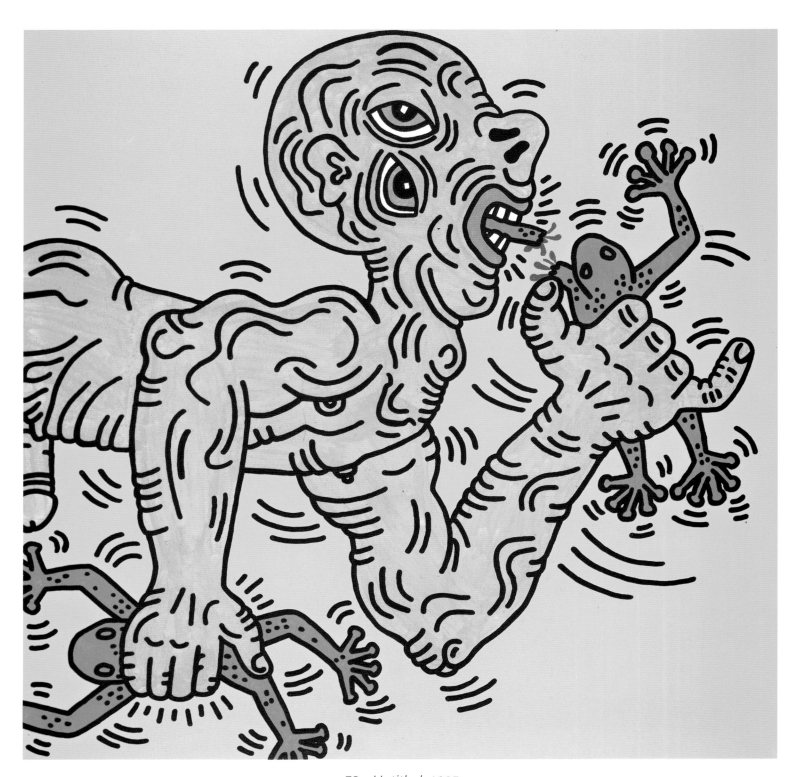

73 *Untitled,* 1985

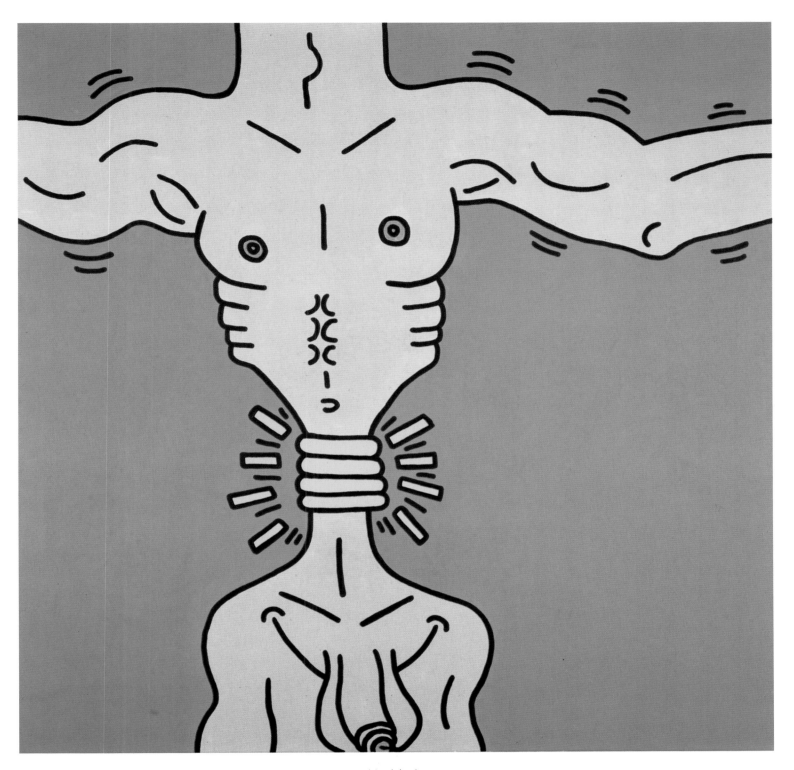

74 *Untitled*, 1985

Overleaf:

75 *Untitled*, 1985

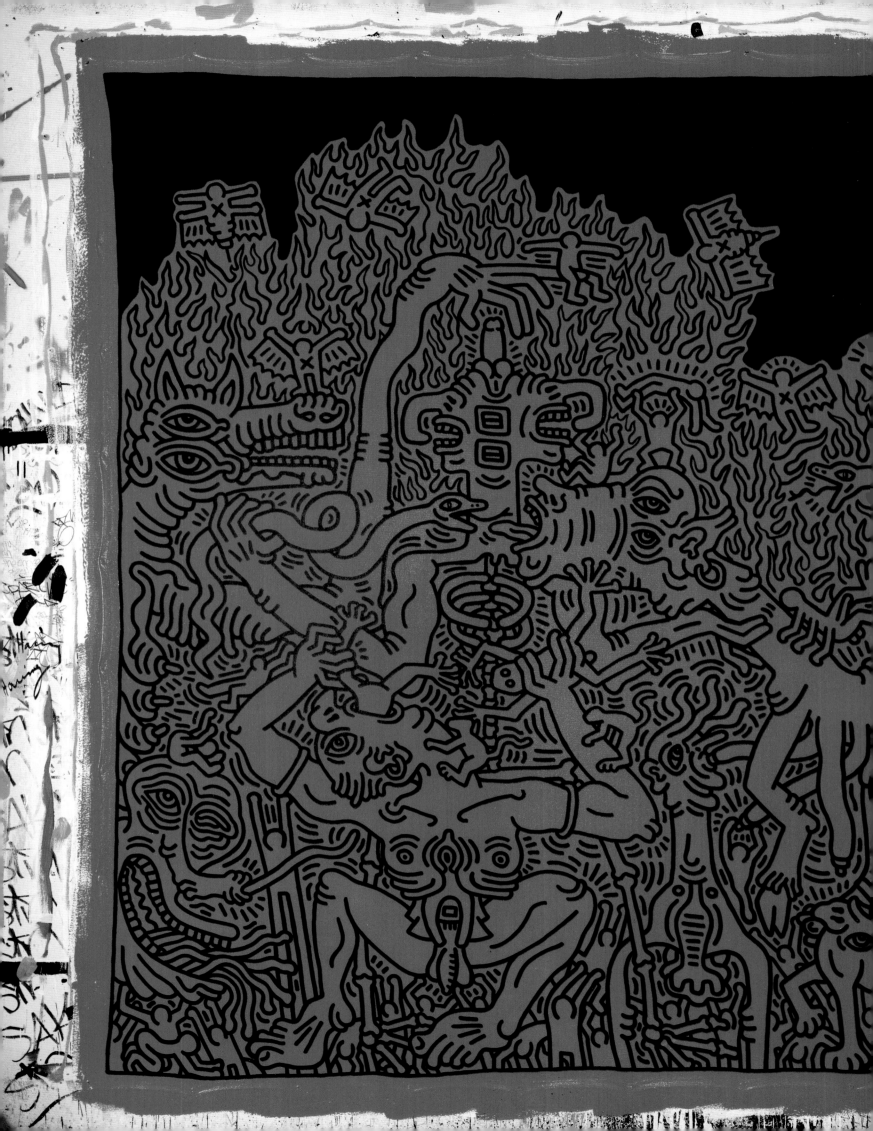

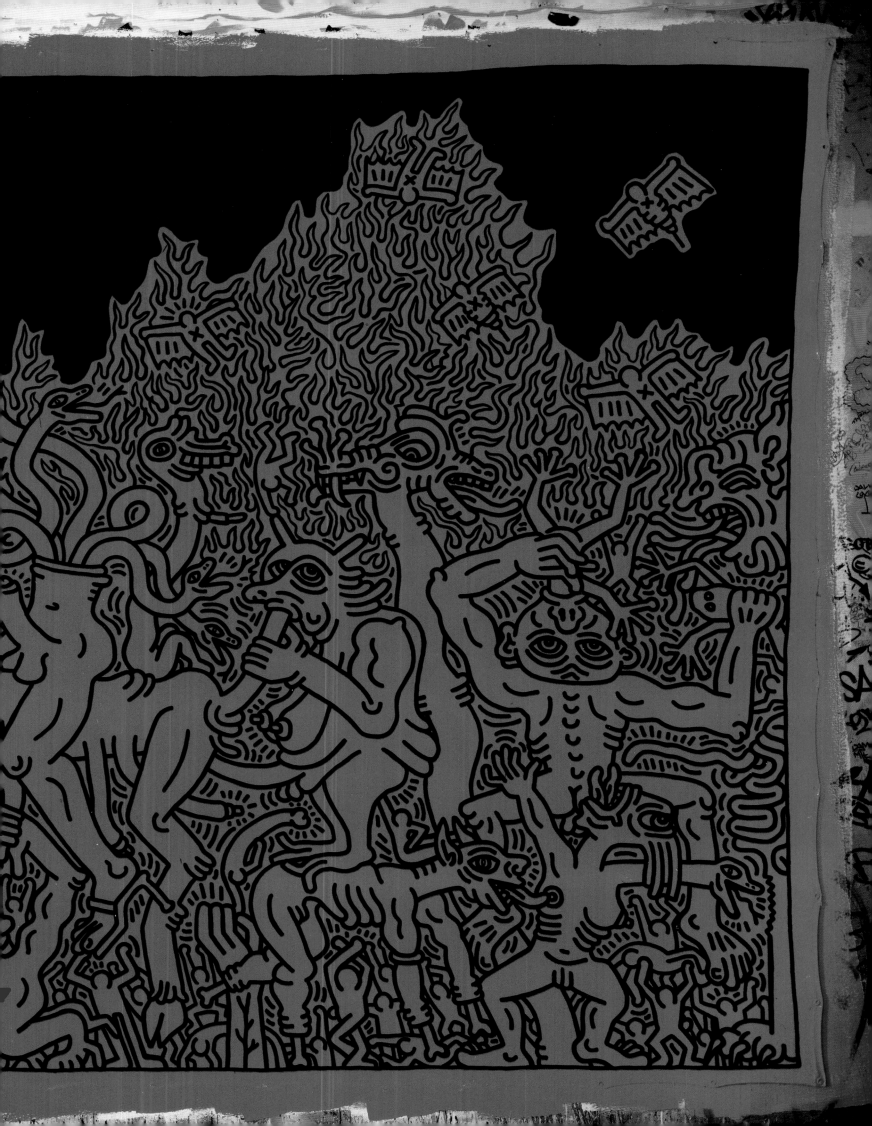

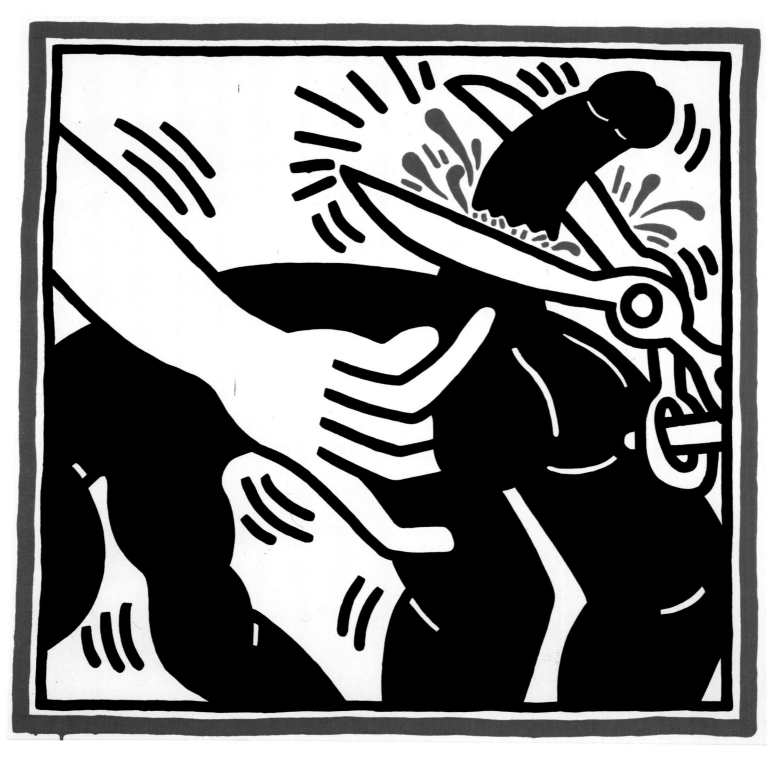

76 *Untitled,* 1985

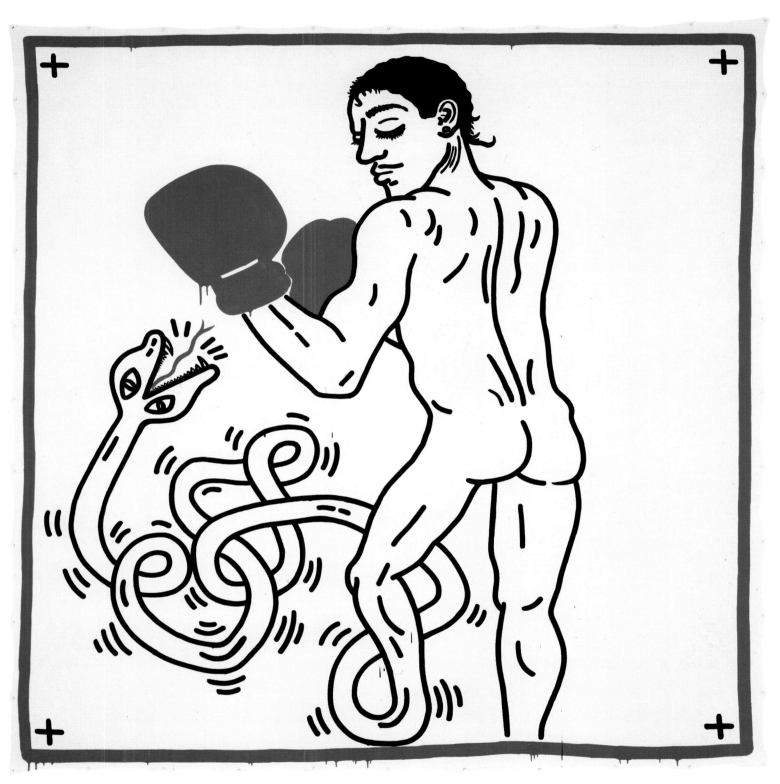

77 *Portrait of Macho Camacho,* 1985

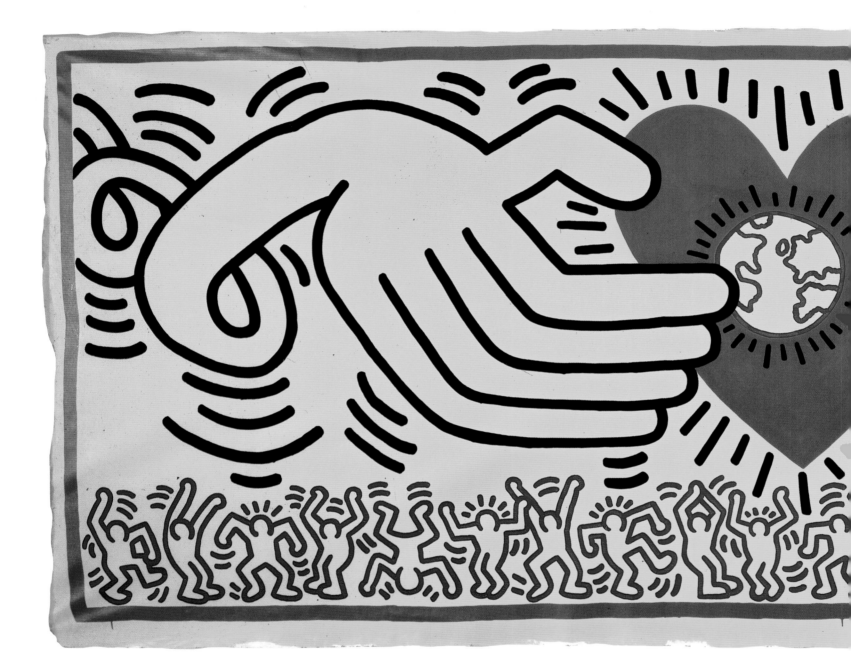

78 *Untitled,* 1985

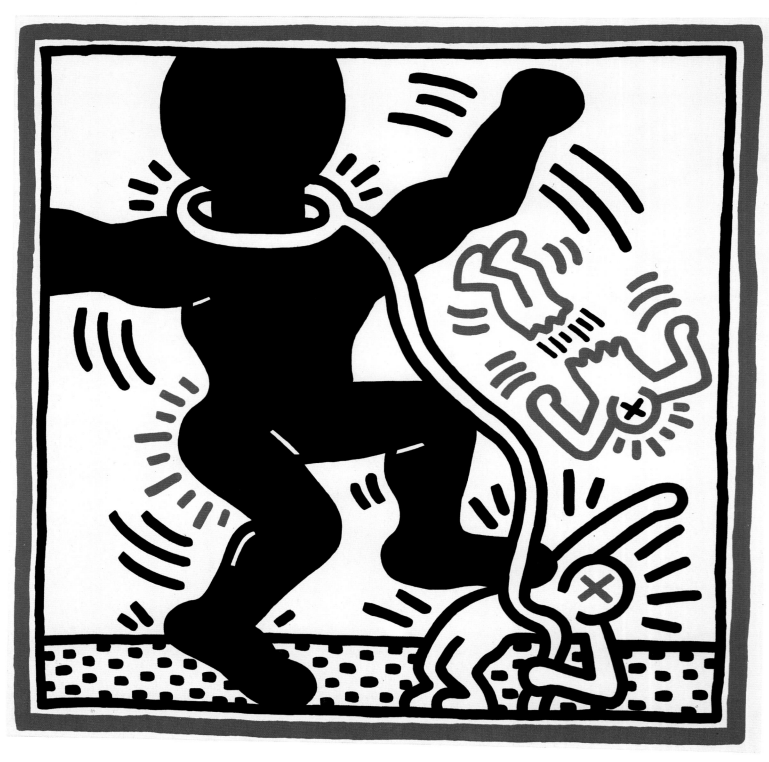

79 *South Africa,* 1985

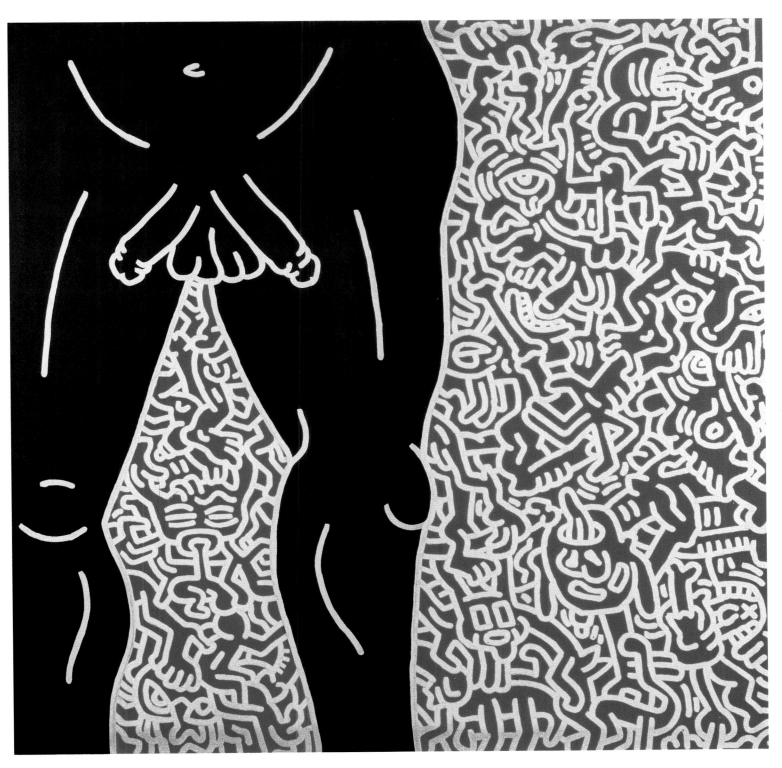

80 *Untitled,* 1985

"I wish I didn't have to sleep"

Excerpts from Interviews
with Keith Haring

On Drawing and Painting

The drawings I do have very little to do with classical, post-Renaissance drawings where you try to imitate life or make it appear to be life-like. My drawings don't try to imitate life, they try to create life, try to invent life. That's a much more so-called primitive idea, which is the reason that my drawings look like they could be Aztec or Egyptian or Aboriginal or all these other things, and why they have so much in common with them. It has the same attitude toward drawing: inventing images. You're sort of depicting life, but you're not trying to make it life-like. I don't use colors to try to look life-like, and I don't use lines to try to look life-like. It's also much more Pop, I guess, after growing up in a really cartoon- and comic-dominated period. And, also, growing up with Pop art.

Cliff Flyman, Interview with Keith Haring, September 26, 1980

A lot of times before I do a painting I make the border around the whole thing. So it's first define the space, then go inside. I was doing a face with two cartoon sort of faces, taking pieces of it, taking from Mickey Mouse, with a generic mouth taken from the fifties and sixties, but it was really about making the painting a cartoon. The whole painting is a cartoon of the cartoon, a cartoon of a painting.

From: "Interview: Keith Haring Talks with Paul Cummings," *Drawing* (May/June 1989), p. 11

Keith Haring in his studio, 1983

When I paint, it is an experience that, at its best, is transcending reality. When it is working, you completely go into another place, you're tapping into things that are totally universal, of the total consciousness, completely beyond your ego and your own self. *That's* what it's all about. That's why it's the biggest insult of all when people talk about me selling out. I've spent my entire life trying to avoid that, trying to figure out why it happens to people, trying to figure out what it means. How do you participate in the world but not lose your integrity? It's a constant struggle. Part of growing is trying to teach yourself to be empty enough that the thing can come through you completely so it's not affected by your preconceived ideas of what a work of art should be or what an artist should do. Since there have been people waiting to buy things, I've known that if I wanted to make things people would expect or people would want, I could do it easily. As soon as you let that affect you, you've lost everything. As soon as you get some acclaim, you have alienated some people that think that they deserved it instead of you. So you sold out. I never sold out.

From: David Sheff, "Keith Haring: An Intimate Conversation," *Rolling Stone* (August 10, 1989), p. 64

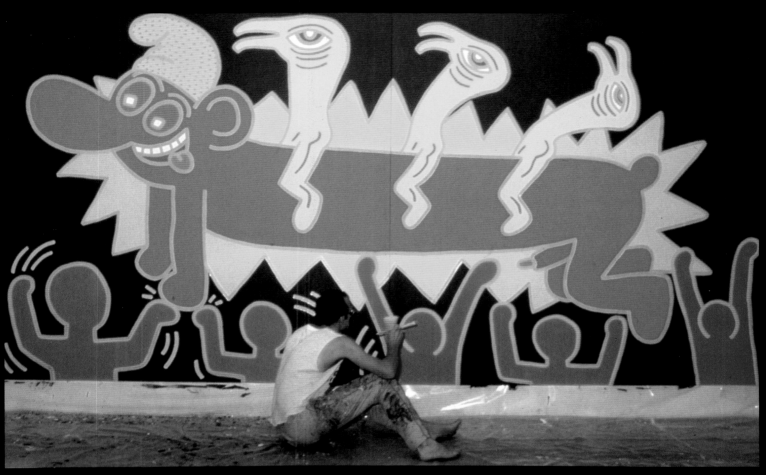

Keith Haring working on *Untitled* (June 11, 1984) at the Galleria Salvatore Ala, Milan, 1984

Untitled, 1981 *Untitled*, 1981

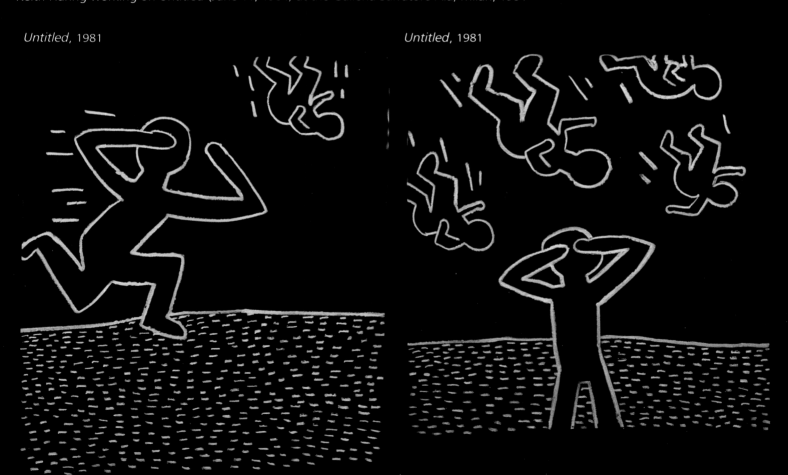

On Art and the Public

I'm not trying to compete with television or media as much as use them. People are capable of consuming a lot of information. The human brain keeps growing and expanding. I don't know that it is so overloaded that things have no meaning. If it's overloaded, things find their rightful place in it. Things that are marginally important get discarded, but some things gain more importance. People filter out and edit in their own minds what comes in and how they deal with it when it goes in. So it depends on the importance that the person who's receiving an image gives it.

From: Daniel Drenger, "Art and Life: An Interview with Keith Haring," *Columbia Art Review* (Spring 1988), p. 52

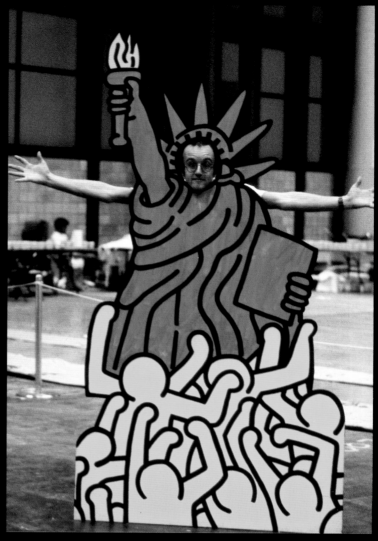

Statue of Liberty centennial celebrations, New York, 1986

Maybe it's sort of a romantic idea of the artist as an artist of the people, as a communicator of the people, and as a part of the general population and culture. A lot of artists have strived for that and not that many people have really succeeded at it. The subway drawings opened my eyes to this whole other understanding of art as something that really could have an effect on and communicate to larger numbers of people that were increasingly becoming the harbors of the art. Art was the symbol of the bourgeois and the people that could afford it and "understand" it. And it was used as a way of separating the general population from the upper class and used in a lot of ways as a tool against the rest of the population, even though over time art went through an over-intellectualization process. People assumed that if they didn't understand it then they didn't like it then they were not part of it. I think those barriers started being broken down by Madison Avenue, advertising, television, and Andy Warhol, but there's still a really long way to go. In the beginning of the '80s I was not the only artist who was addressing this issue of making available and acknowledging the bigger population for art; Jenny Holzer and John Ahearn were working through the Colab (Collaborative Projects), Fashion Moda, and the graffiti artists.

The context of where you do something is always going to have an effect. The subway drawings were, as much as they were drawings, performances: It was where I learned how to draw in public. You draw in front of people. For me it was a whole sort of philosophical and sociological experiment. When I drew, I drew in the daytime which meant there were always people watching. There were always confrontations, whether it was with people that were interested in looking at it, or people that wanted to tell you you shouldn't be drawing there. I was learning, watching people's reactions and interactions with the drawings and with me and looking at it as a phenomenon. Having this incredible feedback from people, which is one of the main things that kept me going so long, was the participation of the people that were watching me and the kinds of comments and questions and observations that were coming from every range of person

historians. The subways in New York are filled with all kinds of people. I had discussions about Mayan carvings with a man who related them to my drawings. I had discussions with bums that were slobbering and drunk. I had discussions with school kids. Because of the situation you were drawing in, even the materials, the subtle materials of drawing with chalk on this soft black paper was like nothing else I had ever drawn on. It was a continuous line, you didn't have to stop and dip it in anything. It was a constant line, it was a really graphically strong line and you had a time limit. You had to do these things as fast as you could. And you couldn't erase. So it was like there were no mistakes. You had to be careful to not get caught. And dealing with drawing in places that might be freezing cold or where you were standing over a puddle of piss or vomit, being in all these weird positions to draw, there were all kinds of factors that made it interesting.

From: Jason Rubell, "Keith Haring: The Last Interview," *Arts Magazine* (September 1990), pp. 55, 59

Set design for *Secret Pastures*, Brooklyn Academy of Music, New York, 1984

Set design for *Interrupted River*, Joyce Theater, New York, 1987

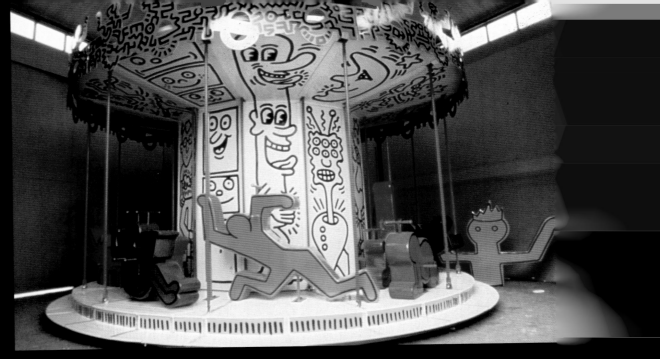

Carousel for "Luna, Luna," Hamburg, 1987

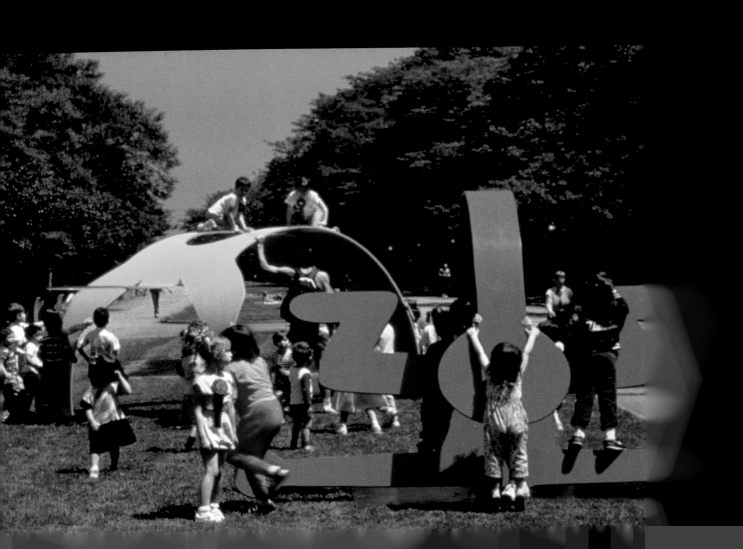

On AIDS and his Final Work Phase

Generations of kids growing up now have the advantage of knowing that it [AIDS] is out there. Before it existed, it is something you never would have thought about, that you could associate love, or blood, or sperm with the carriers of death. Blood and sperm are supposed to be about life. It is a very strange time to have to be alive, especially as an artist, to see people, losing people quickly, other good artists and designers, a lot of creative people. The only good thing to come out is that it has put this real intensity to the time, that forces people to really rethink why they're here and why they're alive, and to appreciate every second. My production, my working time is totally important now. I wouldn't consider taking a break for a year, or going on vacation for three months. Every day is important. It's an interesting thing to think. To a degree, I always took it like that because I never really grew up thinking that I would be planning on a future or something. You do what you can now because growing up scared of a nuclear explosion and of wars, and all the times I fly in airplanes and drive in cars, you have this certain disbelief about the future. I've had that since I was a kid, really. I remember really thinking when I was 12 or 13 that I don't want to plan. I want to do everything I want to do now; I'm not going to wait. My parents said "save money so that you can have a family and two-car garage; you shouldn't quit commercial art school; you should do this and this." I always knew that that's not what it's about.

From: Daniel Drenger, "Art and Life: An Interview with Keith Haring," *Columbia Art Review* (Spring 1988), p. 50

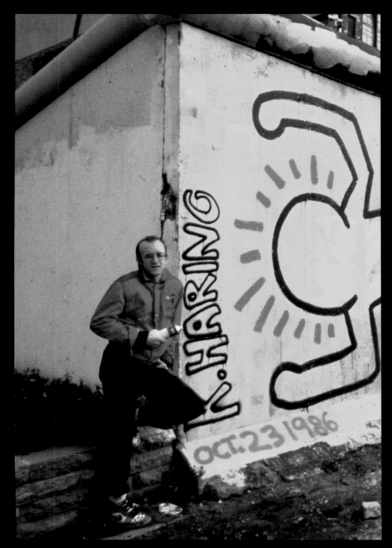

Keith Haring with part of his Berlin Wall mural, 1986

I wish I didn't have to sleep. But otherwise, it's all fun. It's all part of the game. [*He is quiet, and then he looks up.*] There's one last thing in my head. With the thought of – of summing up. My last show in New York felt like it had to be the best painting that I could do. To show everything I have learned about painting. The thing about all the projects I'm working on now – a wall in a hospital or new paintings – is that there is a certain sense of summing up in them. Everything I do now is a chance to put a – a crown on the whole thing. It adds another kind of intensity to the work that I do now; it's one of the good things to come from being sick.

If you're writing a story you can sort of ramble on and go in a lot of directions at once, but when you are getting to the end of the story, you have to start pointing all the things toward one thing. That's the point that I'm at now, not knowing where it stops but knowing how important it is to do it now. The whole thing is getting much more articulate. In a way it's really liberating.

From: David Sheff, "Keith Haring: An Intimate Conversation," *Rolling Stone* (August 10, 1989), p. 102

81 *Untitled,* 1985

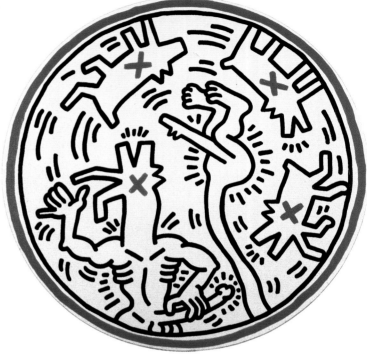

82 *Untitled,* 1985

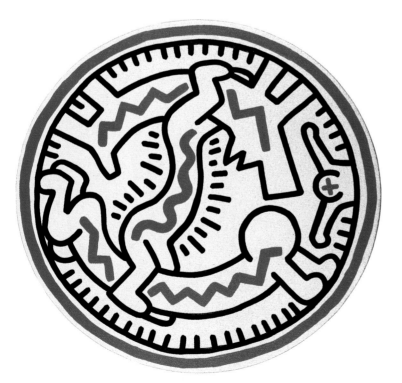

83 *Untitled,* 1985

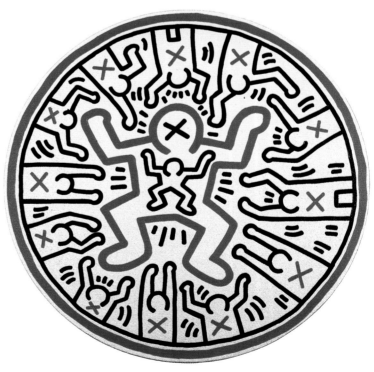

84 *Untitled,* 1985

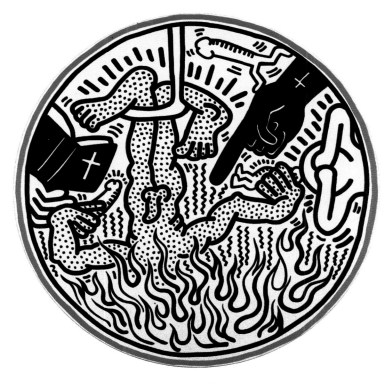

85 *Untitled*, 1985

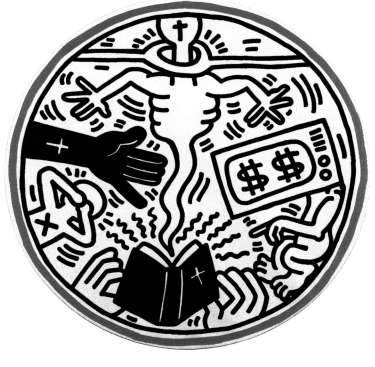

86 *Untitled*, 1985

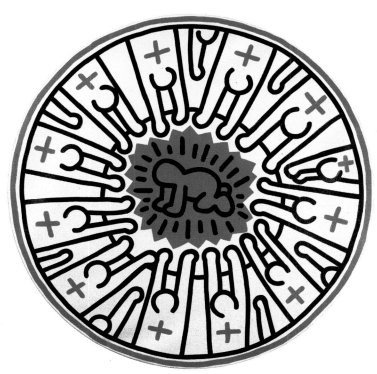

87 *Untitled*, 1985

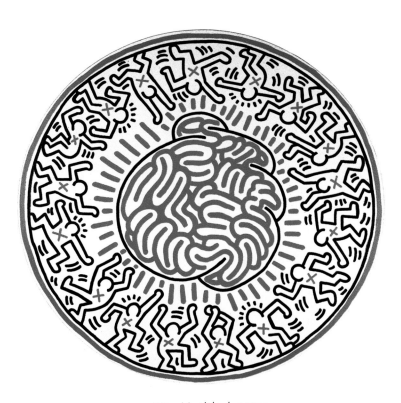

88 *Untitled*, 1985

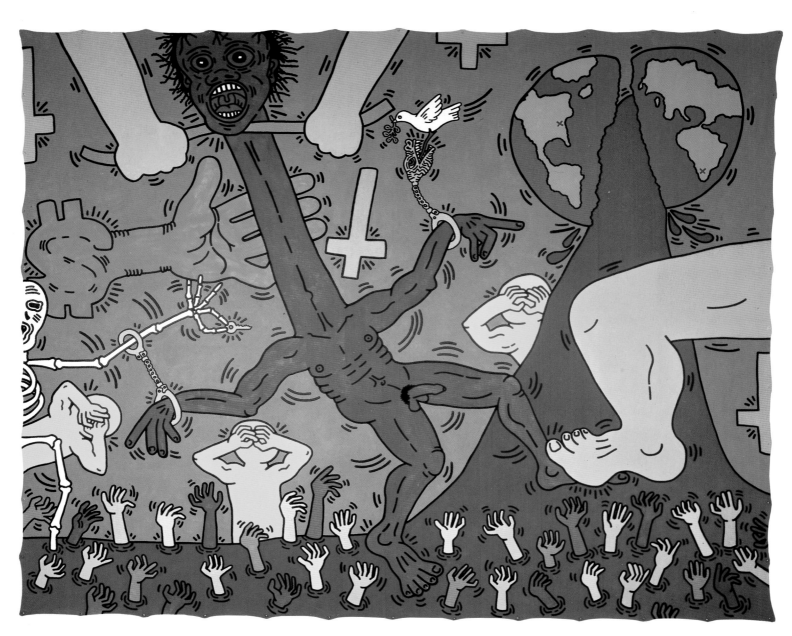

89 *Michael Stewart – USA for Africa*, 1985

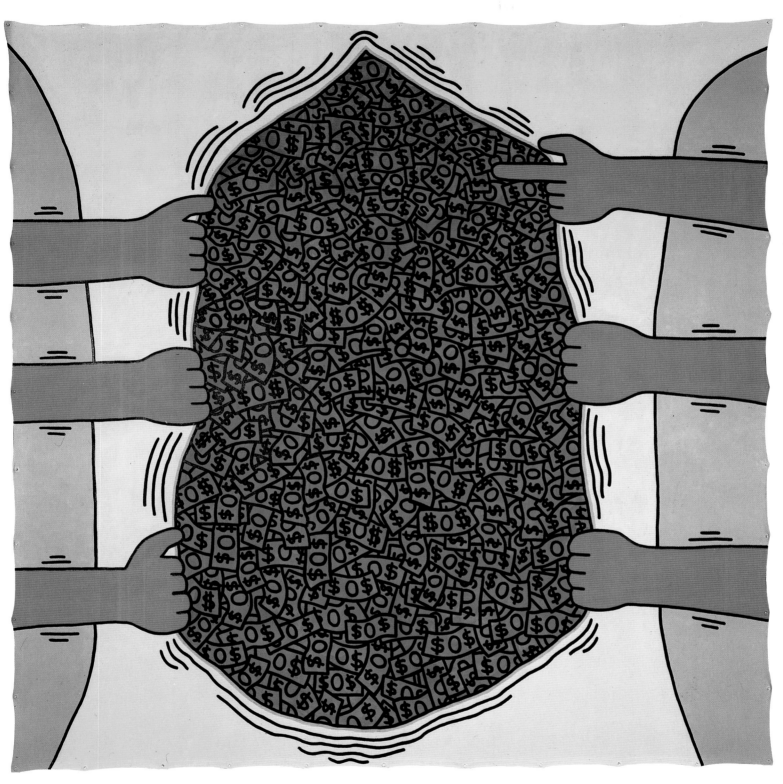

90 *Untitled,* 1985

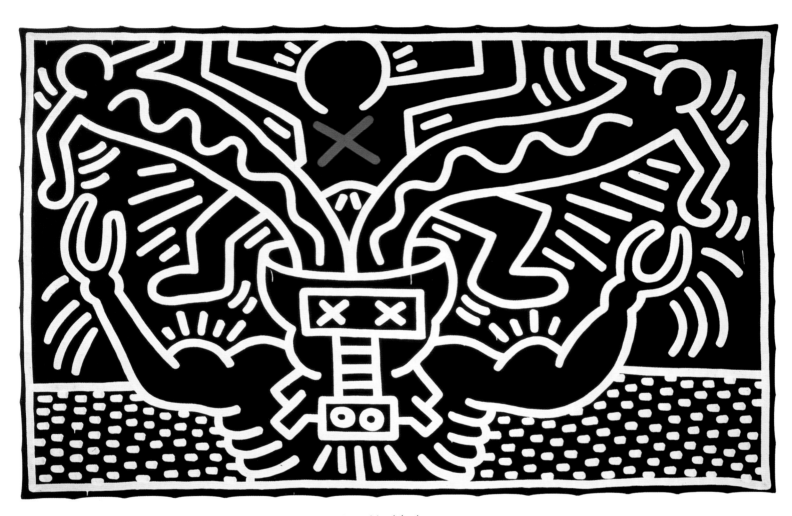

91 *Untitled,* 1985

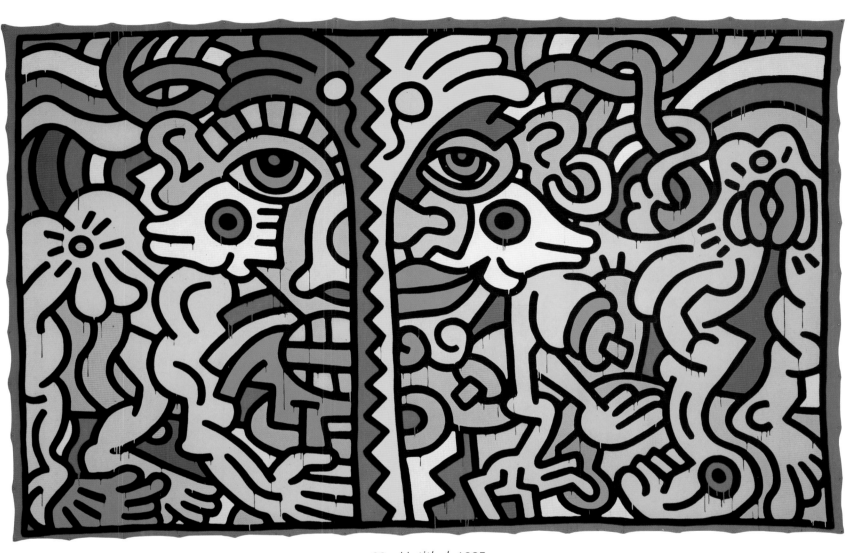

92 *Untitled,* 1985

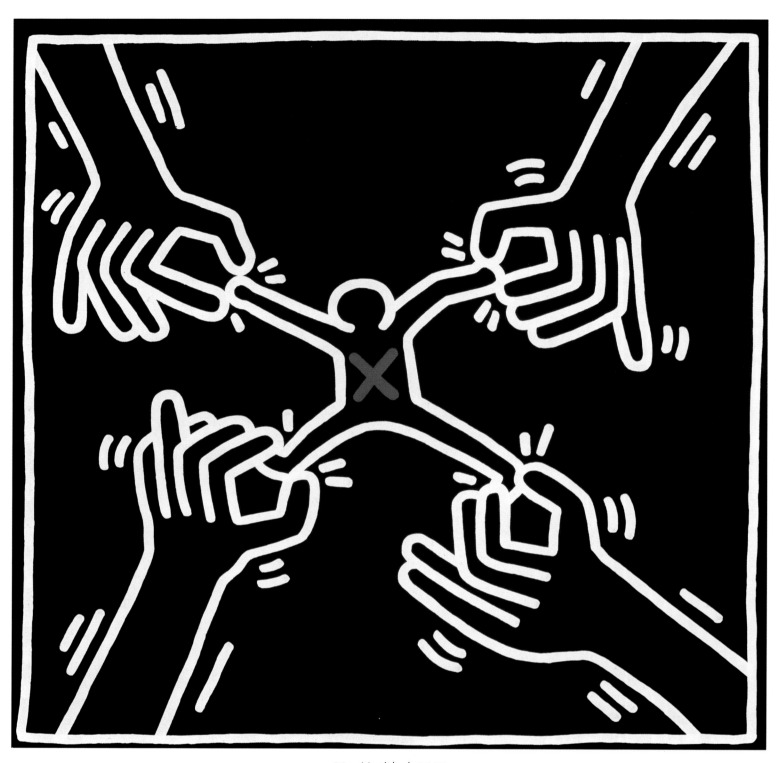

93 *Untitled,* 1985

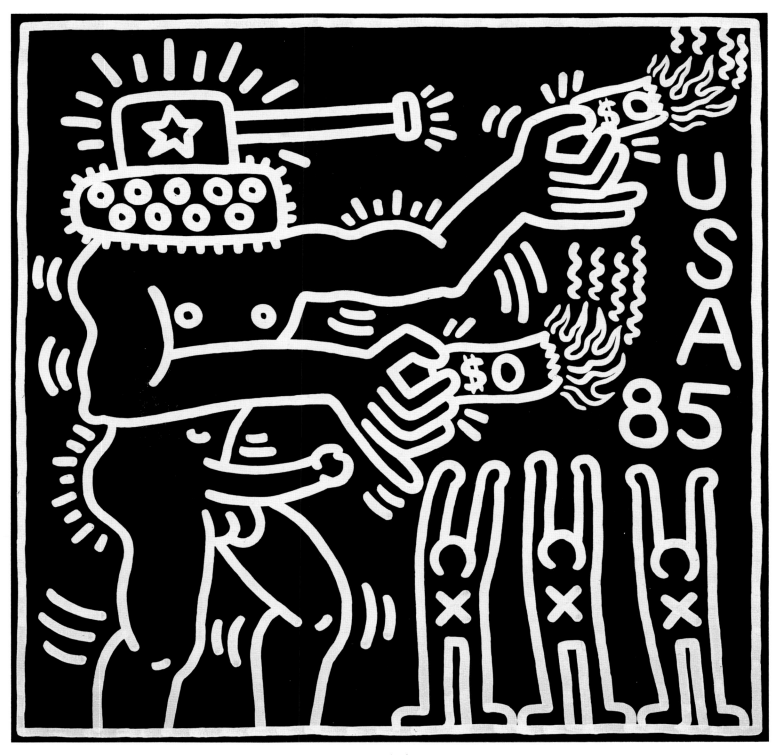

94 *Untitled,* 1985

Following pages:

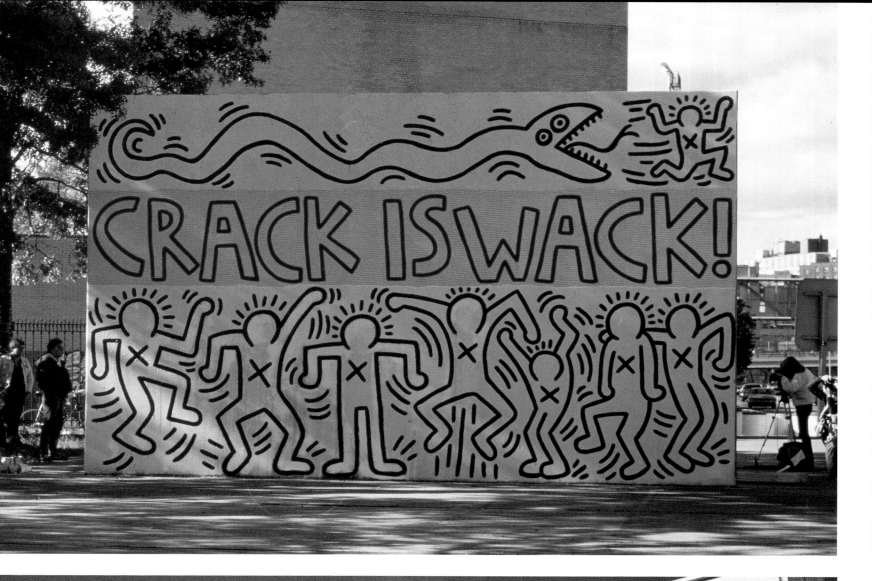

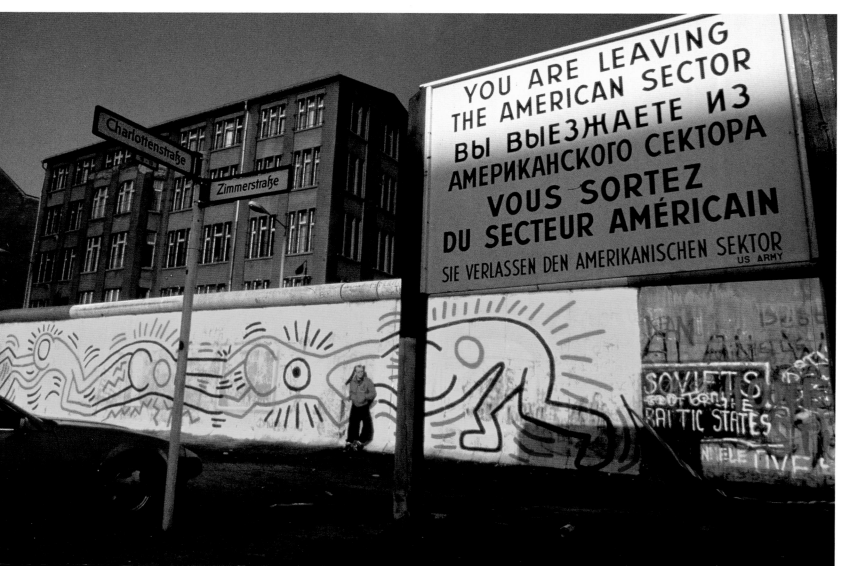

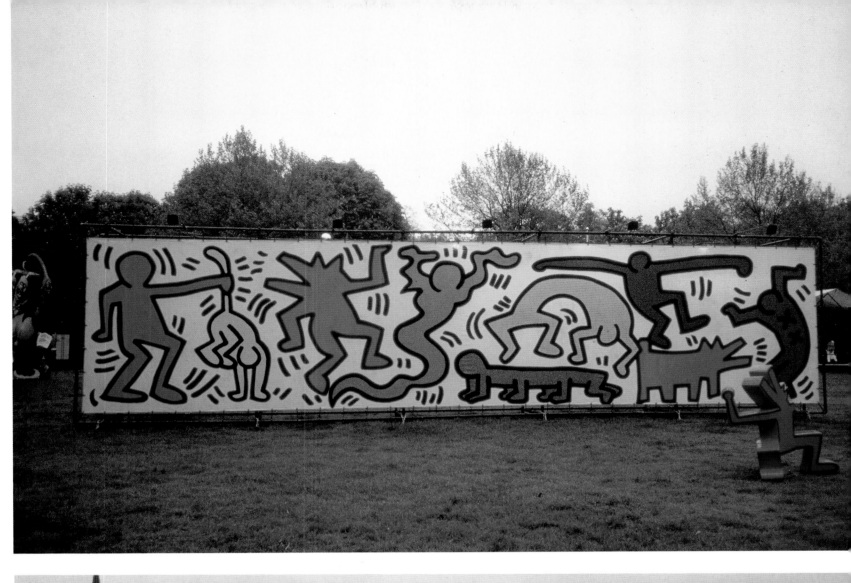

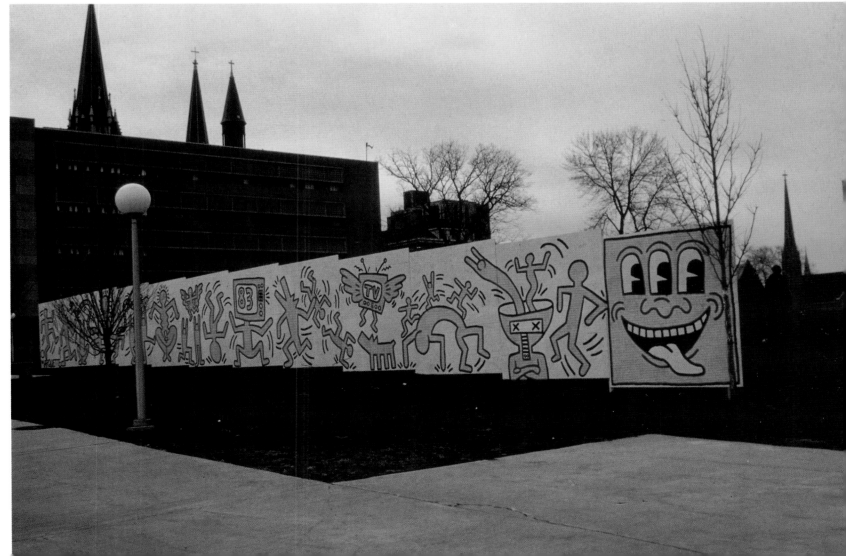

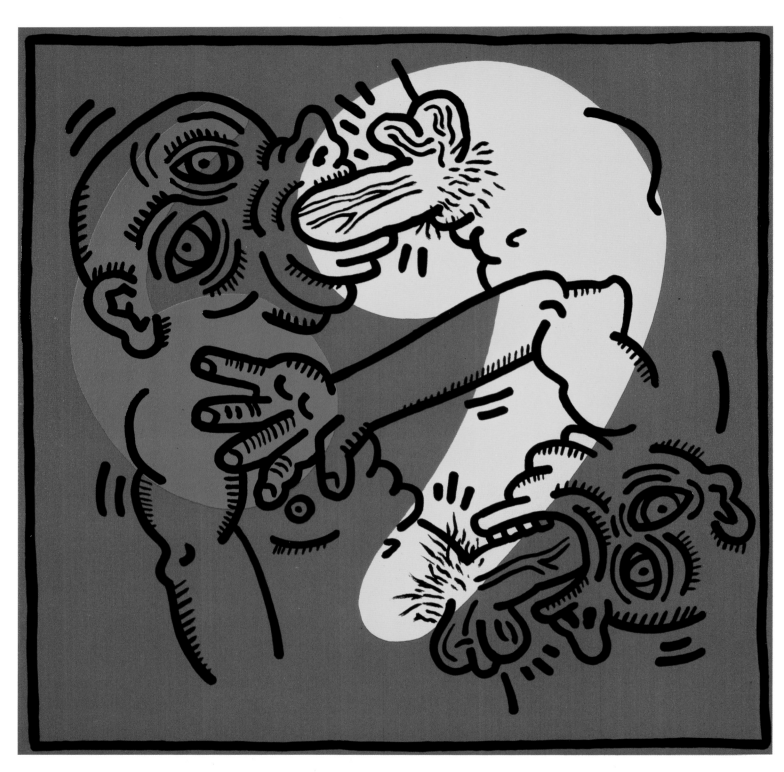

99 69, 1986

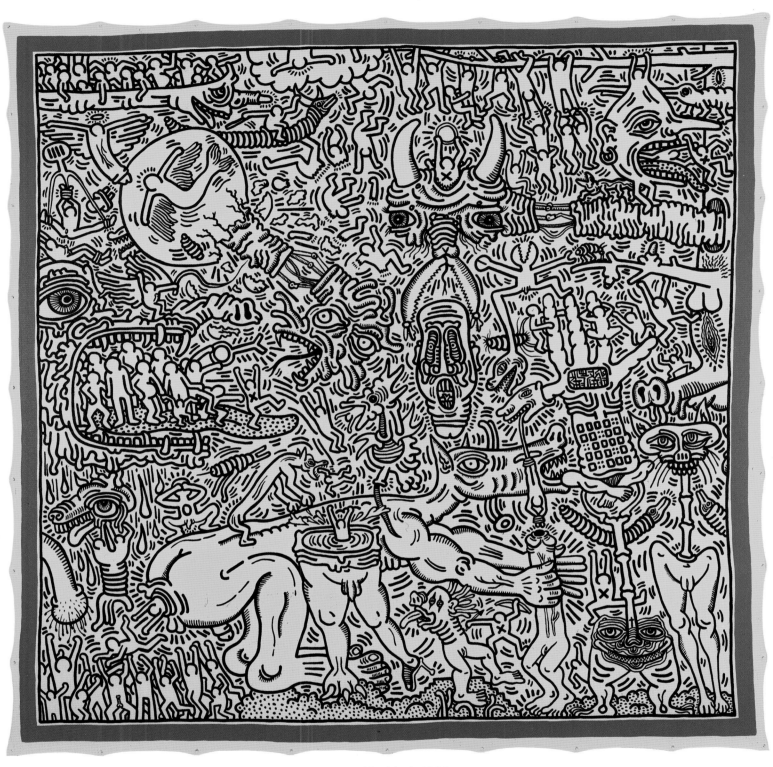

100 *Untitled,* 1986

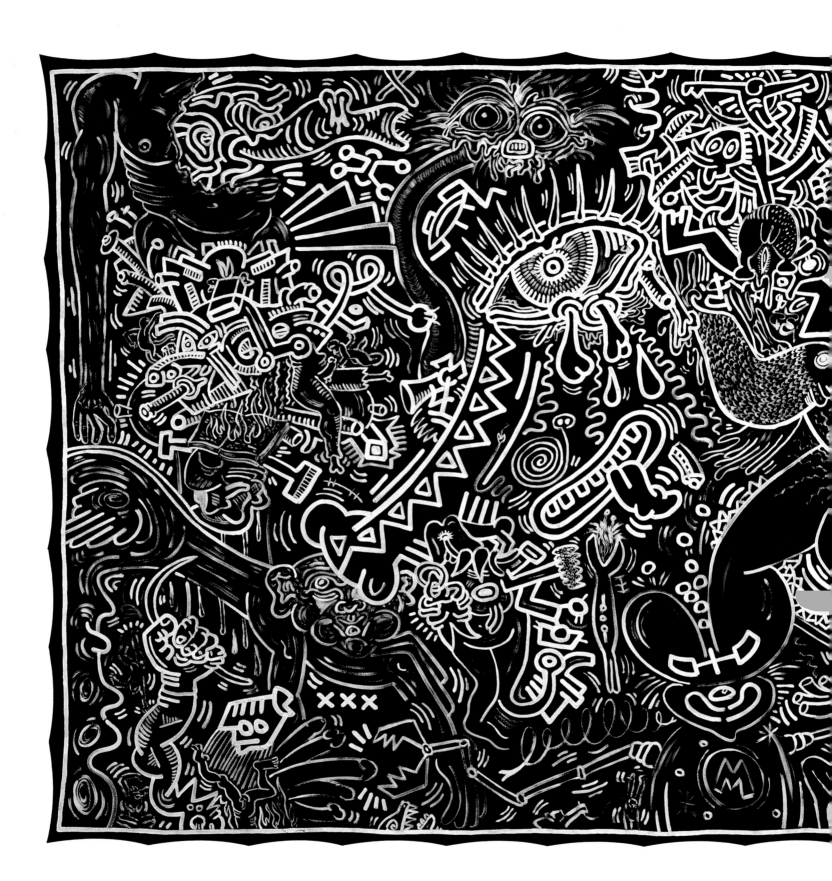

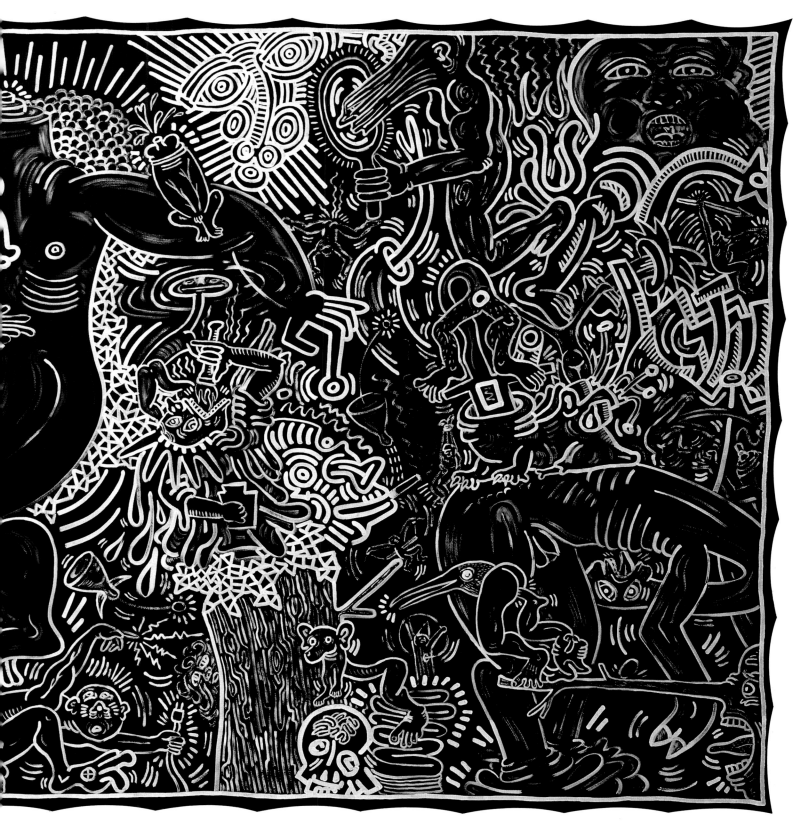

101 *Untitled,* 1986

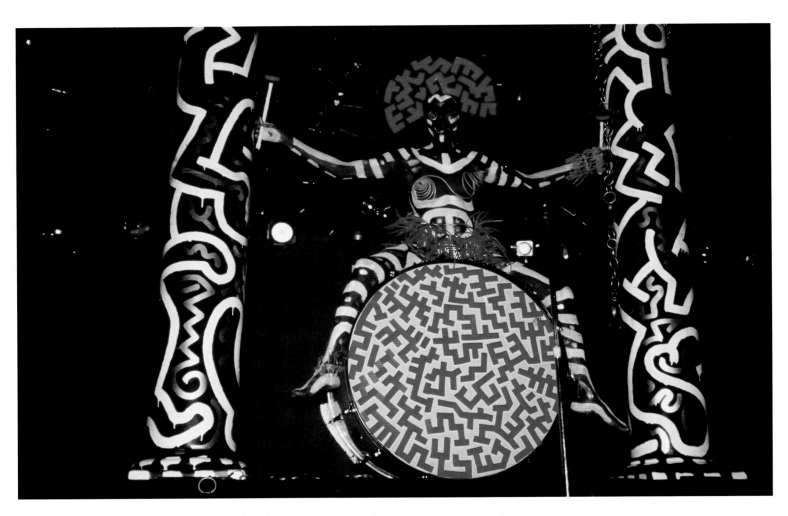

102 Painted body of Grace Jones during performance at the Paradise Garage, 1984

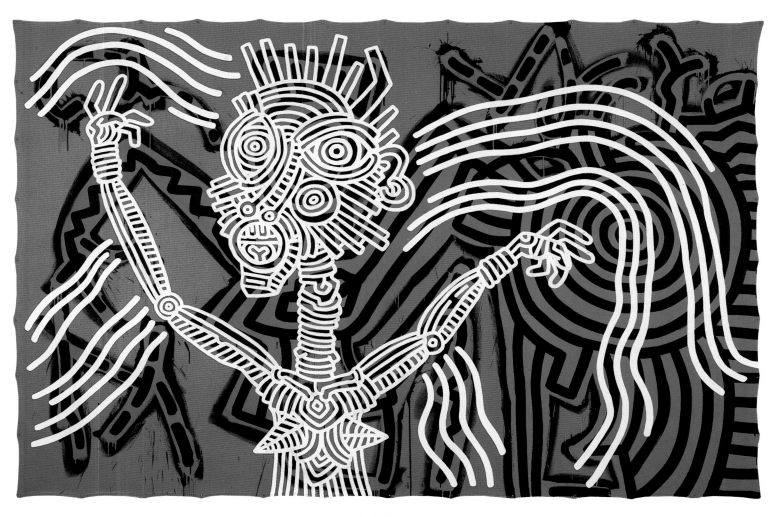

103 *Portrait of Grace Jones,* 1986

Overleaf:

104 *Citykids Speak on Liberty* banner, 1986

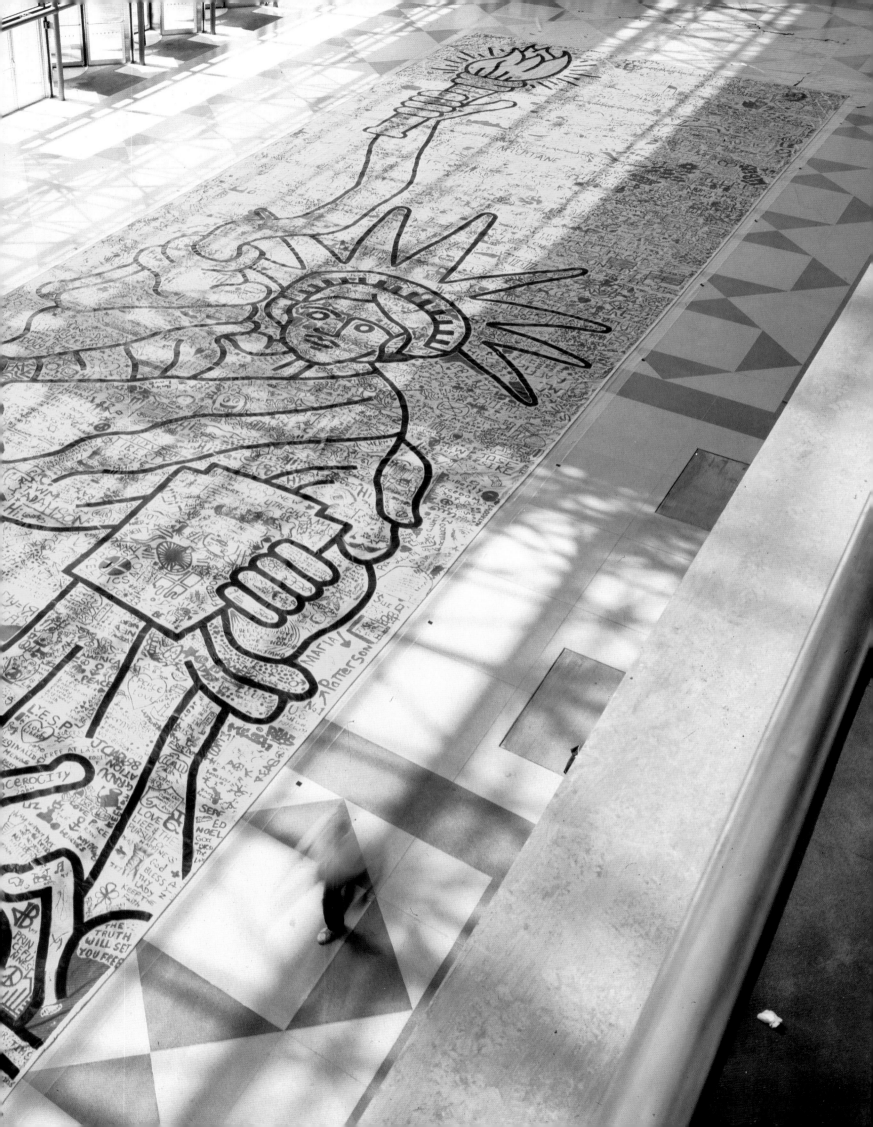

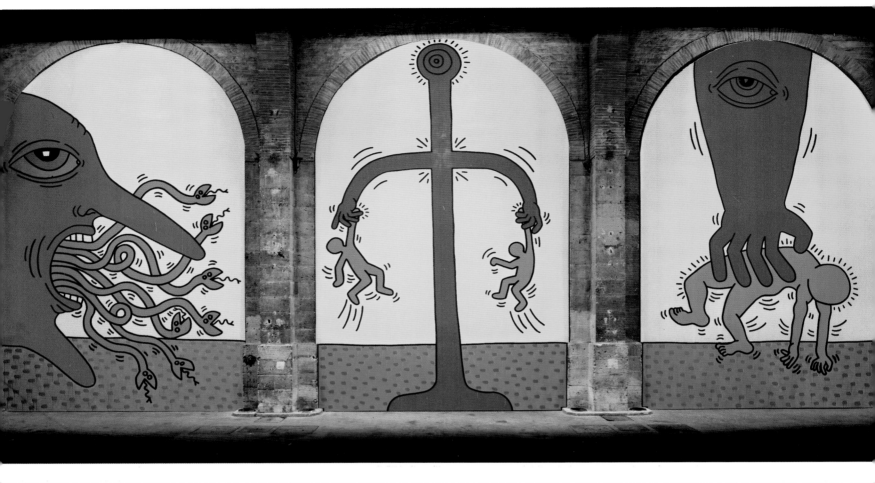

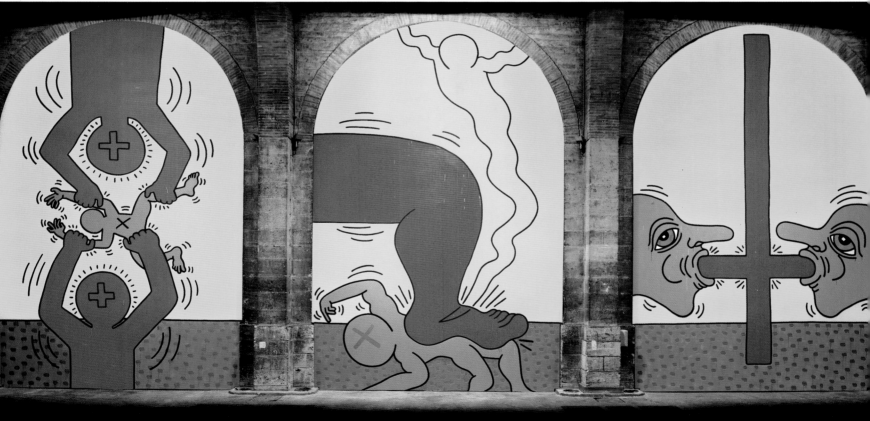

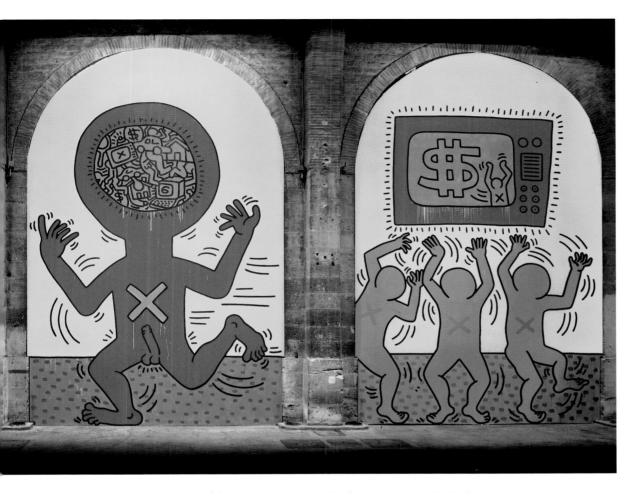

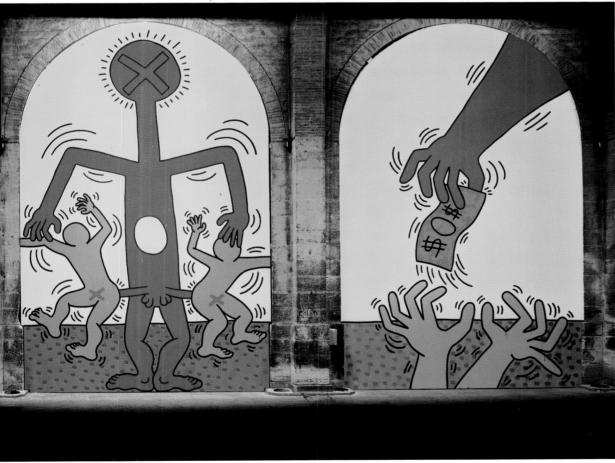

105, 106
The Ten Commandments,
1985

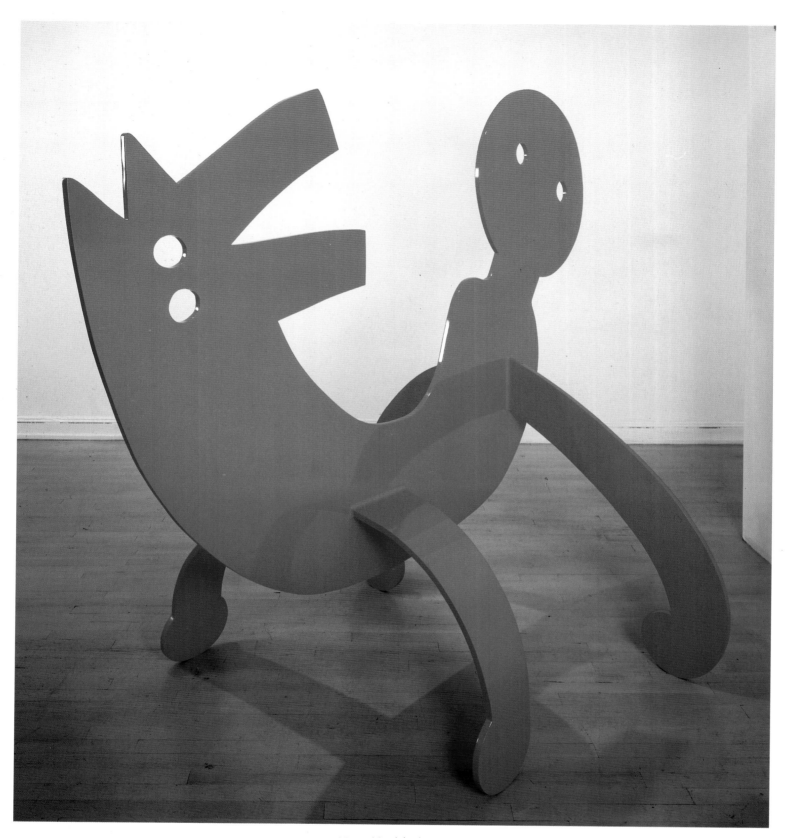

107 *Untitled,* 1986

108 *Untitled,* 1985

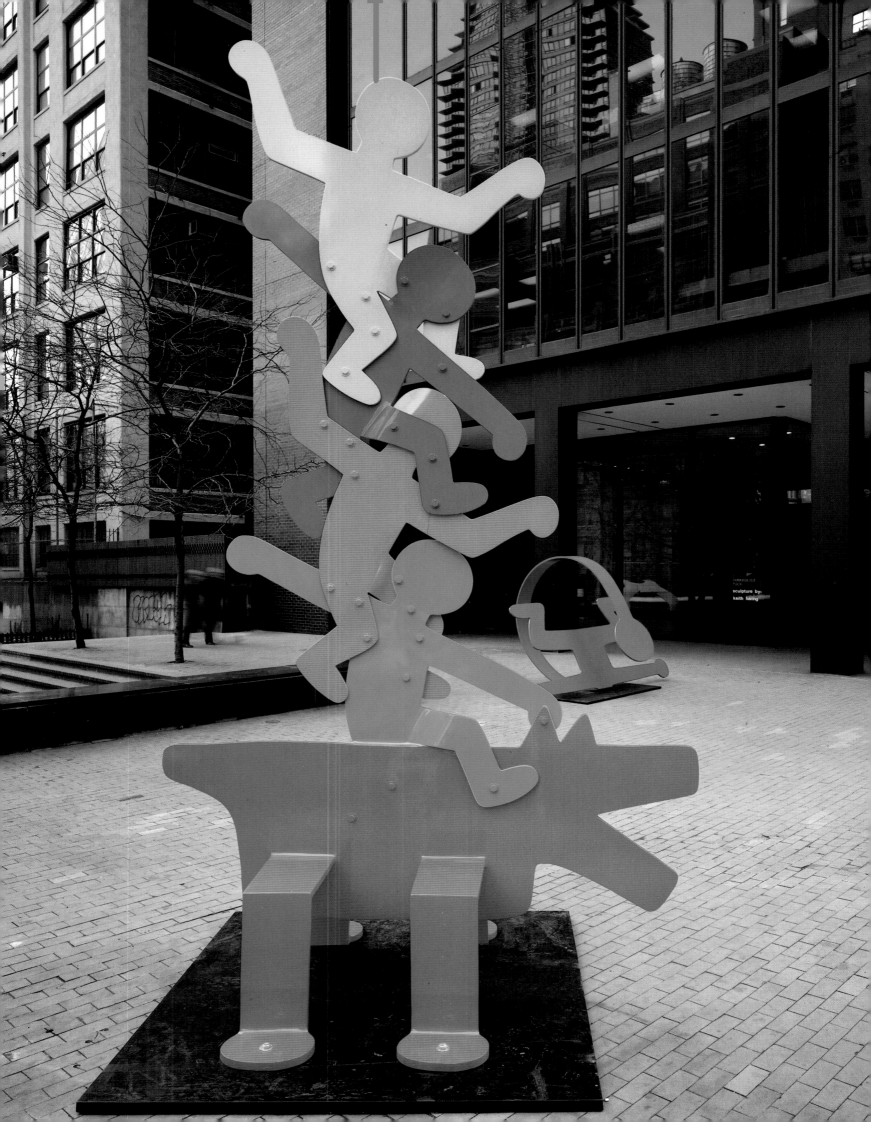

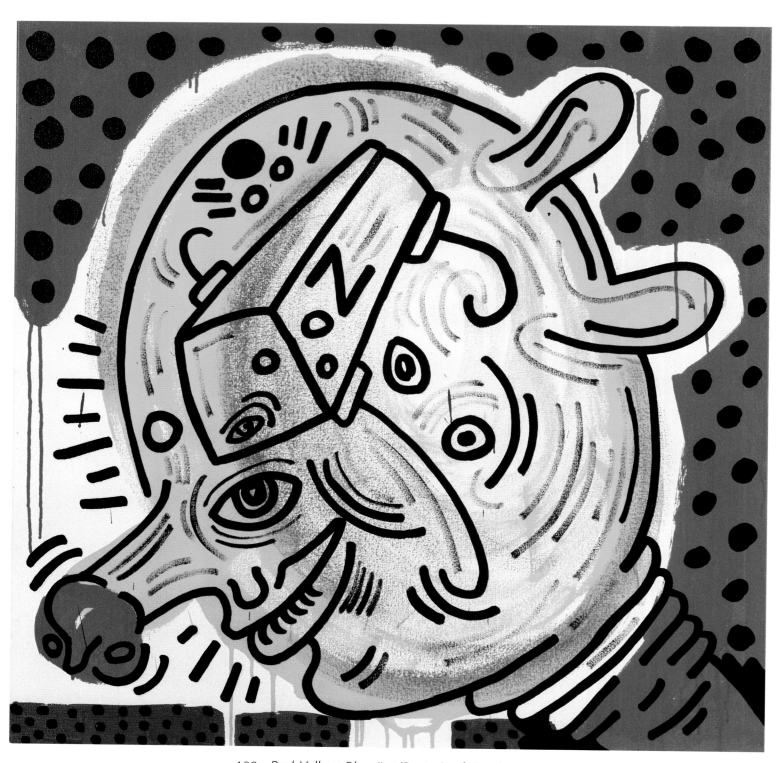

109 *Red-Yellow-Blue # 5* (Portrait of Zena), 1987

110 *Knokke #10,* 1987

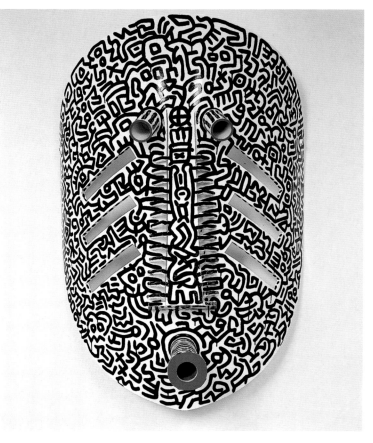

111 *Untitled* (Mask with a Long Mouth), 1987

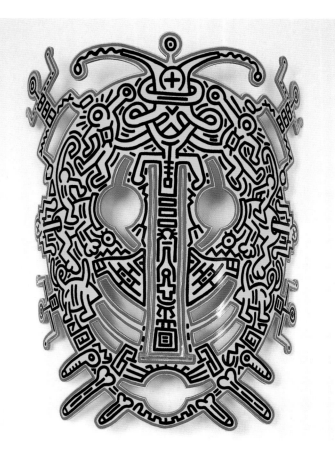

112 *Untitled* (Large Goon Mask), 1987

113 *Untitled* (Egg Head for Picasso), 1987

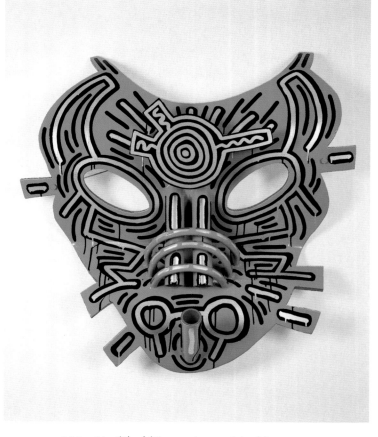

114 *Untitled* (Grace Jones Mask), 1987

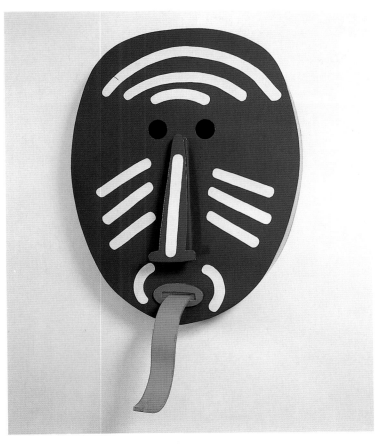

115 *Untitled* (Tongue Man), 1987

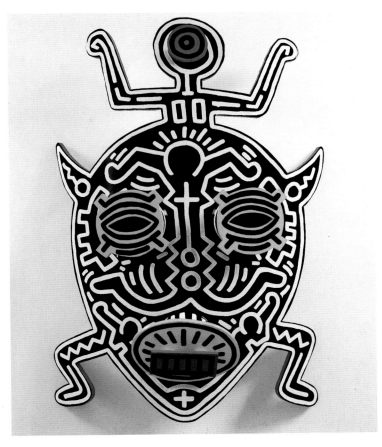

116 *Untitled* (Hollywood African Mask), 1987

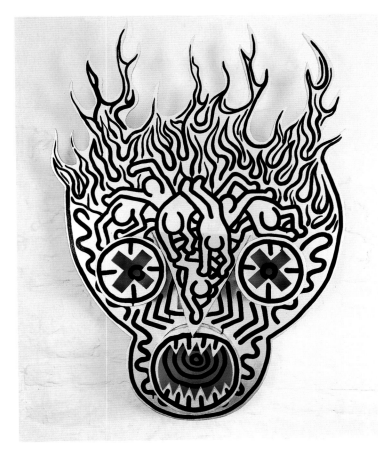

117 *Untitled* (Burning Skull), 1987

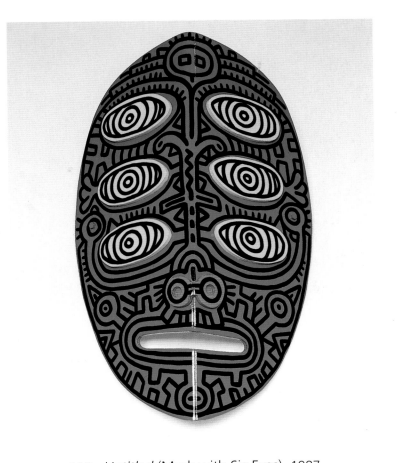

118 *Untitled* (Mask with Six Eyes), 1987

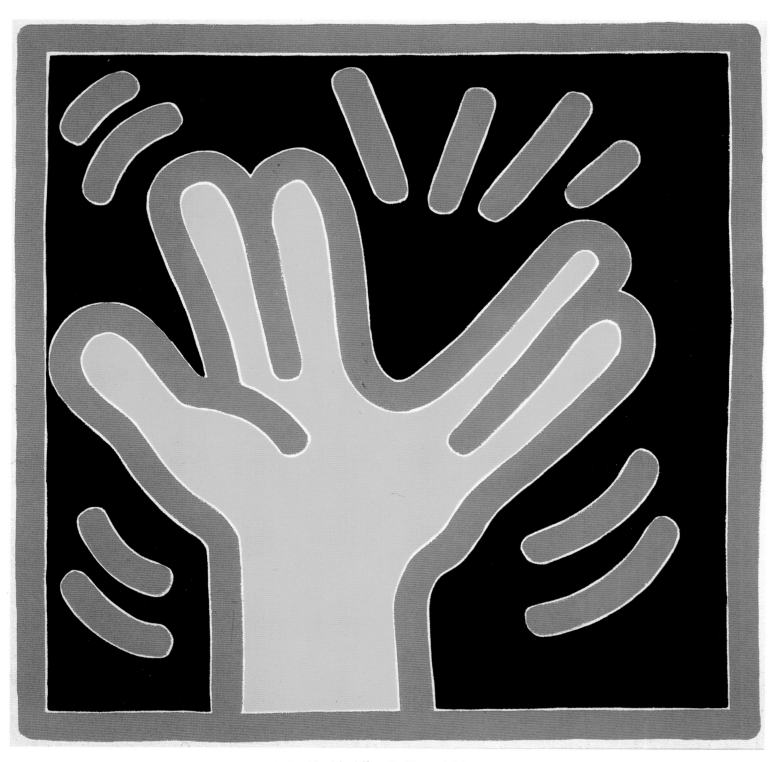

119 *Untitled* (for Cy Twombly), 1988

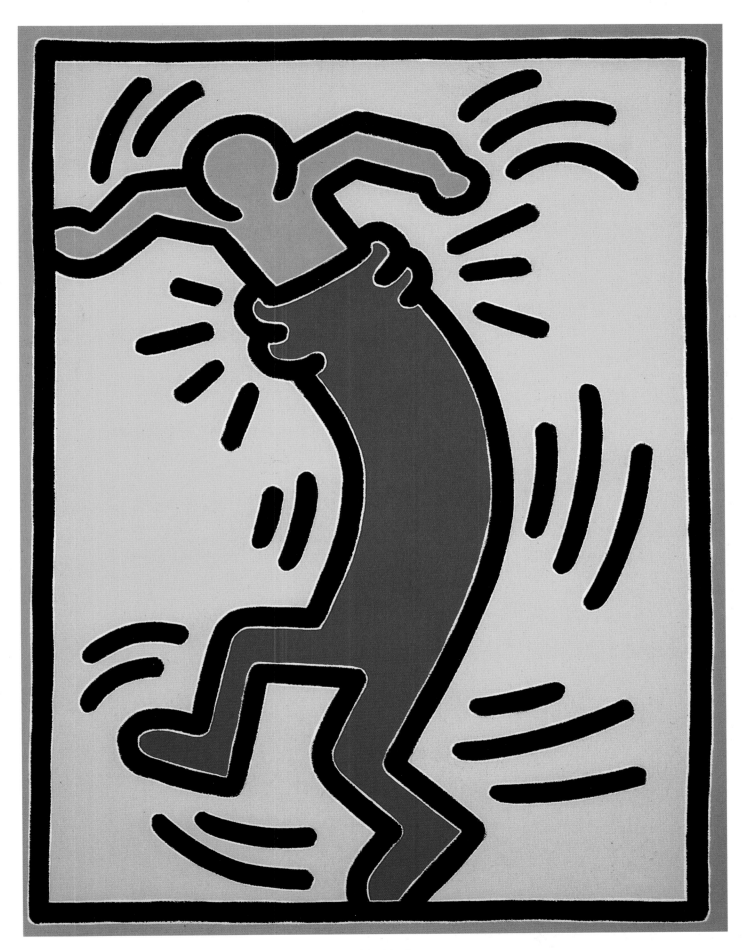

120 *Untitled*, 1988

121 *Untitled,* 1988

122 *Red Room*, 1988

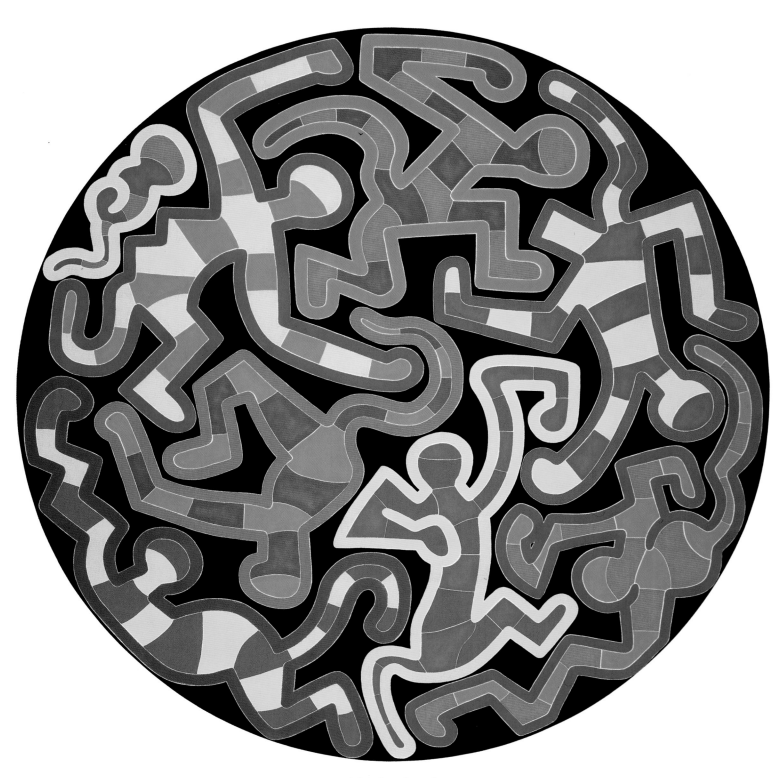

123 *Monkey Puzzle,* 1988

124 *Mom*, 1989

Following pages:

125 Mural done with school children, Chicago, 1989

126 Mural on exterior of the Stedelijk Museum warehouse, Amsterdam, 1986

127 Mural on Church of Sant' Antonio, Pisa, 1989

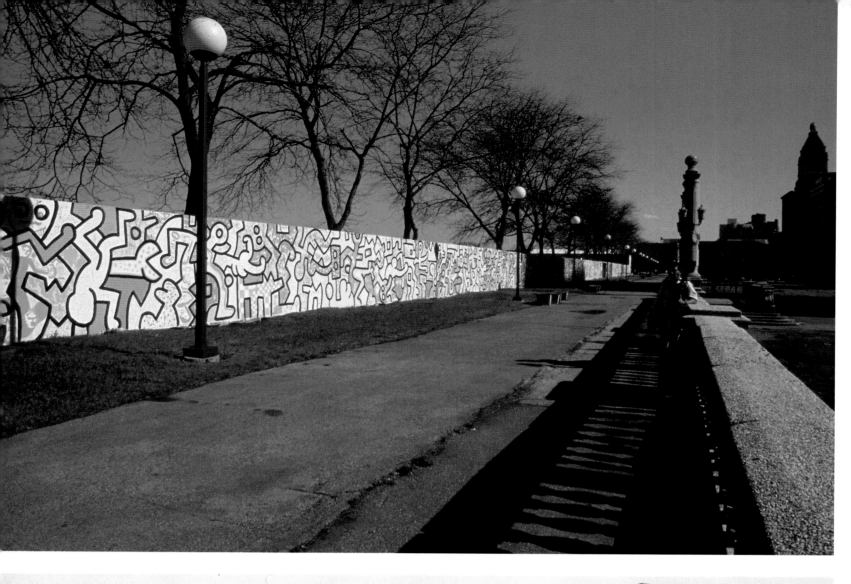

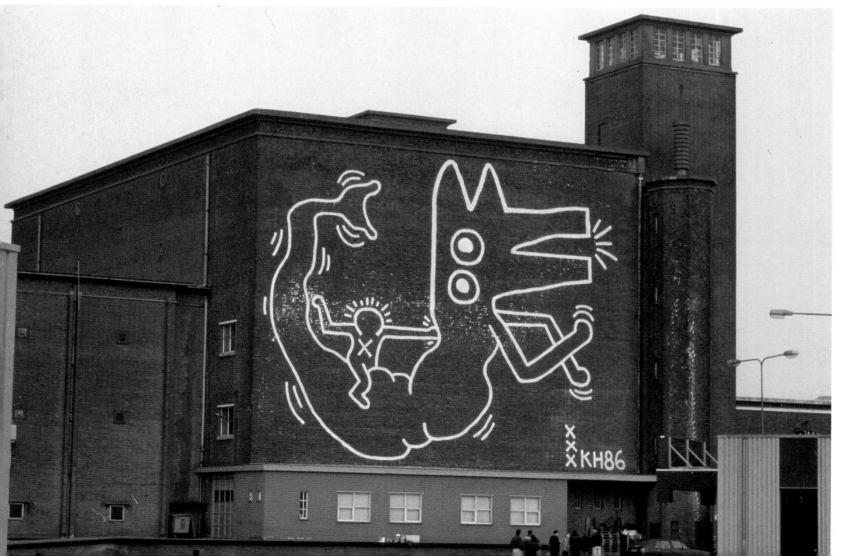

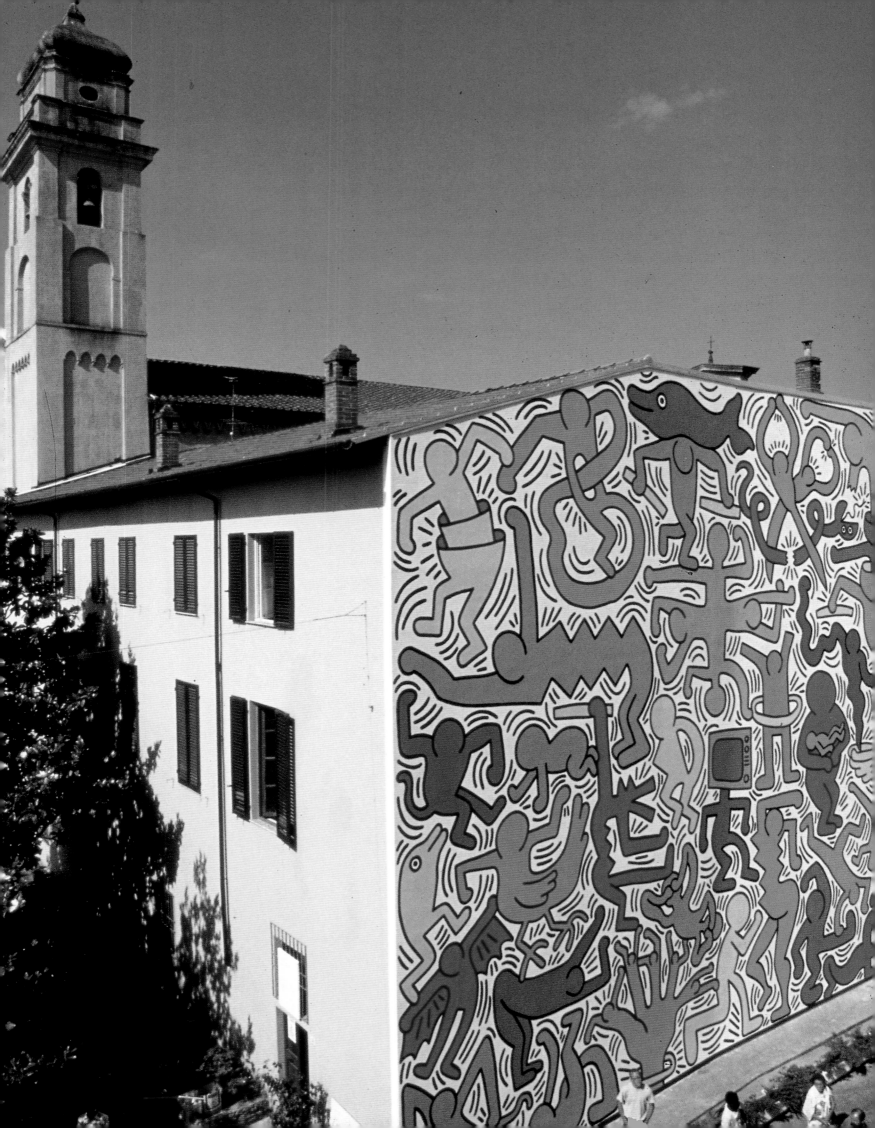

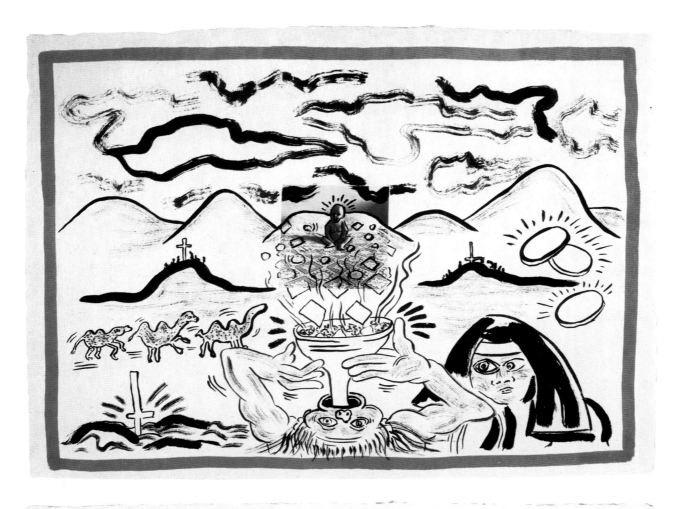

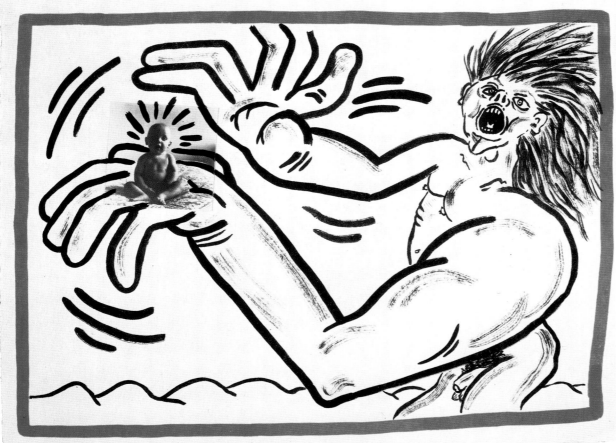

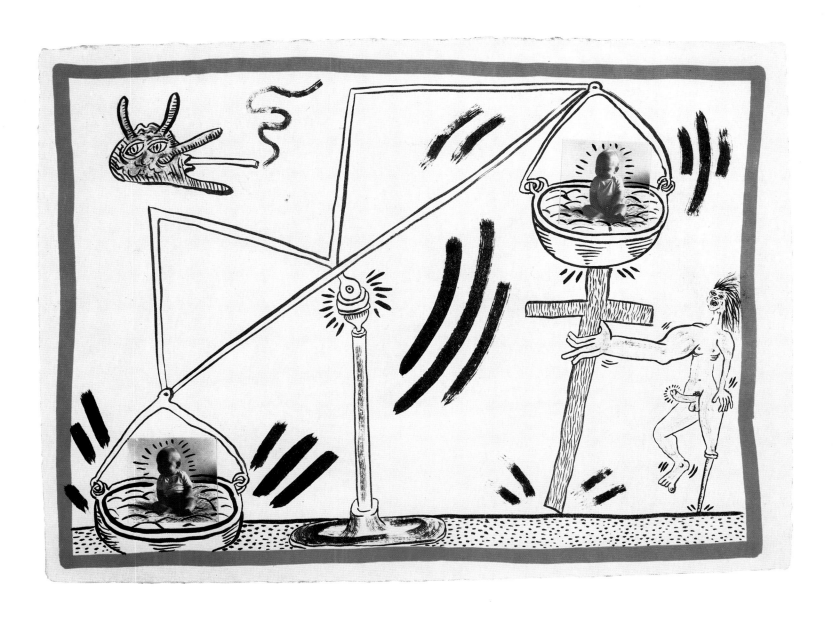

128-30 *The Story of Jason,* 1987 (1-3 of 9)

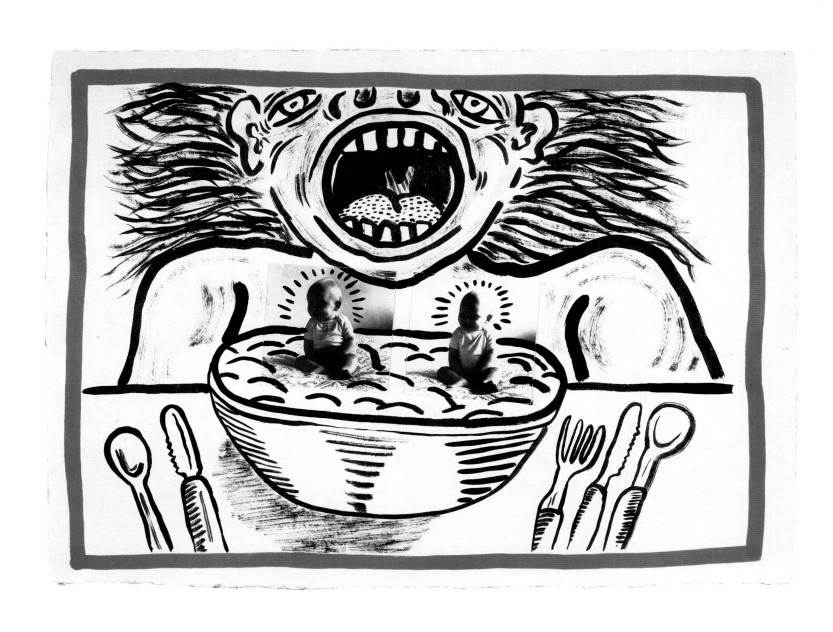

131-33 *The Story of Jason*, 1987 (4-6 of 9)

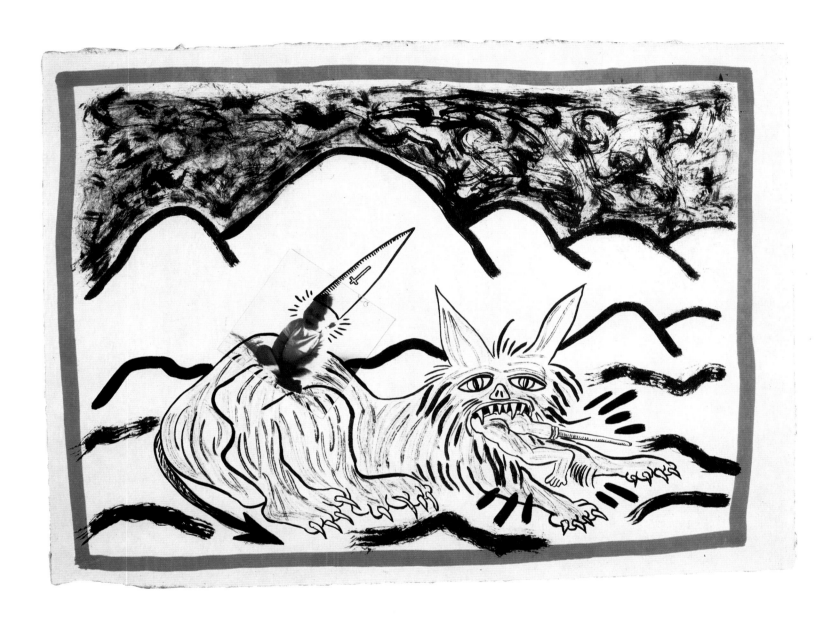

134-36 *The Story of Jason*, 1987 (7-9 of 9)

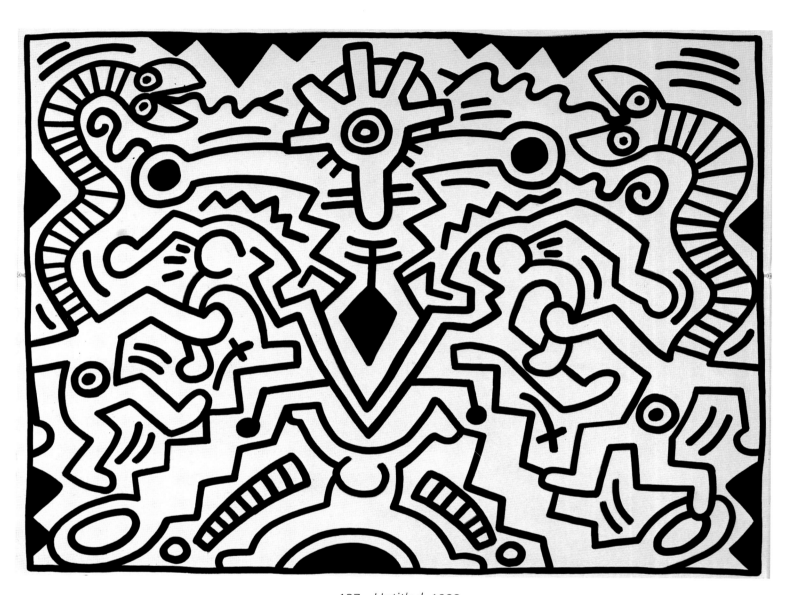

137 *Untitled,* 1988

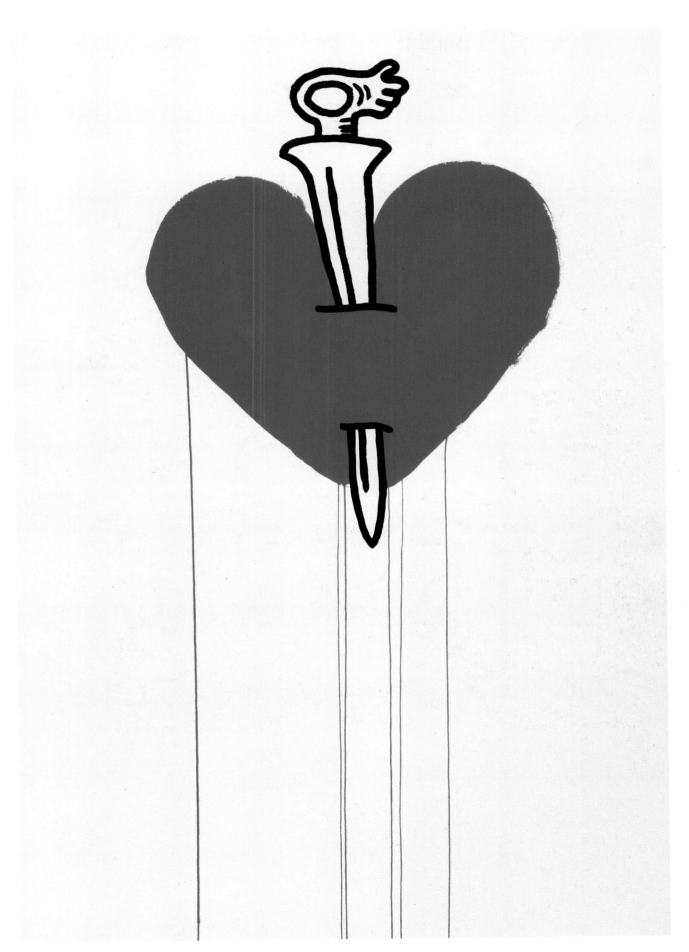

138 *Untitled,* 1988

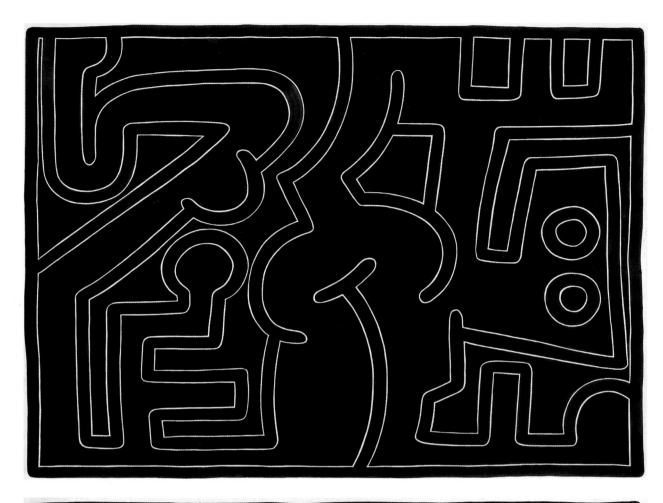

139
Untitled,
1989

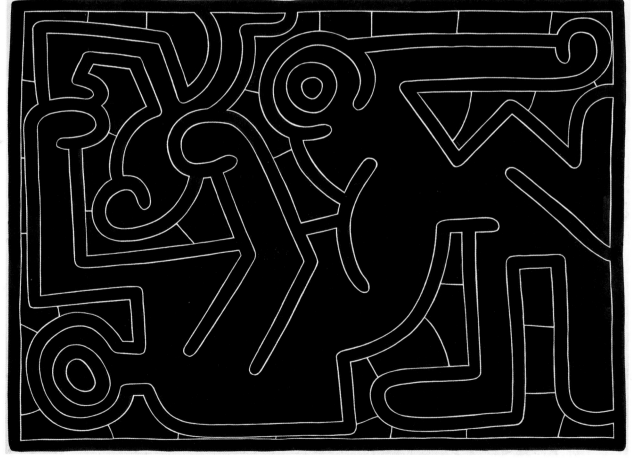

140
Untitled,
1989

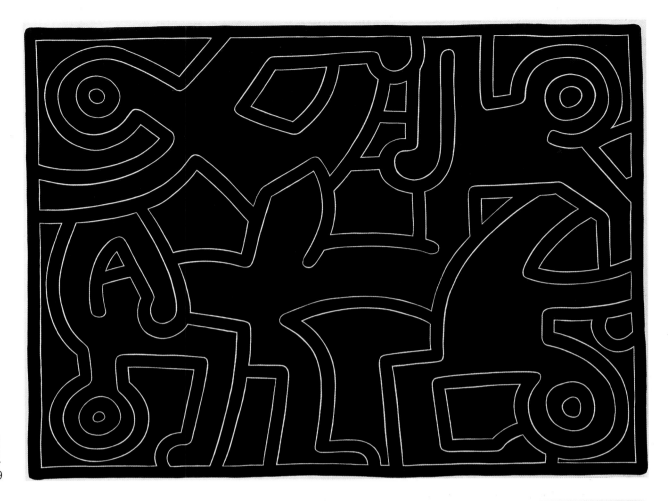

141
Untitled,
1989

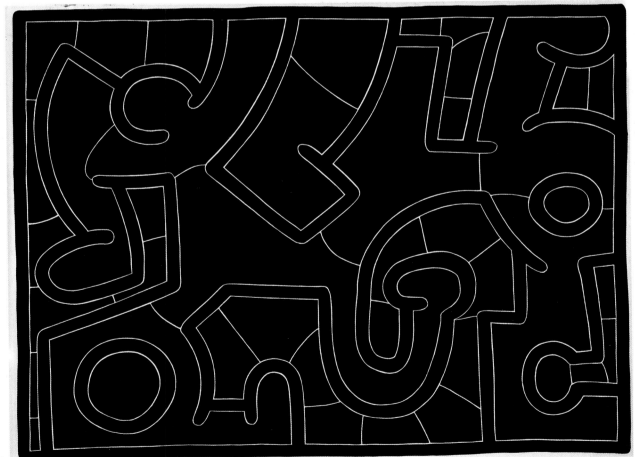

142
Untitled,
1989

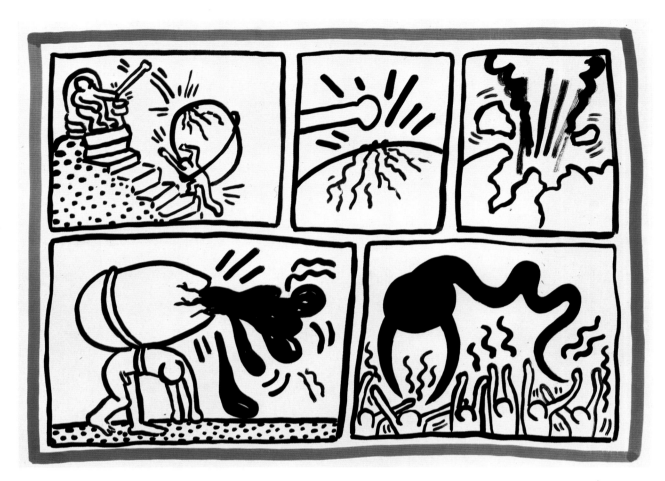

143
Untitled,
1988

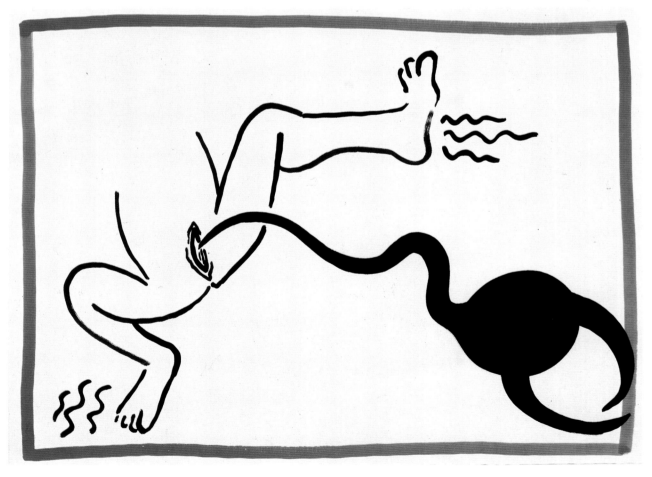

144
Untitled,
1988

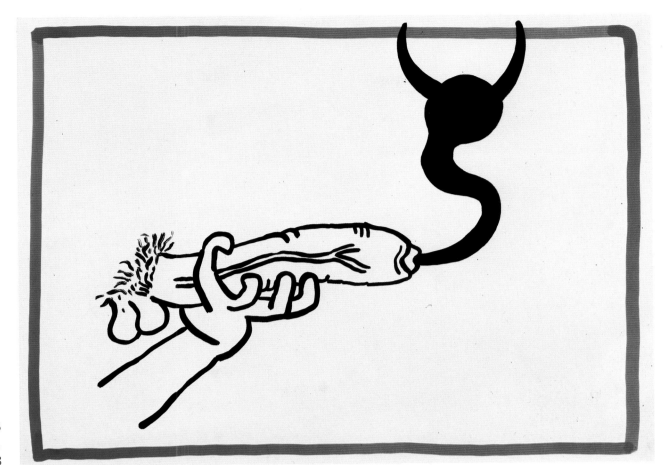

145
Untitled,
1988

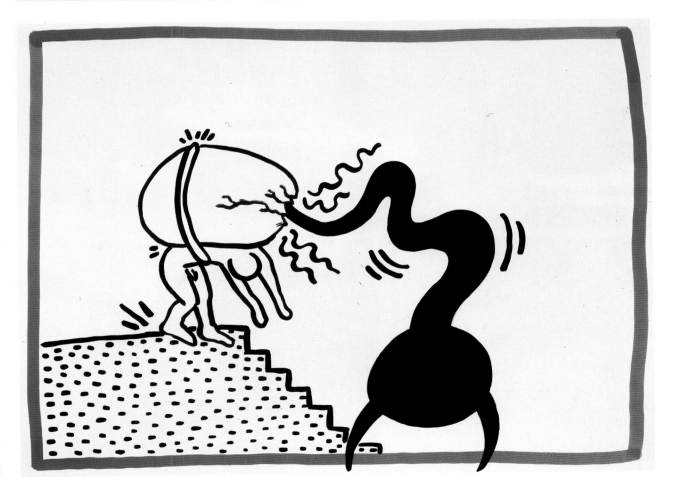

146
Untitled,
1988

151 *Ignorance = Fear,* 1989

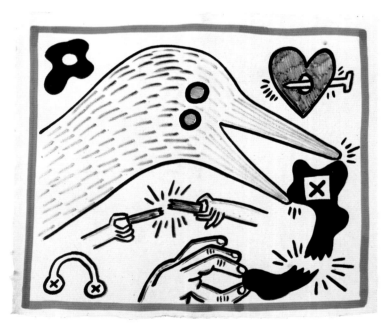

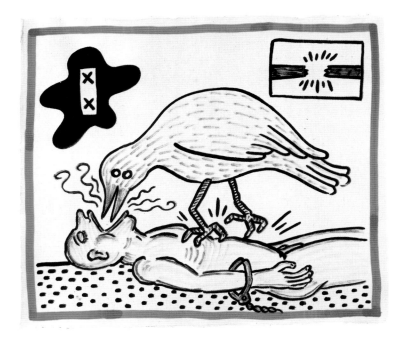 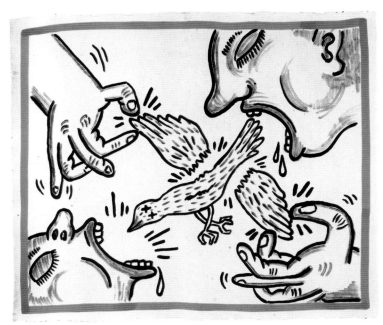

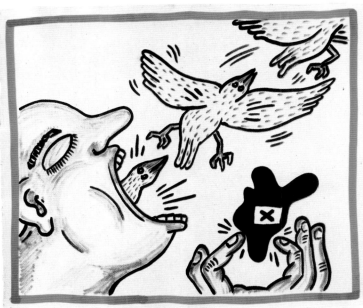 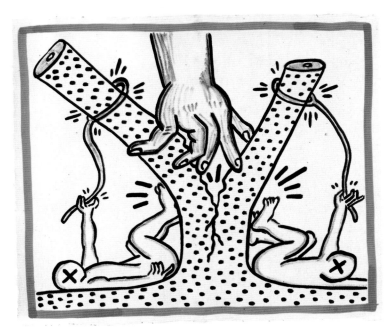

152-59 *Untitled* (1-8 of 17), 1989

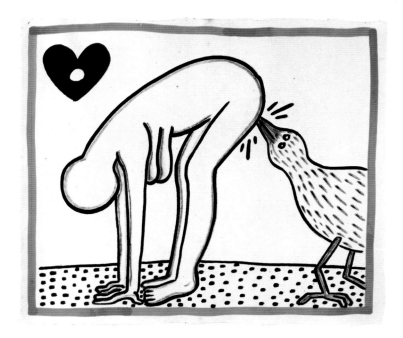
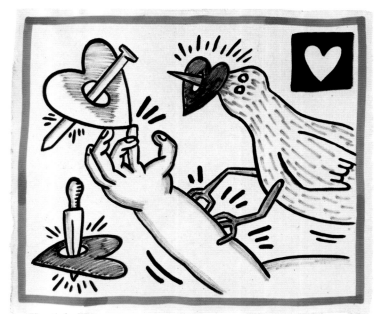

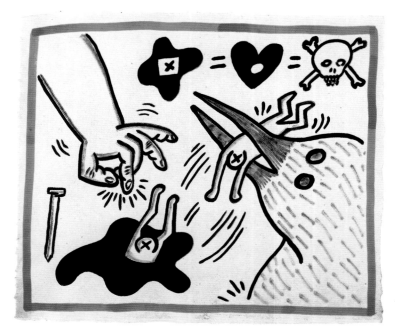

160-68 *Untitled* (9-17 of 17), 1989

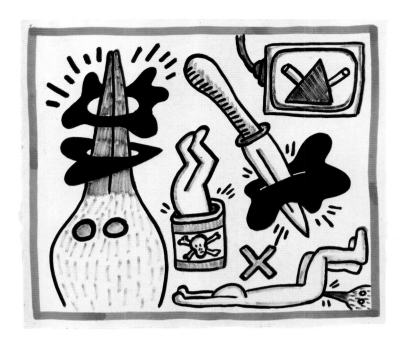 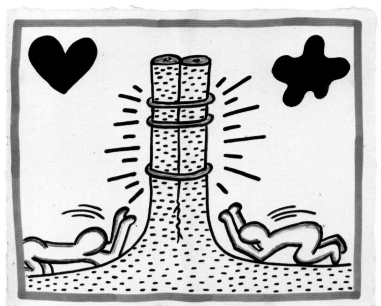

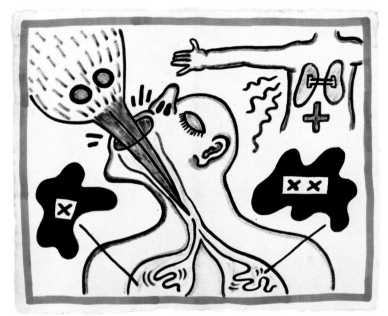 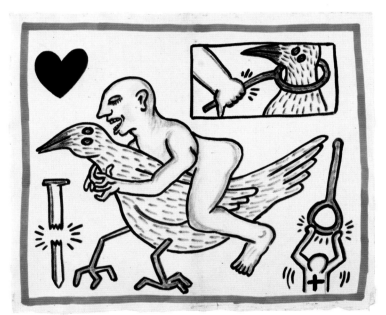

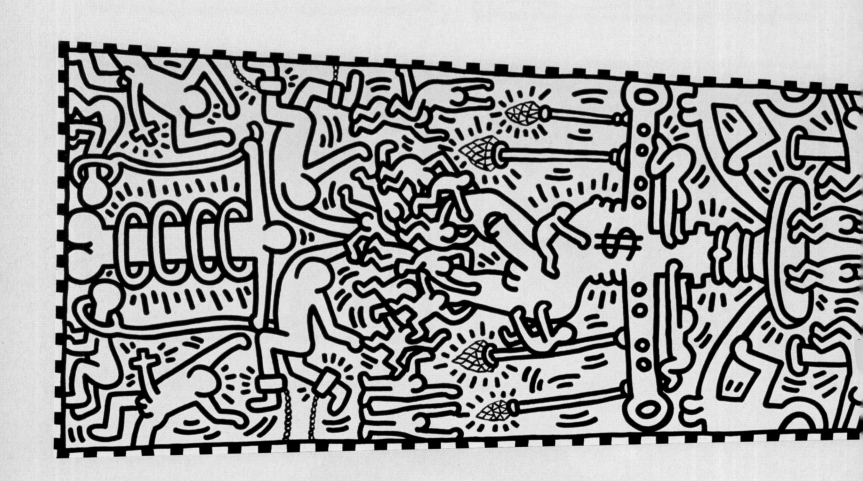

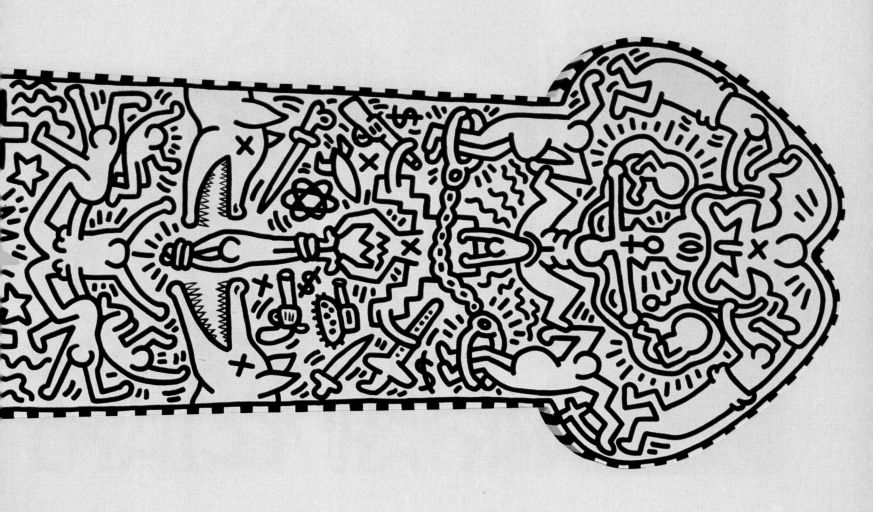

170 *Untitled,* 1988

Previous pages:
169 *The Great White Way,* 1988

171 *Untitled,* 1988

172 *Untitled,* 1988

173 *A Pile of Crowns for Jean-Michel Basquiat,* 1988

Following pages:

174 *Untitled,* 1985

175 *Untitled* (Figure Balancing on Dog), 1989

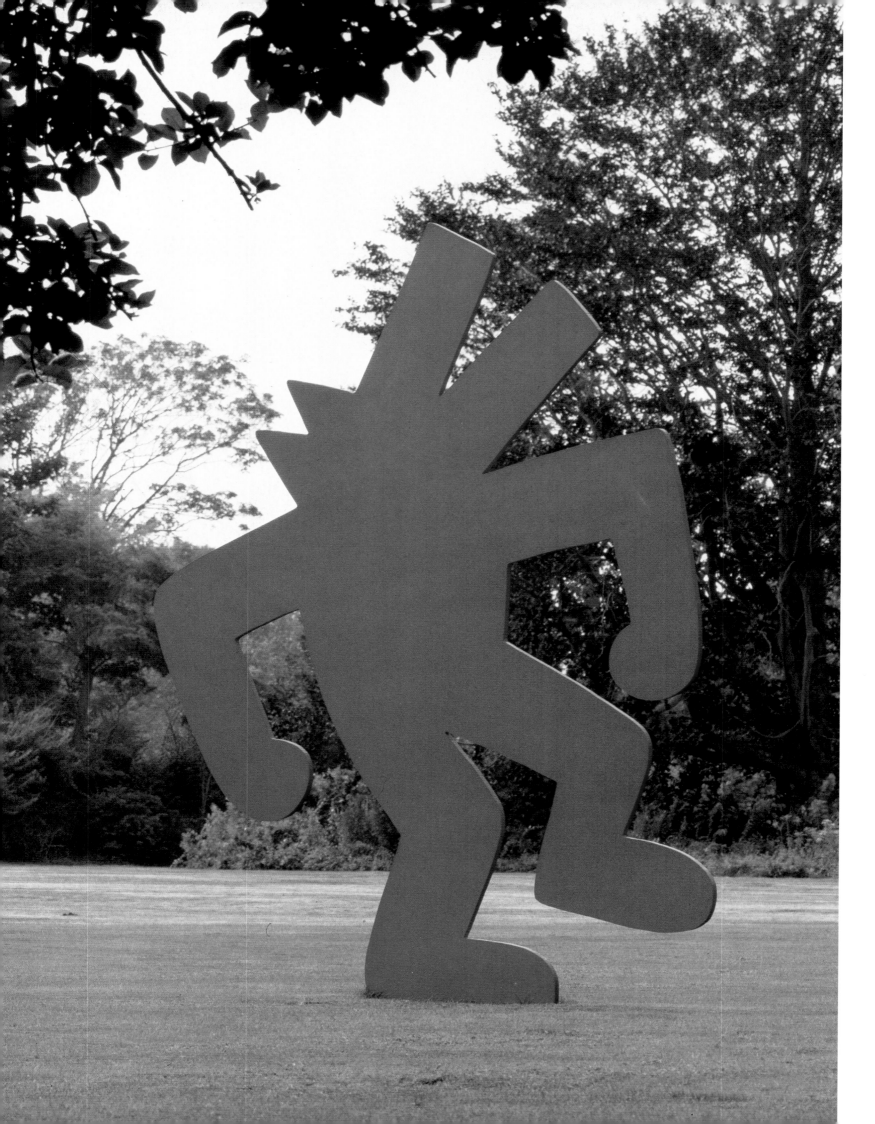

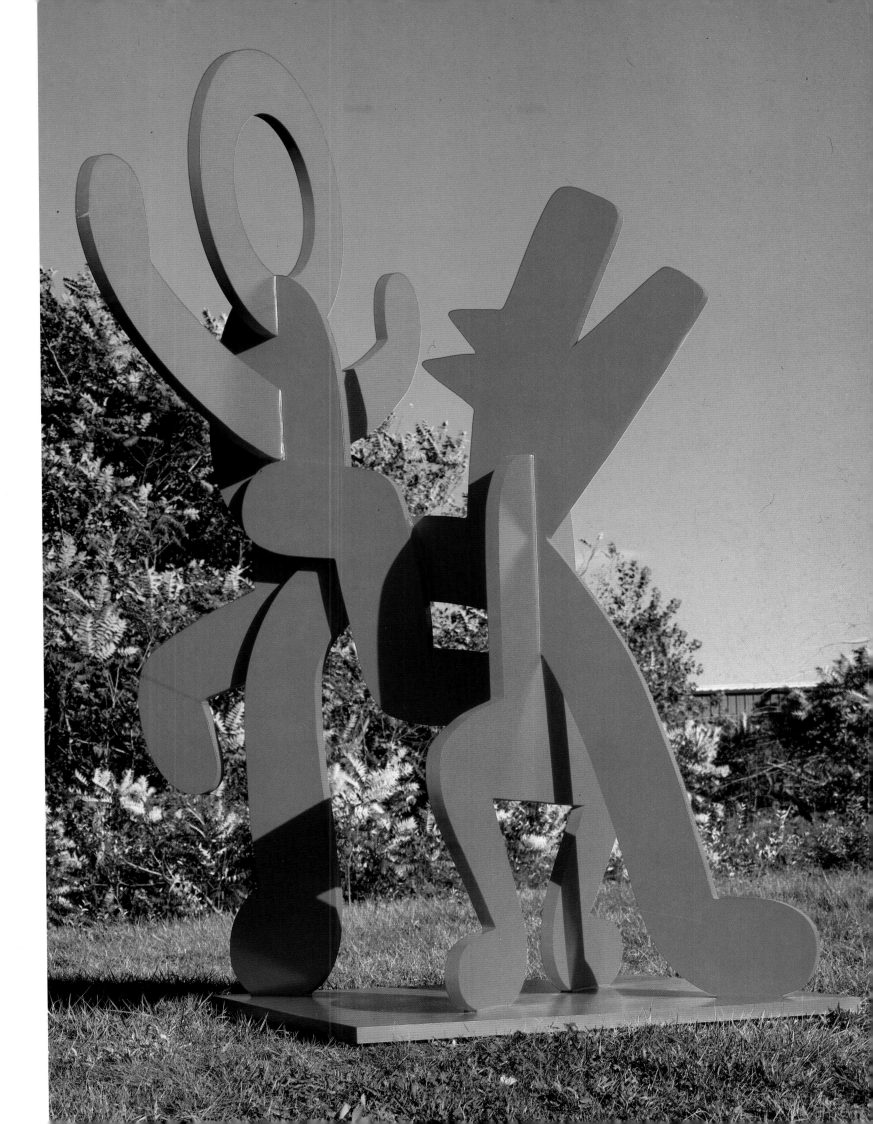

176 *The Last Rainforest,* 1989

177 *Walking in the Rain,* 1989

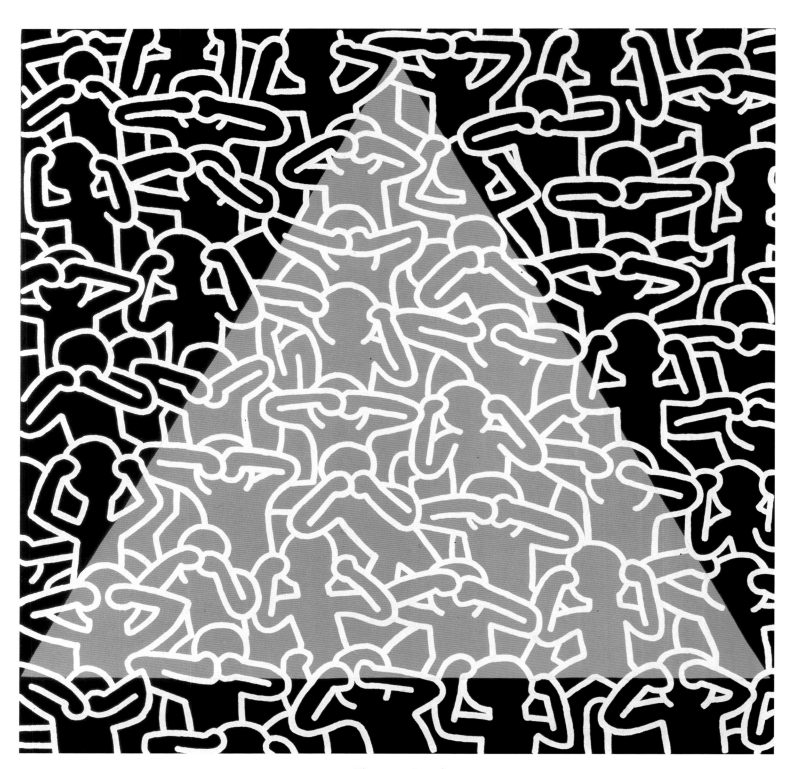

178 *Silence = Death,* 1989

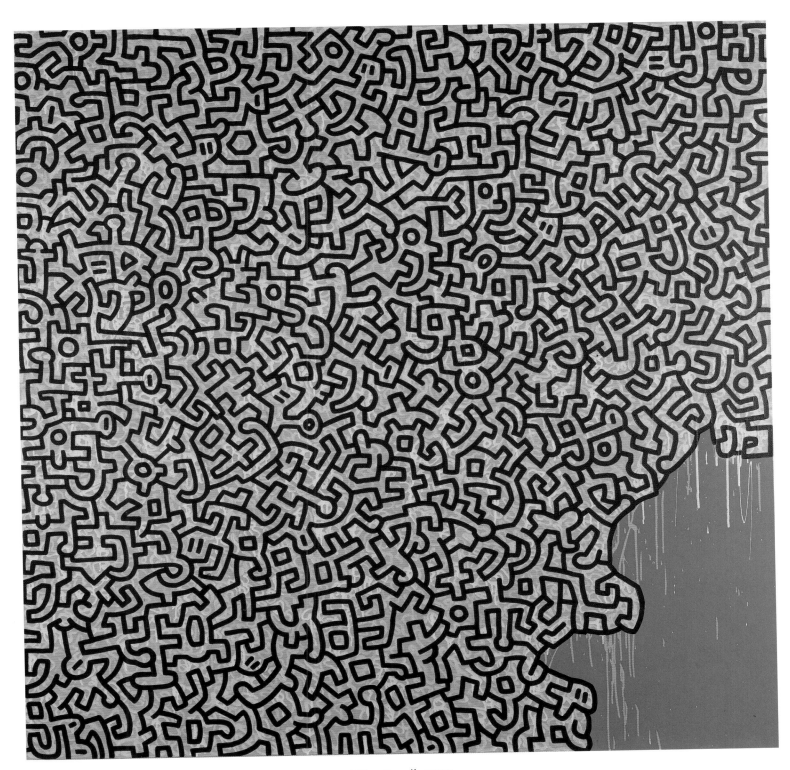

179 *Brazil*, 1989

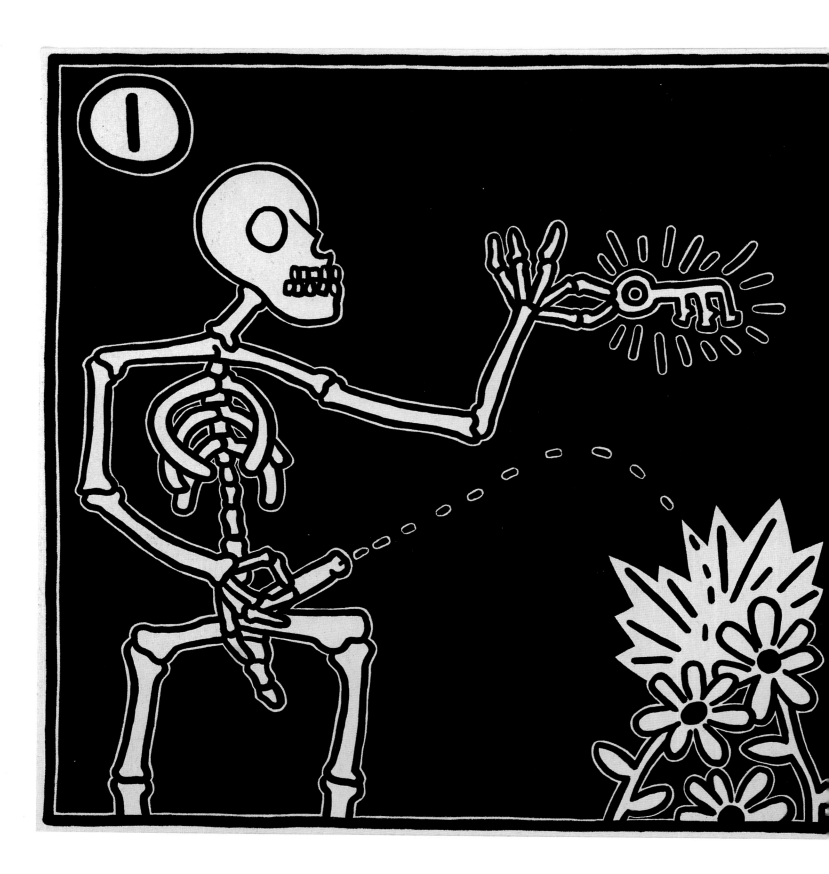

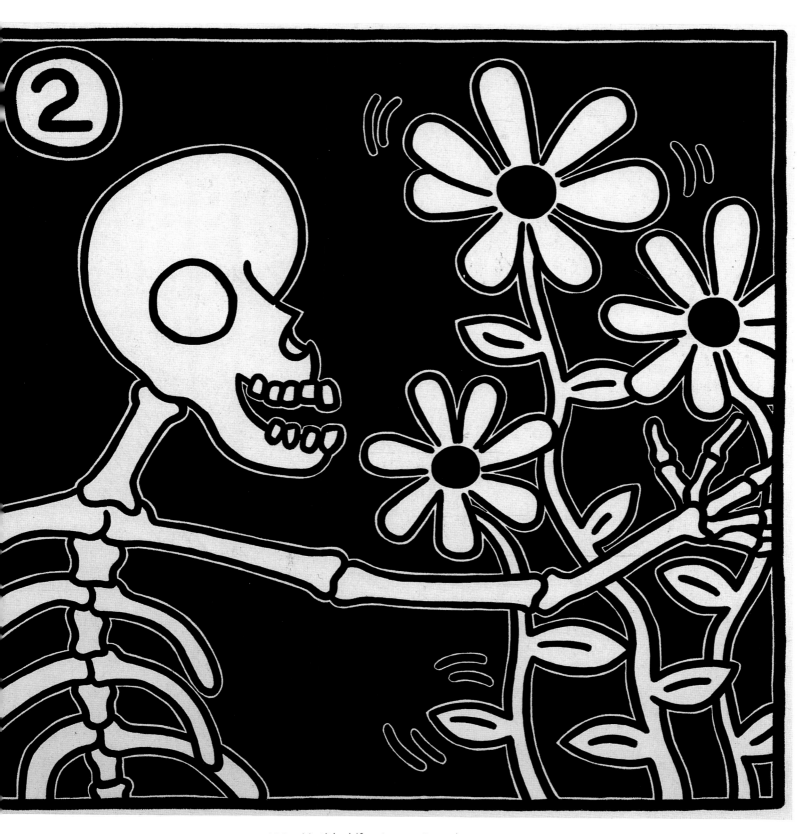

180 *Untitled* (for James Ensor), 1989

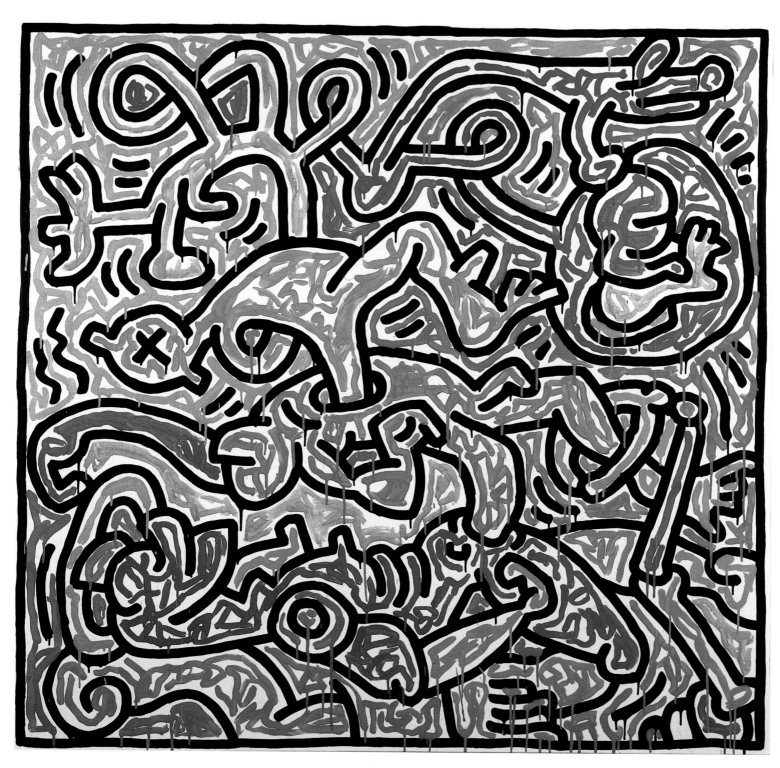

181 *Rebirth,* 1989

182 *Untitled*, 1989

List of Plates
Chronology
Selected Bibliography

List of Plates

1
Untitled, 1981
Ink on Masonite, 34½ x 35"
Courtesy Tony Shafrazi Gallery, New York

2
Untitled, 1981
Sumi ink on vellum, 42 x 46¾"
Courtesy Tony Shafrazi Gallery, New York

3
"Times Square Show," New York, 1980

4
Untitled, 1982
Vinyl paint on vinyl tarpaulin, 144 x 144"
Courtesy Tony Shafrazi Gallery, New York

5
Untitled, September 1981
Vinyl paint on vinyl tarpaulin, 96 x 96"
Private collection

6 - 9
Drawings in the New York City subway,
1983, 1982, 1984, and 1985
Chalk on black paper

10
15 by 50-foot mural on Houston Street,
New York City, 1982

11
Untitled (Mermaid), August 1982
(with LA II)
Marker ink and enamel paint on fiberglass
figure, 37 x 22 x 23"
Courtesy Tony Shafrazi Gallery, New York

12
Untitled, September 14, 1982 (with LA II)
Vinyl paint on vinyl tarpaulin, 85¼ x 87"
Collection The Estate of Keith Haring

13
Untitled, December 16, 1981 (with LA II)
Fluorescent enamel paint and felt-tip
marker on wooden headboard,
43 x 30½ x ¾"
Collection The Estate of Keith Haring

14
Untitled, 1983
Enamel paint on baby crib
Private collection, New York

15
Untitled, April 25, 1982
Marker ink and acrylic on found canvas,
86 x 86"
Private collection

16
Untitled, 1983
Vinyl paint on vinyl tarpaulin, 120 x 120"
Private collection

17
Untitled, July 18, 1980
Sumi ink and spraypaint on poster board,
48 x 63½"
Collection The Estate of Keith Haring

18
Untitled, September 2, 1980
Sumi ink and spraypaint on poster board,
48 x 31¼"
Collection The Estate of Keith Haring

19
*Three Men Die in Rescue Attempt Six
Months After John Lennon's Death*
June 15, 1981
Sumi ink and acrylic on paper, 38 x 50"
Private collection

20
Untitled, 1981
Sumi ink on paper, 72 x 144"
Private collection

21
Untitled, September 22, 1980
Felt-tip marker on paper, 20 x 26"
Collection The Estate of Keith Haring

22
Untitled, 1981
Red and black sumi ink on paper, 38 x 50"
Private collection

23
Untitled, February 1982
Sumi ink and acrylic on paper, 72 x 130"
Private collection

24
Untitled, April 29, 1982
Sumi ink on paper, 19½ x 27½"
Courtesy Tony Shafrazi Gallery, New York

25
Untitled, February 12, 1982
Sumi ink and acrylic on paper, 72 x 113"
Collection The Estate of Keith Haring

26
Untitled, 1982
Sumi ink on paper, 72 x 144"
Collection The Estate of Keith Haring

27
Untitled, 1982
Sumi ink on paper, 38 x 50"
Private collection

28
Untitled, August 20, 1983
Sumi ink on paper, 23 x 29⅛"
Collection The Estate of Keith Haring

29
Untitled, August 10, 1983
Sumi ink on paper, 23 x 29⅛"
Collection The Estate of Keith Haring

30
Untitled, August 20, 1983
Sumi ink on paper, 23 x 29⅛"
Collection The Estate of Keith Haring

31
Untitled, 1983
Red and black sumi ink on paper,
72 x 132"
Collection The Estate of Keith Haring

32
Untitled, 1984
Felt-tip marker on paper, 21 x 19"
Collection The Estate of Keith Haring

33
Untitled, 1983
Sumi ink on paper, 23 x 29"
Collection The Estate of Keith Haring

34
Untitled, 1982 (with LA II)
Acrylic and felt-tip marker on wooden
figure, height 19½"
Collection The Estate of Keith Haring

35
Untitled, 1982
Felt-tip marker on found canvas, 86 x 86"
Private collection

36
Untitled, 1983
Enamel paint on incised wood, 72 x 72"
Private collection

37
Untitled, November 1983
Enamel paint on incised wood,
35 x 36 x 2½"
Collection The Estate of Keith Haring

38
Untitled, 1983
Vinyl paint on vinyl tarpaulin, 120 x 120"
Private collection

39
Untitled, 1983
Vinyl paint on vinyl tarpaulin, 72 x 72"
Private collection

40
Installation view of (a) sarcophagus
and (b) screen, 1983 (with LA II)
(a) Gold paint and felt-tip marker on
fiberglass sarcophagus, 98 x 34 x 20"
(b) Gold paint, sumi ink, and felt-tip
marker on Japanese screen
(a) Courtesy Tony Shafrazi Gallery
(b) Private collection

41
Untitled, 1983
Vinyl paint on vinyl tarpaulin, 72 x 72"
Private collection

42
Untitled, 1983
Vinyl paint on vinyl tarpaulin, 84 x 84"
Private collection

43
Untitled, 1981
Felt-tip marker and gold paint on
fiberglass vase; height 40", diameter 28"
Private collection

44
Untitled, 1981
Felt-tip marker and enamel paint on
fiberglass vase; height 40", diameter 28"
Private collection

45
Untitled, May 26, 1984
Ink on terracotta vase; height 19",
diameter 13½"
Private collection

46
Untitled, May 26, 1984
Ink on terracotta vase; height 21½",
diameter 17½"
Private collection

47
Untitled, May 25, 1984
Ink on terracotta vase; height 47",
diameter 12"
Private collection

48
Untitled, May 24, 1984
Ink on terracotta vase; height 31",
diameter 16½"
Private collection

49
Untitled, January 20, 1990
Acrylic and felt-tip marker on terracotta
vase; height 24", diameter 11"
Collection The Estate of Keith Haring

50
Untitled, 1983
Vinyl paint on vinyl tarpaulin, 180 x 276"
Private collection

51
Untitled, April 5, 1984
Acrylic and sumi ink on paper, 38 x 50"
Courtesy Tony Shafrazi Gallery, New York

52
Untitled, 1984
Acrylic on muslin, 60 x 60"
Private collection

53
Untitled, 1984
Acrylic on muslin, 60 x 60"
Private collection

54
Untitled, June 5, 1984
Enamel paint on incised wood, 109 x 35"
Private collection

55
Untitled, June 5, 1984 (with LA II)
Fluorescent enamel paint and ink
on plaster figure, 60 x 25"
Private collection

56
Untitled, October 22, 1984
Acrylic on canvas, 60 x 60"
Collection The Estate of Keith Haring

57
Cruella Deville, 1984
Acrylic on muslin, 60 x 60"
Private collection

58
Untitled, 1984
Acrylic on canvas tarpaulin, 120 x 120"
Collection The Estate of Keith Haring

59
Untitled, 1984
Acrylic on canvas tarpaulin, 60 x 60"
Private collection

60
Untitled, June 4, 1984
Fluorescent enamel paint and ink on
plaster torso, 39 x 21"
Private collection

61
Untitled, June 9, 1984
Enamel paint on wood, 136 x 43"
Private collection

62
Untitled, 1984
Acrylic on muslin tarpaulin, 120 x 180"
Private collection

63
Untitled, 1984
Acrylic on muslin tarpaulin, 120 x 180"
Courtesy Tony Shafrazi Gallery, New York

64, 65
Drawings in the New York City subway,
1985 and 1983

66
Untitled, 1984
Acrylic on muslin, 60 x 180"
(three panels, each 60 x 60")
Private collection

67
Untitled, May 29, 1984
Acrylic on canvas, 94 x 94"
Private collection

68
Untitled, May 30, 1984
Acrylic on canvas, 94 x 94"
Private collection

69, 70
Painted body of Grace Jones and stage set
for performance at the Paradise Garage,
New York City, 1984

71
Untitled, 1984
Acrylic on canvas tarpaulin, 120 x 180"
Private collection

72
Untitled, 1985
Acrylic on canvas tarpaulin, 120 x 180"
Private collection

73
Untitled, August 1985
Acrylic on canvas, 48 x 48"
Private collection

74
Untitled, 1985
Acrylic on canvas, 48 x 48"
Private collection

75
Untitled, 1985
Acrylic and oil on canvas tarpaulin,
120 x 180"
Private collection

76
Untitled, 1985
Acrylic on canvas, 48 x 48"
Private collection

77
Portrait of Macho Camacho, 1985
Acrylic and oil on canvas tarpaulin,
120 x 120"
Collection The Estate of Keith Haring

78
Untitled, 1985
Acrylic on linen tarpaulin, 93 x 228"
Private collection

79
South Africa, 1985
Acrylic on canvas, 48 x 48"
Private collection

80
Untitled, October 20, 1985
Acrylic on canvas, 60 X 60"
Collection The Estate of Keith Haring

81
Untitled, 1985
Acrylic and oil on canvas, diameter 28"
Private collection

82
Untitled, 1985
Acrylic and oil on canvas, diameter 36"
Private collection

83
Untitled, 1985
Acrylic and oil on canvas, diameter 28"
Private collection

84
Untitled, 1985
Acrylic and oil on canvas, diameter 36"
Private collection

85
Untitled, 1985
Acrylic and oil on canvas, diameter 60"
Private collection

86
Untitled, 1985
Acrylic and oil on canvas, diameter 36"
Private collection

87
Untitled, 1985
Acrylic and oil on canvas, diameter 60"
Private collection

88
Untitled, 1985
Acrylic and oil on canvas, diameter 60"
Private collection

89
Michael Stewart – USA for Africa,
October 5, 1985
Enamel paint and acrylic on canvas
tarpaulin, 120 x 144"
Collection The Estate of Keith Haring

90
Untitled, 1985
Acrylic and oil on canvas tarpaulin,
119 x 116"
Private collection

91
Untitled, 1985
Enamel paint and acrylic on canvas
tarpaulin, 120 x 180"
Collection The Estate of Keith Haring

92
Untitled, September 9, 1985
Acrylic on canvas tarpaulin, 120 x 180"
Private collection

93
Untitled, 1985
Acrylic on canvas, 60 x 60"
Private collection

94
Untitled, 1985
Acrylic on muslin, 60 x 60"
Collection The Estate of Keith Haring

95
Crack Is Wack, June 1986
Mural at East Harlem Drive and
128th Street, New York City

96
350-foot-long mural on the Berlin Wall,
October 1986
Destroyed

97
Luna, Luna, 1987
Vinyl paint on vinyl tarpaulin
Private collection

98
Mural at Marquette University,
Milwaukee, Wisconsin, February 1983

99
69, September 26, 1986
Oil and acrylic on canvas, 30 x 30"
Private collection

100
Untitled, September 23, 1986
Acrylic and oil on canvas tarpaulin,
96 x 96"
Private collection

101
Untitled, September 14, 1986
Acrylic and oil on canvas tarpaulin,
96 x 192"
Collection The Estate of Keith Haring

102
Painted body of Grace Jones during
performance at the Paradise Garage,
New York City, 1984

103
Portrait of Grace Jones, September 19,
1986
Acrylic and oil on canvas tarpaulin,
96 x 144"
Private collection

104
Citykids Speak on Liberty, July 1986
Banner; collaboration with 1,000 New
York City youths for Statue of Liberty
dedication
Private collection

105, 106
The Ten Commandments, 1985
Acrylic and oil on canvas, each approx.
303 x 198"
Installation at the Musée d'Art Contem-
porain, Bordeaux, France
Collection The Estate of Keith Haring

107
Untitled, 1987
Polyurethane-painted aluminum,
96 x 82 x 56"
Private collection

108
Untitled, 1985
Polyurethane-painted aluminum,
173^{1}/$_{4}$ x 94 x 48"
Private collection

109
Red-Yellow-Blue # 5 (Portrait of Zena),
January 11, 1987
Acrylic and enamel paint on canvas,
36 x 36"
Private collection

110
Knokke # 10, June 24, 1987
Acrylic and enamel paint on linen,
70^{3}/$_{4}$ x 70^{3}/$_{4}$"
Collection The Estate of Keith Haring

111
Untitled (Mask with a Long Mouth),
1987
Enamel-painted aluminum, 48 x 33 x 22"
Private collection

112
Untitled (Large Goon Mask), 1987
Enamel-painted aluminum, 75 x 53 x 8"
Private collection

113
Untitled (Egg Head for Picasso), 1987
Enamel-painted aluminum, 44 x 44 x 8"
Private collection

114
Untitled (Grace Jones Mask), 1987
Enamel-painted aluminum, 47 x 44 x 14"
Private collection

115
Untitled (Tongue Man), 1987
Enamel-painted aluminum, 49 x 33 x 22"
Collection The Estate of Keith Haring

116
Untitled (Hollywood African Mask), 1987
Enamel-painted aluminum, 48 x 33 x11"
Private collection

117
Untitled (Burning Skull), 1987
Enamel-painted aluminum, 44 x 31 x 9"
Private collection

118
Untitled (Mask with Six Eyes), 1987
Enamel-painted aluminum, 42 x 27 x 11"
Private collection

119
Untitled (for Cy Twombly), April 1988
Acrylic on canvas, 36 x 36"
Collection The Estate of Keith Haring

120
Untitled, May 1988
Acrylic on canvas, 48 x 36"
Private collection

121
Untitled, October 22, 1988
Acrylic on canvas, 216 x 108"
Collection The Estate of Keith Haring

122
Red Room, 1988
Acrylic on canvas, 96 x 180"
Private collection

123
Monkey Puzzle, November 1988
Acrylic on canvas, diameter 120"
Private collection

124
Mom, October 29, 1989
Acrylic on canvas, 60 x 60"
Private collection

125
500-foot-long mural, Grant Park,
Chicago, May 1989
Collaboration with 300 school children

126
90 by 90-foot mural on the Stedelijk
Museum warehouse, Amsterdam,
March 1986

127
Mural on Church of Sant' Antonio, Pisa,
June 1989

128 - 36
The Story of Jason, June 19, 1987
Red and black sumi ink and photographs
on Japanese paper; nine sheets, each
22½ x 30¼"
Private collection

137
Untitled, January 19, 1988
Sumi ink on paper, 38 x 50"
Collection The Estate of Keith Haring

138
Untitled, July 14, 1988
Red and black sumi ink on paper,
59½ x 40¾"
Collection The Estate of Keith Haring

139
Untitled, September 16, 1989
Sumi ink on paper, 38 x 50"
Collection The Estate of Keith Haring

140
Untitled, September 16, 1989
Sumi ink on paper, 38 x 50"
Collection The Estate of Keith Haring

141
Untitled, September 16, 1989
Sumi ink on paper, 38 x 50"
Collection The Estate of Keith Haring

142
Untitled, September 16, 1989
Sumi ink on paper, 38 x 50"
Collection The Estate of Keith Haring

143
Untitled, April 24, 1988
Red and black sumi ink on paper,
22¼ x 30"
Collection The Estate of Keith Haring

144
Untitled, April 24, 1988
Red and black sumi ink on paper,
22¼ x 30"
Collection The Estate of Keith Haring

145
Untitled, April 24, 1988
Red and black sumi ink on paper,
22¼ x 30"
Collection The Estate of Keith Haring

146
Untitled, April 24, 1988
Red and black sumi ink on paper,
22¼ x 30"
Collection The Estate of Keith Haring

147
Untitled, April 24, 1988
Red and black sumi ink on paper,
22¼ x 30"
Collection The Estate of Keith Haring

148
Untitled, April 24, 1988
Red and black sumi ink on paper,
22¼ x 30"
Collection The Estate of Keith Haring

149
Untitled, April 24, 1988
Red and black sumi ink on paper,
22¼ x 30"
Collection The Estate of Keith Haring

150
Untitled, April 24, 1988
Red and black sumi ink on paper,
22¼ x 30"
Collection The Estate of Keith Haring

151
Ignorance = Fear, 1989
Sumi ink on paper, 24 x 43⅛"
Collection The Estate of Keith Haring

152 - 68
Untitled, December 9, 1989
Red and black sumi ink on Japanese
paper; 17 sheets, each 25 x 28½"
Collection The Estate of Keith Haring

169
The Great White Way, November 27, 1988
Acrylic on canvas, 168 x 45"
Collection The Estate of Keith Haring

170
Untitled, November 21, 1988
Acrylic, enamel paint, and collage on
canvas, 60 x 60"
Private collection

171
Untitled, November 21, 1988
Acrylic, enamel paint, and collage on
canvas, 60 x 60"
Private collection

172
Untitled, November 8, 1988
Acrylic on canvas, 120 x 120"
Private collection

173
A Pile of Crowns for Jean-Michel Basquiat,
August 19, 1988
Acrylic on canvas, 107½ x 119"
Collection The Estate of Keith Haring

174
Untitled, 1985
Polyurethane-painted A-36 steel,
162 x 130 x 1½"
Private collection

175
Untitled (Figure Balancing on Dog), 1989
Painted Cor-Ten steel, 144 x 104 x 122"
Permanent installation in Kutztown,
Pennsylvania

176
The Last Rainforest, October 24, 1989
Acrylic on canvas, 72 x 96"
Courtesy Tony Shafrazi Gallery, New York

177
Walking in the Rain, October 24, 1989
Acrylic and enamel paint on canvas,
72 x 96"
Collection The Estate of Keith Haring

178
Silence = Death, May 7, 1989
Acrylic on canvas, 39½ x 39½"
Private collection

179
Brazil, October 21, 1989
Acrylic and enamel paint on canvas,
72 x 72"
Collection The Estate of Keith Haring

180
Untitled (for James Ensor), May 5, 1989
Acrylic on canvas, 36 x 72" (two panels,
each 36 x 36")
Private collection

181
Rebirth, 1989
Acrylic on canvas, 60 x 60 x 4"
Private collection

182
Untitled, July 5, 1989
Acrylic on canvas, 39$\frac{1}{2}$ x 39$\frac{1}{2}$"
Private collection

Chronology

One-Man Shows and Major Exhibitions

1978

Pittsburgh Center for the Arts, Pittsburgh, Pennsylvania

1981

Westbeth Painters Space, New York City
P.S. 122, New York City
Club 57, New York City

1982

Rotterdam Arts Council, Rotterdam, Holland
Tony Shafrazi Gallery, New York City (with LA II)

1983

Fun Gallery, New York City (with LA II)
Galerie Watari, Tokyo, Japan (with LA II)
Lucio Amelio gallery, Naples, Italy
Gallery 121, Antwerp, Belgium
"Matrix 75," Wadsworth Atheneum, Hartford, Connecticut
Robert Fraser Gallery, London, U.K. (with LA II)
Tony Shafrazi Gallery, New York City

1984

University Museum of Iowa City, Iowa
Galerie Paul Maenz, Cologne, Germany
Galleria Salvatore Ala, Milan, Italy (with LA II)
Paradise Garage, New York City
Galerie Corinne Hummel, Basel, Switzerland
Semaphore East, New York City (with Tseng Kwong Chi)

1985

Schellmann & Kluser, Munich, Germany
Tony Shafrazi Gallery, New York City
Leo Castelli Gallery, New York City
Musée d'Art Contemporain, Bordeaux, France

1986

Hammarskjöld Plaza Sculpture Garden, New York City
Stedelijk Museum, Amsterdam, Holland
"Art in the Park," Whitney Museum of American Art, Stamford, Connecticut
Galerie Daniel Templon, Paris, France

1987

Tony Shafrazi Gallery, New York City
Galerie Kaj Forsblom, Helsinki, Finland
Gallery 121, Antwerp, Belgium Casino Knokke, Knokke le Zoute, Belgium
Kutztown New Arts Program, Kutztown, Pennsylvania
Galerie Rivolta, Lausanne, Switzerland

1988

Michael Kohn Gallery, Los Angeles, California
Galerie Hans Mayer, Düsseldorf, Germany
Tony Shafrazi Gallery, New York City
Hokin Gallery, Bay Harbor Islands, Florida

1989

Gallery 121, Antwerp, Belgium
Casa Sin Nombre, Santa Fe, New Mexico (with William S. Burroughs)

1990

Fay Gold Gallery, Atlanta, Georgia (with Herb Ritts)
Galerie Hete Hünermann, Düsseldorf, Germany
Galerie 1900 - 2000, Paris, France
Charles Lucien Gallery, New York City
Philip Samuels Fine Art, St. Louis, Missouri
Tony Shafrazi Gallery, New York City
Galerie Nikolaus Sonne, Berlin, Germany
"Keith Haring: Future Primeval," The Queens Museum, New York City
Richard Nadeau Gallery, Philadelphia, Pennsylvania
Tony Shafrazi Gallery, New York City (with Jean-Michel Basquiat)

1991

Galerie Hete Hünermann, Düsseldorf, Germany

"Keith Haring: Future Primeval," University Galleries, Normal, Illinois
Museum of Modern Art, Ostende, Belgium
"Haring, Warhol, Disney," Phoenix Art Museum, Phoenix, Arizona
"Keith Haring: Future Primeval," Tampa Museum of Art, Tampa, Florida
Chase Manhattan Bank, Soho Branch, New York
Erika Meyerovich gallery, San Francisco
Molinar Gallery, Scottsdale, Arizona
Steffanoni gallery, Milan, Italy
Galerie Hete Hünermann, Düsseldorf, Germany

1992

"Haring, Warhol, Disney," Tacoma Art Museum, Tacoma, Washington; The Corcoran Gallery of Art, Washington, D.C.; The Worcester Museum, Worcester, Massachusetts
Gallery 56, Budapest, Hungary
Tabula Gallery, Tübingen, Germany
Tony Shafrazi Gallery, New York City

1993

Queens Museum, New York
DIA Art Foundation, Bridgehampton, New York
Michael Fuchs Gallery, Berlin, Germany
"Complete Editions on Paper: 1982-1990," Galerie Littmann, Basel, Switzerland; Galerie der Stadt, Stuttgart, Germany; Aktionsforum, Munich, Germany
"Keith Haring: A Retrospective," Mitsukoshi Museum of Art, Tokyo, Japan
Galerie Nikolaus Sonne, Berlin, Germany
Musée de Louvain-la-Neuve, Belgium

1994

"Keith Haring Retrospective," Castello di Rivoli, Turin, Italy; Malmo Konsthall, Malmo, Sweden; Deichtorhallen, Hamburg, Germany; Tel Aviv Museum, Tel Aviv, Israel
"Complete Editions on Paper: 1982-1990," Hiroshima, Osaka, Nagoya, Tokyo, Fukuoka, Japan
Tony Shafrazi Gallery, New York City

1995

"Keith Haring Altarpiece," Palo Alto Cultural Center, Palo Alto, California and Museum of Contemporary Religious Art, St. Louis, Missouri
"Keith Haring Retrospective," Fundacion La Caixa, Madrid, Spain; Kunsthaus Wien, Vienna, Austria
"Keith Haring: Works on Paper 1989," Andre Emmerich Gallery, New York City
Hans Mayer Gallery, Düsseldorf, Germany
Galerie Krinzinger, Vienna, Austria
"Keith Haring: Family and Friends Collect," Allentown Art Museum, Pennsylvania

1996

Andre Emmerich Gallery, New York City
"Complete Editions of Paper," Museum Bochum and Museum der Bildenden Künste, Leipzig, Germany
Dorothy Blau Gallery, Miami, Florida
"The Ten Commandments," Bruderkirche and Museum Fridericianum, Kassel, Germany
"Keith Haring Retrospective," Museum of Contemporary Art, Sydney, Australia

1997

"Complete Editions on Paper," Kunsthalle, Cologne, Germany
"Keith Haring: A Retrospective," Whitney Museum of American Art, New York City

Selected Group Exhibitions

1980

"Club 57 Invitational," New York City
"Times Square Show," New York City
"Studio Exhibition at P.S. 122," New York City
"Events: Fashion Moda," The New Museum, New York City

1981

"Drawing Show," the Mudd Club, New York City
"New York/New Wave," P.S. 1, Long Island City, New York
Lisson Gallery, London, U.K.
Brooke Alexander Gallery, New York City
Tony Shafrazi Gallery, New York City
Annina Nosei Gallery, New York City
Patrick Verelst Gallery, Antwerp, Belgium
Bard College, Annandale-on-Hudson, New York

1982

"Still Modern After All These Years," Chrysler Museum, Norfolk, Virginia
"Fast," Alexander Milliken Gallery, New York City
"Young Americans," Tony Shafrazi Gallery, New York
Larry Gagosian Gallery, Los Angeles, California
Blum Helman Gallery, New York City
"New Painting 1: Americans," Middendorf Lane Gallery, Washington, D.C.
"Art of the 80's," Westport Weston Arts Council, Westport, Connecticut
Wave Hill, Bronx, New York
Young Hoffman Gallery, Chicago, Illinois
"Agitated Figures: The New Emotionalism, Hallwalls," Buffalo, New York
Holly Solomon Gallery, New York City
"Painting & Sculpture Today," Indianapolis Museum of Art, Indiana
Richard Hines Gallery, Seattle, Washington
"The Pressure to Paint," Marlborough Gallery, New York City
"documenta '82," Kassel, Germany
"The U.F.O. Show," The Queens Museum, New York City
"Urban Kisses," Institute of Contemporary Arts, London, U.K.
"Beast: Animal Imagery in Recent Painting," P.S. 1, Long Island City, New York

1983

"Morton G. Neumann Family Collection," Kalamazoo Institute of Arts, Kalamazoo, Michigan
"New York Painting Today," Carnegie – Mellon University, Pittsburgh, Pennsylvania
"Biennial 1983," Whitney Museum of American Art, New York City
"The Comic Art Show," Whitney Museum of American Art, New York City
"Back to the U.S.A.," Kunstmuseum, Lucerne, Switzerland
"Tendencias en Nueva York," Palacio Velázquez, Madrid, Spain
Bienal de São Paulo, Brazil
"Terrae Motus," Institute of Contemporary Art, Boston, Massachusetts
"Post-Graffiti Artists," Sidney Janis Gallery, New York City
"Currents," Institute of Contemporary Art, Philadelphia, Pennsylvania
Pittsburgh Center for the Arts, Pittsburgh, Pennsylvania (with LA II)

1984

Robert Fraser Gallery, London, U.K.
"Biennial III: The Human Condition," San Francisco Museum of Modern Art, California
Aldrich Museum, Ridgefield, Connecticut
"Via New York," Montreal Museum of Contemporary Art, Montreal, Canada
New Gallery of Contemporary Art, Cleveland, Ohio
"Arte di Frontiera," Galleria d'Arte Moderna, Bologna, Italy
"Aperto '84," Venice Biennale, Italy
"Content," Hirshhorn Museum and Sculpture Garden, Washington, D.C.
"Disarming Images: Art for Nuclear Disarmament" (traveled throughout United States)
Tony Shafrazi Gallery, New York City
Musée d'Art Moderne de la Ville de Paris, France
"New Attitudes: Paris — New York," Pittsburgh Center for the Arts, Pittsburgh, Pennsylvania

1985

"New York '85," ARCA, Marseilles, France
"Of the Street," Aspen Art Museum, Colorado
"Rain Dance," 292 Lafayette Street, New York City
"The Subway Show," Lehman College, Bronx, New York
"La Biennale de Paris," Grand Palais, Paris, France
"Homo Decorans," Louisiana Museum, Humlebaek, Denmark
"Les Piliers de la Coupole," Galerie Beau Lezard, Paris, France

1986

"Life in the Big City: Contemporary Artistic Responses to the Urban Experience," Rhode Island School of Design, Providence, Rhode Island
"An American Renaissance: Painting and Sculpture Since 1940," Fort Lauderdale Museum of Art, Florida
"Spectrum: The Generic Figure," The Corcoran Gallery of Art, Washington, D.C.
"Masterworks on Paper," Galerie Barbara Farber, Amsterdam, Holland
"American Art of the Eighties," Phoenix Art Museum, Phoenix, Arizona
"Sacred Images in Secular Art," Whitney Museum of American Art, New York City
"Surrealismo," Barbara Braathen Gallery, New York
Gabrielle Bryars Gallery, New York City

Linda Ferris Gallery, Seattle, Washington
Vienna Biennial, Austria
Havana Biennial, Cuba
Contemporary Arts Center, New Orleans, Louisiana
"Television's Impact on Contemporary Art," The Queens Museum, New York City
Thomas Cohn Gallery, Rio de Janeiro, Brazil
"The First Decade," Freedman Gallery, Philadelphia, Pennsylvania
"Contemporary Screens: Function, Decoration, Sculpture, and Metaphor," The Art Museum Association of America, San Francisco, California (traveling exhibition)
"What It Is," Tony Shafrazi Gallery, New York City

1987

"Focus on the Image: Selections from the Rivendell Collection," Phoenix Art Museum, Phoenix, Arizona
"L'Epoque, la Mode, la Morale, la Passion," Centre Georges Pompidou, Paris, France
"Borrowed Embellishments," Kansas City Art Institute, Kansas, Missouri
"Skulptur Projekte in Münster," Westfälisches Landesmuseum, Münster, Germany
"Avant-Garde in the Eighties," Los Angeles County Museum of Art, California
"Kunst aus den achtziger Jahren," A 11 Art Forum Thomas, Munich, Germany
"Comic Iconoclasm," Institute of Contemporary Arts, London, U.K.
"Leo Castelli and His Artists," Cultural Center of Contemporary Art, Polanco, Mexico
"Computers and Art," Everson Museum of Art, Syracuse, New York

1988

"Committed to Print," The Museum of Modern Art, New York City
Hokin Gallery, Bay Harbor Islands, Florida
Penson Gallery, New York City (collaboration with Gianfranco Gorgoni)
Bernice Steinbaum Gallery, New York City
Leo Castelli Gallery, New York City (benefit)
"Gran Pavese: The Flag Project," Museum van Hedendaagse Kunst, Antwerp, Belgium
"Ideas from Individual Impressions and Marks," Lehigh University Art Gallery, Bethlehem, Pennsylvania

1989

"Exposition Inaugurale," Fondation Daniel Templon, Frejus, France

1990

"Divergent Style: Contemporary American Drawing," University College of Fine Arts, University of Florida, Miami, Florida
"The Last Decade: American Artists of the 80s," Tony Sharazi Gallery
"Cornell Collects: A Celebration of American Art from the Collection of Alumni and Friends," Herbert F. Johnson Museum of Art, Cornell University, Ithaca, New York

1991

"Hommage à Jean Tinguely," Klaus Littmann Gallery, Basel, Switzerland
"Myth and Magic in America: the 80s," Museo de Arte Contemporaneo de Monterrey, Monterrey, Mexico
"La Couleur d'Argent," Musée de la Poste, Paris, France
"Biennial," Whitney Museum of American Art, New York
"I Love Art," Watari-Um, Tokyo, Japan
"Compassion and Protest: Recent Social and Political Art from the Eli Broad Family Foundation Collection," San Jose Museum of Art, San Jose, California
"Devil on the Stairs: Looking Back on the 80s," Institute of Contemporary Art, Philadelphia, Pennsylvania
"Echt Falsch," Foundation Cartier, France
"Cruciformed: Images of the Cross since 1980," Cleveland Center for Contemporary Art, Cleveland, Ohio

1992

"Allegories of Modernism," Museum of Modern Art, New York
"The Power of the City/The City of Power," Whitney Museum of American Art, Downtown Branch, New York
"Read My Lips: New York AIDS Polemic," Tramway Gallery, Glasgow, Scotland
"From Media to Metaphor: Art About AIDS," Emerson Gallery, Hamilton College, Clinton, New York; Center of Contemporary Art, Seattle, Washington; Sharadin Art Gallery, Kutztown University, Kutztown, Pennsylvania; Musée d'Art Contemporain de Montreal, Montreal, Canada; Grey Art Gallery and Study Center, New York University, New York City

1993

Socrates Sculpture Park, Long Island City, New York
"Coming from the Subway: New York Graffiti Art," Groninger Museum, Groninger, Holland

"American Art in the Twentieth Century: Painting and Sculpture," Martin Gropius Bau, Berlin, Germany; Royal Academy, London, England
"Art Against AIDS," Peggy Guggenheim Museum, Venice, Italy; Guggenheim Museum Soho, New York City
"Extravagance," Tony Shafrazi Gallery, New York; Russian Cultural Center, Berlin, Germany
"An American Homage to Matisse," Sidney Janis Gallery, New York City

1994

"Outside the Frame," Cleveland Center for Contemporary Art, Cleveland, Ohio
"Power Works from the MCA Collection," Museum of New Zealand, Wellington, New Zealand
"Art's Lament: Creativity in the Face of Death," Isabella Stewart Gardner Museum, Boston, Massachusetts
"New York Realism Past and Present," Tampa Museum of Art, Tampa, Florida and Japan Tour
"Art in the Age of AIDS," National Gallery of Australia
"2X Immortal: Elvis & Marilyn," Institute of Contemporary Art, Boston, Massachusetts, traveled to Contemporary Art Museum, Houston, Texas; Mint Museum of Art, Charlotte, North Carolina; Cleveland Museum of Art, Cleveland, Ohio; Jacksonville Museum of Contemporary Art, Jacksonville, Florida; Portland Museum of Art, Portland, Oregon; Philbrook Museum of Art, Tulsa, Oklahoma; Columbus Museum of Art, Columbus, Ohio; Tennessee State Museum, Nashville, Tennessee; San Jose Museum of Art, San Jose, California; Honolulu Academy of Art, Honolulu, Hawaii
"Significant Losses," University of Maryland Art Gallery
"Keith Haring and Yoko Ono," Ken Frankel Gallery, Palm Beach, Florida
"Cedarhurst Sculpture Park," Mount Vernon, Illinois
"Changin Your Mind: Drugs and the Brain," Museum of Science/Harvard Medical School, Boston, Massachusetts

1995

"In a Different Light," University of California, Berkeley, California
"Matrix is 20!," Wadsworth Athenaeum, Hartford, Connecticut
"A New York Time: Selected Drawings of the 80s," Bruce Museum, Greenwich, Connecticut
"Crossing State Lines; 20th Century Art

from Private Collections in Westchester and Fairfield Counties," Neuberger Museum of Art, Purchase College, Purchase, New York
"Recent 20th Century Acquisitions," The Bass Museum of Art, Miami, Florida
"Male Desire: Homoerotic Images in Twentieth Century American Art," Mary Ryan Gallery, New York City
"Americans in Venice: The Biennale Legacy," Arizona State University Art Museum, Nelson Fine Arts Center, Tempe, Arizona
"Unser Jahrhundert: Menschenbilder—Bilderwelten," Museum Ludwig, Cologne, Germany
"Temporarily Possessed: The Semi-Permanent Collection," The New Museum of Contemporary Art, New York City

1996

"Private Passions," Musée de l'Art Moderne de la Ville de Paris, France
"Thinking Print: Books to Billboards, 1980–95," Museum of Modern Art, New York City
Tony Shafrazi Gallery, New York City
"Ports of Entry: William S. Burroughs & the Arts," Los Angeles County Museum of Art, Los Angeles, California
"Art and Money," Galerie Schoen & Nalepa, Berlin, Germany

Special Projects

1979

Video Clones, video-dance performance with Molissa Fenley, New York City
Organized group shows at Club 57, New York City
Began drawing on blank advertising panels in New York City subway stations

1982

Spectacolor Billboard, Times Square, New York City, a thirty-second animated drawing repeating every twenty minutes for one month
Installation, Paradise Garage, New York City
Printed and distributed 20,000 free posters for June 12 antinuclear rally, Central Park, New York City
Painted fluorescent mural on cement handball court, Houston Street at Bowery, New York City

1983

Artist-in-residence, Montreux Jazz Festival, Montreux, Switzerland
Fabric design for Vivienne Westwood, London, U.K.
Computer graphics album cover for New York City Peech Boys
Painted Fiorucci, Milan, Italy, with LA II
Painted choreographer Bill T. Jones, London, U.K., photographed by Tseng Kwong Chi
Painted murals, Marquette University, Milwaukee, Wisconsin
Painted building in Tokyo, Japan, with LA II
Painted mural on Avenue D, New York City

1984

Painted mural at National Gallery of Victoria, Melbourne, Australia
Painted mural at Collingwood Technical School, Melbourne, Australia
Painted mural at Gallery of New South Wales, Sidney, Australia
Artist-in-residence, Ernest Horn Elementary School, Iowa City, Iowa
"The Kutztown Connection," performances to benefit the New Arts Program, Kutztown, Pennsylvania
"Children's Festaville," artist-in-residence and mural, Walker Art Center, Minneapolis, Minnesota
Artist-in-residence, poster and sticker design, Le Mans, France
Painted candy store murals, Avenue D, New York City
Anti-Litterpig Campaign, created logo for New York City Department of Sanitation
On-site painting, Museum of Modern Art, Rio de Janeiro, Brazil
Painted fishermen's houses, Ilheus, Brazil
Painted mural, Children's Village, Dobbs Ferry, New York
Body-painted Grace Jones, New York City, photographed by Robert Mapplethorpe
Created sixty-second animated commercial for Big, a store in Zurich, Switzerland
Designed set for *Secret Pastures*, Brooklyn Academy of Music, New York, choreographed by Bill T. Jones and Arnie Zane
Painted 4 by 300-foot mural for Asphalt Green Park, New York City
Created First Day Cover and limited edition lithograph to accompany United Nations' stamp issue of November 15 commemorating 1985 as International Youth Year

1985

Organized and curated "Rain Dance," a benefit party and exhibition for the U.S. Committee for UNICEF's African Emergency Relief Fund
Designed set for *Sweet Saturday Night*, Brooklyn Academy of Music, New York
Painted set for *The Marriage of Heaven and Hell*, choreographed by Roland Petit, for the Ballet National de Marseille, Marseilles, France
Created cover illustration and centerfold for *Scholastic News*, reaching an audience of three million American school children, grades one through six
Collaborative poster with Brooke Shields and Richard Avedon
Created 25 by 32-foot backdrop for permanent installation at The Palladium, New York City
Created mural and distributed free T-shirts and balloons for Keith Haring Day at Children's Village, Dobbs Ferry, New York
Hosted painting workshop and distributed free coloring books at the first Children's Worlds Fair celebrating International Youth Year, Asphalt Green Park, New York City
Printed and distributed 20,000 *Free South Africa* posters
Created painting at "Live Aid," July 13, J. F. K. Stadium, Philadelphia, Pennsylvania, to be auctioned with proceeds donated to African Famine Relief
Painted mural on handball court, P.S. 97, New York City
Body-painted Grace Jones for performance at Paradise Garage, New York City
Painted St. Patrick's Daycare Center, San Francisco, California
Designed four watches for Swatch Watch U.S.A.
Children's drawing workshop, Musée d'Art Contemporain, Bordeaux, France

1986

Painted set on MTV during guest appearance of Duran Duran's Nick Rhodes and Simon Le Bon, New York City
Painted permanent murals at Mt. Sinai pediatrics ward, New York City
Collaborated with Brian Gysin on *Fault Lines*
Collaborated with Jenny Holzer on billboards for Vienna Festival '86, Austria
Body-painted Grace Jones for feature film *Vamp*, Los Angeles, California
Painted 90 by 90-foot outdoor mural, Amsterdam, Holland
Children's drawing workshop, Stedelijk Museum, Amsterdam, Holland

Opened Pop Shop retail store, 292 Lafayette Street, New York City

Created background art for RUN DMC/ADIDAS tour poster

Designed set for *The Legend of Lily Overstreet*, featuring Rhodessa Jones, Limbo Theater, New York City

Drawing workshop, Children's Museum of Manhattan, New York City

Collaborated with 1,000 New York City youths on six-story *Citykids Speak on Liberty* banner, dedicated on July 2 for Statue of Liberty centennial celebration, organized by Network International

Created mural for Club DV8, San Francisco, California

Painted *Crack Is Wack* murals, New York City

Painted permanent murals at Woodhull Hospital, Brooklyn, New York

Collaborated with Grace Jones on *I'm Not Perfect* video, Paris, France, and New York City

Painted mural at Jouets & Cie toy store, Paris, France

Painted 350-foot-long mural on Berlin Wall, Germany

Collaborated on outdoor mural with Phoenix, Arizona, school children, Washington and Adams streets, Phoenix, Arizona

1987

Lecture at Yale University, New Haven, Connecticut

Drawing workshop and lecture, Whitney Museum of American Art, Stamford, Connecticut

Drawing workshop with finalists from WNET/13's Student's Art Festival, New York City

Set design and costume concept for *Interrupted River*, choreography by Jennifer Muller, music by Yoko Ono, Joyce Theater, New York City

Painted permanent outdoor mural at Necker Children's Hospital, Paris, France

Designed carousel for "Luna, Luna," a traveling amusement park and art museum organized by André Heller, Hamburg, Germany

Judge in Nippon Object Competition; designed street signs for Parco Company, Tokyo, Japan

Body-painted a model, for cover of *Schweizer Illustrierte*, Monte Carlo, Monaco

Painted permanent mural at Casino Knokke, Knokke le Zoute, Belgium

Participated in "Art Against AIDS," a benefit exhibition curated by Steven Reichard

Painted mural at Museum of Contemporary Art, Antwerp, Belgium

Painted mural for Channel Surf Club, Knokke le Zoute, Belgium

Painted mural at Team BBD&O European Headquarters, Düsseldorf, Germany

Children's drawing workshop at Institute of Contemporary Arts, London, U.K.

Painted mural at Carmine Street public swimming pool, New York City, sponsored by New York City Parks Department

Collaborative mural with Philadelphia Citykids, Pennsylvania, sponsored by Brandywine Arts Workshop

Painted permanent mural, Boys Club of New York, 135 Pitt Street, New York City

Permanent murals and sculpture commission, Schneider Children's Hospital, New Hyde Park, New York

Artist-in-residence and mural installation, Cranbrook Academy of Art Museum, Bloomfield Hills, Michigan

Drawing workshop, Brookside School, Bloomfield Hills, Michigan

Collaborated on two murals and painting workshops with 500 children, Tama City, Japan. Paintings donated to permanent collection of Tama City

Designed album cover, posters, and limited edition silkscreen for A&M Records' *A Very Special Christmas*, proceeds donated to Special Olympics (platinum album, cassette, and compact disc)

1988

Opened Pop Shop Tokyo retail store, Tokyo, Japan

Designed sets and costumes for *Body and Soul*, choreographed by George Faison and produced by André Heller, Munich, Germany

Artist-in-residence, Toledo Museum of Art, Toledo, Ohio

Created poster and spoke public service announcement for Literacy Campaign, sponsored by Fox Channel 5 and New York Public Library-Associations

Easter at the White House, an 8 by 16-foot mural erected on White House lawn, and donated to the Children's Hospital, National Medical Center, Washington, D.C., sponsored by Crayola Company

Lecture and drawing workshops, High Museum of Art, Atlanta, Georgia

Permanent mural, Grady Hospital pediatrics emergency room, Atlanta, Georgia

New York City Ballet 40th Anniversary/American Music Festival: created image for use as poster, program cover, stage projection, and T-shirt

Created First Day Cover and limited edition lithograph to accompany United Nations' stamp issue commemorating 1988 as International Volunteer Year

Painted *Don't Believe the Hype* mural, Houston Street at FDR Drive, New York City

1989

Painted *Together We Can Stop AIDS* mural in Barrio de Chino, Barcelona, Spain

Designed invitations and plates for Gloria von Thurn und Taxis's birthday celebration, Regensburg, Germany

Designed mural to be executed by students at Wells Community Academy, Chicago, Illinois

Artist-in-residence for Chicago Public Schools. Museum of Contemporary Art mural project: painted 500-foot-long mural with 300 high-school students, Chicago, Illinois

Painted two murals at Rush Presbyterian–St. Luke's Medical Center, Chicago, Illinois

Designed logo and T-shirts for Young Scientist's Day at Mt. Sinai School of Medicine, New York City

Artist-in-residence and mural project, Ernest Horn Elementary School, Iowa City, Iowa

Painted mural at the Center, a lesbian and gay community services center, New York City

"Keith Haring Progetto Italia": commissioned by the City of Pisa to paint permanent mural on exterior wall of Sant' Antonio Church, June 14-20

Painted permanent mural at Princess Grace Maternity Hospital, Monte Carlo, Monaco

Painted banner intended for airship to be flown over Paris as part of Galerie Celeste, a project with Soviet painter Eric Bulatov commemorating the bicentennial of the French Revolution. Complications eventually prevented the launch of the airship

1990

Created First Day Cover and limited edition lithograph to accompany United Nations' stamp issue of March 16 commemorating 1990 as Stop AIDS Worldwide Year

Selected Bibliography

Books and Catalogues

1982

Tony Shafrazi Gallery, New York. *Keith Haring*. Texts by Robert Pincus-Witten, Jeffrey Deitch, and David Shapiro. New York: Tony Shafrazi Gallery.

Galerie 't Venster, Rotterdam. *Vernon Fisher, Keith Haring*. Text by Richard Flood. Rotterdam: Galerie 't Venster.

Hallwalls, Buffalo, New York. *Agitated Figures: The New Emotionalism*. Buffalo: Hallwalls.

Marlborough Gallery, New York. *The Pressure to Paint*. Text by Diego Cortez. New York: Marlborough Gallery.

Haring, Keith. *Keith Haring*. Appearances Press.

documenta. Kassel: documenta GmbH.

1983

Tony Shafrazi Gallery, New York. *Champions*. Text by Tony Shafrazi. New York: Tony Shafrazi Gallery.

Centre d'Estudis d'Art Contemporani, Barcelona. *Tendencias en Nueva York*. Text by Carmen Gimenez. Barcelona: Centre d'Estudis d'Art Contemporani.

Kunstmuseum, Lucerne, Rheinisches Landesmuseum, Bonn, and Württembergischer Kunstverein, Stuttgart. *Back to the USA: Amerikanische Kunst der siebziger und achtziger Jahre*. Texts by Klaus Honnef and Barbara Kuckels. Cologne: Rheinland Verlag.

1984

Pittsburgh Center for the Arts. Text by Fidel Marquez, photographs by Tseng Kwong Chi. Pittsburgh.

Palazzo della Esposizioni, Rome, and Galleria Communale d'Arte Moderna, Bologna. *Arte di Frontiera: New York Graffiti*. Texts by Franco Solmi, Francesca Alinovi, Tony Shafrazi, and Roberto Daolio. Milan: Mazzotta.

San Francisco Museum of Modern Art. *The Human Condition: SFMMA Biennial III*. Texts by Henry Hopkins and Dorothy Martinson. San Francisco.

Institute of Contemporary Art, University of Pennsylvania, Philadelphia. *Keith Haring*. Philadelphia: The Institute.

Villa Campolieto, Ercolano. *Terrae Motus*. Texts by Michele Bonuomo, David Robbins, Barbara Rose, and Diego Cortez. Ercolano: Fondazione Amelio.

Hirshhorn Museum and Sculpture Garden, Washington, D.C. *Content: A Contemporary Focus, 1974 - 1984*. Texts by Howard Fox, Miranda McClintic, and Phyllis Rosenzweig. Washington, D.C.: Smithsonian Institution Press.

The Museum of Modern Art, New York. *"Primitivism" in 20th Century Art: Affinity of the Tribal and the Modern*. Text by William Rubin. New York: The Museum of Modern Art.

Freeman, Phyllis, Eric Himmel, Edith Pavese, and Anne Yarowsky, eds. *New Art*. New York: Abrams.

Hagenberg, Roland. *Untitled 84*. Introduction by Robert Pincus-Witten. New York: Pelham Press.

Hager, Steven. *Hip Hop: The Illustrated History of Break Dancing, Rap Music, and Graffiti*. New York: St. Martin's Press.

Haring, Keith. *Art in Transit: Subway Drawings*. New York: Harmony Books.

1985

Lee, Marshall. *Art at Work: The Chase Manhattan Collection*. New York: E.P. Dutton/International Archive of Art.

Gorgoni, Gian Franco. *Beyond the Canvas: Artists of the Seventies and Eighties*. Introduction by Leo Castelli. New York: Rizzoli.

Warhol, Andy. *America*. New York: Harper and Row.

Belsito, Peter, ed. *Notes from the Pop Underground*. Berkeley: Last Gasp of San Francisco.

Musée d'Art Contemporain, Bordeaux. *Keith Haring: Peintures, Sculptures et Dessins*. Text by Sylvie Couderc. Bordeaux: CAPC.

Centre d'Art Contemporain, Marseilles. *New York 85*. Texts by Marcelin Pleynet, Roger Pailhas, and Jean-Louis Marcos. Marseilles: ARCA, Centre d'Art Contemporain.

1986

Hunter, Sam, ed. *An American Renaissance: Painting and Sculpture since 1940*. New York: Abbeville Press.

Palau, Silvio Marinez. *Made in the USA: Estudio en Naturealezas Muertas*. Drawings by Keith Haring. Hanover,

New Hampshire: Ediciones del Norte.

Stedelijk Museum, Amsterdam. *Keith Haring 1986: Paintings, Drawings, and a Vellum*. Texts by Wim Beeren, Rini Dippel, and Dorine Mignot. Amsterdam: Stedelijk Museum.

Hager, Steven. *Art after Midnight: The East Village Scene*. New York: St. Martin's Press.

The Corcoran Gallery of Art, Washington, D.C. *The Generic Figure*. Washington D.C.: The Corcoran Gallery.

Input/Output. Alexandria, Virginia: Time-Life Books.

Tony Shafrazi Gallery, New York. *What It Is*. Text by Wilfried Dickhoff. New York: Tony Shafrazi Gallery.

Haring, Keith. *Art in Transit* [Japanese edition]. Tokyo: Kawade Shobo Shinsha.

1987

Los Angeles County Museum of Art. *Avant-Garde Art in the Eighties*. Text by Howard Fox. Los Angeles: County Museum of Art.

A 11 Art Forum Thomas, Munich, and Ausstellungshallen Mathildenhöhe, Darmstadt. *Kunst aus den achtziger Jahren*. Texts by Janina Forell-Briggs and Rosmarie Schulz. Munich: A 11 Art Forum Thomas.

Institute of Contemporary Arts, London. *Comic Iconoclasm*. Text by Sheena Wagstaff. London: ICA.

Centre Georges Pompidou, Musée National d'Art Moderne, Paris. *L'Epoque, la Mode, la Morale, la Passion: Aspects de l'Art d'Aujourd'hui, 1977 - 1987*. Texts by Bernard Blistene, Catherine David, and Alfred Pacquement. Paris: Le Musée.

Goodman, Cynthia. *Digital Visions: Computers and Art*. New York: Abrams.

Westfälisches Landesmuseum für Kunst und Kulturgeschichte, Münster. *Skulptur Projekte in Münster 1987*. Ed. Klaus Bussman and Kasper König. Cologne: DuMont.

Heller, André, and Hilde Spiel. *Luna Luna*. Munich: Wilhelm Heyne.

1988

Cameron, Dan. *Keith Haring 1988*. Van Nuys, California: Martin Lawrence Limited Editions.

Mayor Rowan Gallery, London. *Collaborations: Andy Warhol, Jean-Michel Basquiat*. Introduction by Keith Haring.

London: Mayor Rowan Gallery.

Rosenblum, Robert. *The Dog in Art from Rococo to Post-Modernism.* New York: Abrams.

Haring, Keith. *Apocalypse.* Text by William S. Burroughs. New York: George Muldar Fine Arts.

1989

Haring, Keith. *Keith Haring: Eight Ball.* Kyoto: Kyoto Shoin International.

1990

La Galerie de Poche, Paris. *Keith Haring.* Paris: La Galerie.

Tony Shafrazi Gallery, New York. *Keith Haring: A Memorial Exhibition — Early Works on Paper.* Text by Tony Shafrazi. New York: Tony Shafrazi Gallery.

Philip Samuels Fine Art, St. Louis, Missouri. *Keith Haring.* St. Louis, Missouri: Philip Samuels Fine Art.

Illinois State University Art Galleries, Normal, Illinois. *Keith Haring: Future Primeval.* Texts by Barry Blinderman and William S. Burroughs. Normal, Illinois. Reprinted 1992 as *Keith Haring,* New York: Abbeville Press.

Gallery 56, Geneva. *K. Haring.* Text by Sam Havadtoy. Geneva.

Haring, Keith. *Against All Odds.* Rotterdam: Bebert Publishing, with Mr. & Mrs. Donald Rubell, New York.

Galerie Nikolaus Sonne, Berlin. *Subway Drawings.* Texts by Nikolaus Sonne and Christian Holzfuss. Berlin: Edition Achenbach.

Tony Shafrazi Gallery, New York. *The Last Decade: American Artists of the 80s.* Texts by Robert Pincus-Witten and Collins & Milazzo. New York: Tony Shafrazi Gallery.

1991

Gruen, John. *Keith Haring: The Authorized Biography.* New York: Prentice Hall Press.

Watariumu Museum, Tokyo. *I Love Art.* Text by Etsuko Watario. Tokyo: Watari-um.

Echt Falsch. Milan: Mondadori.

Museo de Arte Contemporaneo, Monterrey. *Myth and Magic in America: The Eighties.* Ed. Guillermina Olmedo. Monterrey, Mexico.

The Art of Mickey Mouse. Text by John Updike. New York: Hyperion.

Meller, Susan, and Joost Elffers. *Textile Designs: Two Hundred Years of European and American Patterns for Printed Fabrics.* New York: Abrams.

Musée de la Poste, Paris. *Les Couleurs de l'argent.* Paris.

Whitney Museum of American Art, New York. *1991 Biennial Exhibition.* New York: Whitney Museum of American Art and W. W. Norton & Co.

Institute of Contemporary Art, University of Pennsylvania, Philadelphia. *Devil on the Stairs: Looking Back on the Eighties.* Text by Robert Storr. Philadelphia: The Institute.

Compassion and Protest: Recent Social and Political Art from the Broad Family Collection. New York: Cross River Press.

Cleveland Center for Contemporary Art, Cleveland. *Cruciformed: Images of the Cross since* 1980. Cleveland, Ohio.

In the Vernacular: Interviews at Yale with Sculptors of Culture. Jefferson, North Carolina: McFarland

1992

Atkins, Robert, and Thomas W. Sokolowski. *From Media to Metaphor: Art About AIDS.* New York: Independent Curators, Inc.

Keith Haring. Texts by Barry Blinderman and William S. Burroughs. New York: Abbeville Press. Reprint of Illinois State University Art Galleries exhibition catalogue *Keith Haring: Future Primeval,* 1990.

The Museum of Modern Art, New York. *Allegories of Modernism.* Text by Bernice Rose. New York: The Museum of Modern Art.

Whitney Museum of American Art, New York. *The Power of the City/ The City of Power.* Texts by Christel Hollevoex, Karen Jones, and Timothy Nye. New York: Whitney Museum of American Art.

Kurtz, Bruce D., ed. *Keith Haring, Andy Warhol, and Walt Disney.* Munich: Prestel-Verlag, and Phoenix, Arizona: Phoenix Art Museum.

Germano Celant. *Keith Haring.* Munich: Prestel-Verlag.

Groninger Museum, Groningen. *Coming from the Subway.*

1993

Mitsukoshi Museum of Art, Tokyo. *Keith Haring: A Retrospective.* Germano Celant.

Littmann, Klaus and Werner Jehle. *Keith Haring, Complete Editions on Paper, 1982-1990.* Stuttgart: Cantz Publishing.

1994

Celant, Germano. *Keith Haring.* Exhibition Catalogue — Italian, Swedish, German, Hebrew/English and Spanish Editions. Milan: Charta Publishing.

1995

Andre Emmerich Gallery, New York. *Keith Haring: Works on Paper 1989.* Text by Alexandra Anderson-Spivy. New York City: Estate of Keith Haring.

In a Different Light: Visual Culture, Sexual Identity, Queer Practice. San Francisco: City Lights Books.

Irish Museum of Modern Art, Dublin. *From Beyond the Pale: Art and Artists at the Edge of Consensus.*

Museum Ludwig, Cologne. *Unser Jahrhundert. Menschenbilder – Bilderwelten.* Ed. Marc Scheps. Munich: Prestel-Verlag.

Lenbachhaus, Kunstbau, Munich and Kunstmuseum Bern. *Mit dem Auge des Kindes.* Ed. Jonathan Fineberg. Stuttgart: Verlag Gerd Hatje.

The New Museum of Contemporary Art, New York City. *Temporarily Possessed: The Semi-Permanent Collection.*

1996

Keith Haring Journals. Preface by David Hockney. Introduction by Robert Farris Thompson. New York: Viking-Penguin.

Museum Fridericianum, Kassel. *Keith Haring: The Ten Commandments.* Introduction by Tilman Osterwold, and various texts.

1997

Whitney Museum of American Art, New York. *Keith Haring.* Foreword by David A. Ross. Essays by Elisabeth Sussman, David Frankel, Jeffrey Deitch, Ann Magnuson. Robert Farris Thompson, Robert Pincus Witten. New York: Little, Brown (Bullfinch).

Keith Haring Journals. (Paperback edition). Preface by David Hockney. Introduction by Robert Farris Thompson. New York: Penguin USA.

Articles

1981

Marzorati, Gerald. "Sign of the Times." *Soho News,* May 13.

Blinderman, Barry. "Keith Haring's Subterranean Signatures" [interview]. *Arts Magazine* 56 (September), pp. 164-65.

"Chalkman Meets Eraserhead." *Westsider.*

Ricard, Rene. "The Radiant Child." *Artforum* 20 (December), pp. 35-43.

1982

Alinovi, Francesca. "Arte di frontiera." *Flash Art* [Italy] (February/March), pp 22-26.

Storr, Robert. [Exhibition review: Hal Bromm Gallery, New York]. *Art in America* 70 (March), p. 144.

Duyvis, Paul. *Museum Journal.*

Morera, Daniela. *L'Uomo Vogue* (May).

De Ak, Edit, and Diego Cortez. "Discorsi infantili." *Flash Art* [Italy] (May), pp. 49-53.

De Santis, Tullio Francesco. *Reading Eagle.*

Henry, G. "Keith Haring: Subways Are For Drawing." *Print Collector's Newsletter* 13 (May/June), p. 48.

Norklun, Kathi. *Los Angeles Weekly,* June 4.

Kates, Brian. "Beneath the Ground, Chalking It Up to Art." *New York Daily News,* June 2, p. M3.

Glueck, Grace. *New York Times,* June 12.

Anderson, Alexandra. "Vignettes: Keith Haring — 'I'd Rather Draw.'" *Portfolio* 4, no. 4 (July/August), p. 8.

Rose, Barbara. "Talking about … Art." *Vogue* 172 (August), p. 120.

Goldstein, Richard. "Art Beat: Elite in the Street." *The Village Voice,* September 21, p. 37.

Gablik, Suzi. "Report from New York: The Graffiti Question." *Art in America* 70 (October), pp. 33-39.

Nadelman, Cynthia. "Graffiti is a Thing that's Kind of Hard to Explain." *Artnews* 81 (October), pp. 76-77.

Frackmann, Noel, and Ruth Kaufmann. "Documenta 7: The Dialogue and a Few Asides." *Arts Magazine* 57, no. 2 (October), pp. 91-97.

Hager, Stephen. "Keith Haring: Graffiti from the Ground Up" [interview]. *The East Village Eye* 4, no. 26 (October), pp. 8-9.

"Art and Accessories: Twelve Original Works of Art for Twelve Original Shoes" [Keith Haring for Mark Balet and Robert Becker]. *Interview* 12, no. 10 (October), pp. 65-72.

Moufarrege, Nicholas A. "Lightning Strikes (not Once but Twice): An Interview with Graffiti Artists." *Arts Magazine* 57, no. 3 (November), pp. 87-93.

Stapp, Duane. "Beast: Animal Imagery" [exhibition review: P.S. 1, New York]. *Arts Magazine* 57, no. 4 (December), p. 10.

1983

De Ak, Edit, and Lisa Liebmann. [Exhibition review: Tony Shafrazi Gallery, New York]. *Artforum* 21 (January), pp. 79-80.

[Exhibition review: Tony Shafrazi Gallery, New York]. *Artnews* 82 (January), pp. 145-46.

Hapgood, Susan. "Irrationality in the Age of Technology." *Flash Art* 110 (January), pp. 41-43.

Ashberry, John. "Biennials Bloom in the Spring." *Newsweek* 101, no. 16 (April 18), pp. 93-94.

Anderson, A. [Exhibition review: Fun Gallery, New York]. *Flash Art* 112 (May), p. 61.

"New York Aktuell: Das Ende der amerikanischen Ära." *Kunstforum* (May), pp. 142-50.

[Exhibition review: Lucio Amelio gallery, Naples]. *Domus* 641 (July/August), p. 68.

Lipton, Amy. "American Graffiti" [interview]. *Heavy Metal* 7, no. 5 (August), pp. 6-8.

"Tintin." *Decoration International* (September).

Hershkovits, D. "Art in Alphabetland." *Artnews* 82 (September) p. 90.

Moufarrege, Nicholas A. "The Mutant International." *Arts Magazine* 58, no. 1 (September), pp. 120-25.

Smith, Roberta. "Critical Dealings." *The Village Voice,* September 13, p. 71.

Heit, Janet. "The Comic Art Show" [exhibition review: Whitney Downtown, New York]. *Arts Magazine* 58, no. 2 (October), p. 9.

Cornand, Brigitte. "Haring Crayonne ses Bebettes Partout." *Actuel* (October).

"Books and Records" [record review: *A Side, B Side* (artwork by Keith Haring)]. Domus 643 (October), n. p.

Alinovi, Francesca. "Twenty-First Century Slang: Keith Haring — Interview with the Artist." *Flash Art* 114 (November), pp. 23-31.

Fawcett, Anthony, and Jane Withers. *The Face* (November).

"Room with a View." *Interview* 13, no. 11 (November), p. 69.

Los Angeles Times, Nov. 12, sec. IA, p. 6.

Finch, Liz. *Art Beat* (December).

Licitra Ponti, L. "Keith Haring" [interview]. *Domus* 645 (December), pp. 72-73.

De Santis, Tullio Francesco. *Reading Eagle* (December).

Fawcett, Anthony, and Jane Withers. [Exhibition review: Robert Fraser Gallery, London]. *Studio International* 196, no. 1003 (December), p. 50.

Romine, John. *Upstart* (December).

Small, Michael. "Drawings on Walls, Clothes and Subways: Keith Haring Earns Favor with Art Lovers High and Low." *People* 20 (December 5), pp. 147-51.

Brenson, Michael. [Exhibition review: Tony Shafrazi Gallery, New York]. New York Times, December 16, sec. III, p. 30.

Tallmer, Jerry. "Onto the Black, the Zap of Art" [exhibition review: Tony Shafrazi Gallery, New York]. *New York Post,* December 24, p. 12.

Calendar Magazine [Japan], nos. 4-7, cover.

1984

Reading Eagle, January 1.

Licitra Ponti, L. "Gli Americani a Milano Ottobre 1983" [interview]. *Domus* 646 (January), pp. 70-71.

Dimitrijevic, N. [Exhibition review: Robert Fraser Gallery, London]. *Flash Art* 116 (January), p. 39.

Raynor, Vivien. [Exhibition review: Katonah Gallery]. *New York Times,* January 29, sec. XXII, p. 20.

"Graffiti: Von der U-Bahn ins Museum." *Art: Das Kunstmagazin* 96, no. 2 (February), pp. 40-49 and cover.

Panicelli, Ida. "Latitudine Napoli New York" [exhibition review: Lucio Amelio gallery, Naples]. *Artforum* 22 (February), p. 88.

[Keith Haring: *A 1984 Valentine,* reproduction]. *Vanity Fair* (February), cover.

Ponti, Lisa Licitra. *Wolkenkratzer* (February/March).

Linker, Kate. [Exhibition review: Tony Shafrazi Gallery, New York]. *Artforum* 22 (March), p. 93.

Perrone, Jeff. "Porcelain and Pop." *Arts Magazine* 58, no. 7 (March), pp. 80-82.

"Keith Haring." *Flash Art* 116 (March), pp. 20-24.

Parmesani, L. "Significant Celebrations: Haring, Cutrone, Scharf, Brown" [exhibition review: Galleria Salvatore Ala], *Flash Art* 116 (March), p. 32.

Moufarrege, Nicholas A. [Exhibition review: Tony Shafrazi Gallery, New York]. *Flash Art* 116 (March), p. 39.

Collier, C. "Sub (way) Art" [exhibition review: Robert Fraser Gallery, London]. *Studio International* 97, no. 1006 (March), p. 48.

Broner, Kaisa. "Keith Haring: eli tayd ellisen onnistumisen taito" [interview]. *Taide* 25 (March), pp. 34-39.

Lukas, Isabel. "The Busy Life of a Wall-to-Wall Artist." *Sydney Morning Herald,* March 2, p. 2.

Reynard, Delphine. "Graffiti-Writers, Graffiti-Artists." *Art Press* 81 (May), p. 8ff.

Lovelace, Carey. "Graffiti-ist Chalks Up Art Stardom." *Los Angeles Times,* May 13, p. C6.

Dawetas, Demosthene. *Libération* [France], May 31.

Angeius, Margherita. *Viva Milano* (June), cover.

Pini, Francesca. *Amici*, June 6.

"Wenn Künstler ihren Bildern Beine machen." *Stern*, June 20, pp. 20-38.

Robinson, Walter, and Carlo McCormick. "Slouching Toward Avenue D: Report from the East Village." *Art in America* 72, no. 6 (Summer), pp. 156-59.

Grazioli, Elio. "Vita, morte e miracoli dell' arte." *Flash Art* [Italy] (Summer), pp. 17-21.

Trini, Tommaso. *Flash Art* [Italy] (Summer), pp. 26-27.

Angelus, Margherita. *Alter* (July).

Crawford, Ashley. *Tension* 4 (July/August), cover.

The Face (August).

Salholz, Eloise. "Art in the Showroom." *Newsweek* 104, no. 7 (August 13), pp. 70-71.

Small, Michael. "Art after Midnight." *People* 22 (August 20), p. 99.

"Sixties." *Brutus* (September).

Decoration International (September).

Morera, Daniela. *Vogue* [Italy] (September).

Foltz, Kim, and Maggie Malone. "Golden Paintbrushes." *Newsweek* 104 (October 15), pp. 82-83.

Mulcahy, Susan. "Page Six: Haring's Atomic Babies Go Legit." *New York Post*, November 21, p. 6.

Van Damme, Leo. *Artefactum* (November/December).

Panicelli, Ida. [Exhibition review: Galleria Salvatore Ala, Milan]. *Artforum* 23 (December), p. 97.

"Keith Haring with Halston and Philip Johnson" [interview]. *Interview* 14, no. 12 (December), pp. 129-32.

Cook, Karen. "Little Shop of Harings." *Manhattan Inc.* (December).

Vinyl (December).

1985

Haring, Keith. [Interview: Kenny Scharf]. *Flash Art* 120 (January), pp. 14-17.

Weinstein, Jeff. "No Criterion." *The Village Voice*, January 8, pp. 30-32.

Art and Antiques (February).

Gardner, Paul. "The Electronic Palette." *Artnews* 84 (February), pp. 66-73.

McGuigan, Cathleen. "New Art, New Money: The Marketing of an Artist." *New York Times*, February 10, sec. X, pp. 20-35, 74.

Metropolitan Home (April).

McGuigan, Cathleen. "A Garden of Disco Delights." *Newsweek* 105 (May 20), p. 76.

McCormack, Ed. "Pop goes the Easel." *New York Daily News*, August 4, Sunday Magazine, p. 10ff.

Ratcliff, Carter. "Dramatis personae: The Scheherazade Tactic." *Art in America* 73 (October), p. 9ff.

Gardner, Paul. "When Is a Painting Finished?" *Artnews* 84 (November), pp. 89-99.

Raynor, Vivien. [Exhibition review: Leo Castelli Gallery, New York]. *New York Times*, November 8, sec. III, p. 26.

McGill, Douglas. "Art People" [interview]. *New York Times*, November 8, sec. III, p. 33.

Actuel (December).

Span, Paula. "Subways to Museums: Graffiti's Scrawl of Success." *Washington Post*, December 30, pp. D1-2.

Westfall, Stephen. "Surrealist Modes among Contemporary New York Painters." *Art Journal* 45 (Winter), pp. 315-18.

1986

"Neue Aktualität des Portraits." *Art: Das Kunstmagazin* (January), pp. 20-39.

Handy, Ellen. [Exhibition review: Leo Castelli Gallery, New York]. *Arts Magazine* 60, no. 5 (January), p. 134.

[Illustration]. *Playboy* (January).

[Photograph]. *New York Times*, January 19, sec. I, p. 1.

[Photograph]. *Los Angeles Times*, January 20, sec. II.

Tallmer, Jerry. *New York Post*, January 20.

Kuspit, Donald. [Exhibition review: Tony Shafrazi Gallery, Leo Castelli Gallery, New York]. *Artforum* 24 (February), pp. 102-3.

Poirier, Maurice. [Exhibition review: Tony Shafrazi Gallery, Leo Castelli Gallery, New York]. *Artnews* 85 (February), pp. 120-21.

Lebovici, Elisabeth. *Beaux Arts Magazine* (February).

Decoration International (February).

Cotter, Holland. [Exhibition review: Tony Shafrazi Gallery, Leo Castelli Gallery, New York]. *Flash Art* 126 (February/March), p. 48.

Lessem, Don. *TWA Ambassador Magazine* (March).

Stout, Mira. "Bordeaux Nouveau." *Vanity Fair* (March), pp. 68-69.

Cox, Christopher. *U.S. Magazine*, March 10.

Revson, James. "Little Shop of Harings, Haring's Gift: Gifts." *New York Newsday*, April 18, sec. II, pp. 2-3.

Slesin, Suzanne. "An Artist Turns Retailer." *New York Times*, April 18, sec. I, p. 22.

Trebay, Guy. "The Look: Keith Haring's Pop Shop." *The Village Voice*, May 6, p. 92.

Gilbert, Leslie. "From the Subways to his own Pop Shop: Haring has Arrived." *Advertising Age*, May 19, p. 54.

Anderson, Susan Heller, and David Dunlap. *New York Times*, May 28, sec. II, p. 4.

Radakovich, Anka. "Keith Haring Tells You How to Put the Writing on Your Walls." *New York Post*, May 29, pp. 25-26.

Cronin, Dan. *New York Daily News*, May 30.

Verzotti, Giorgio. "Portrait of the Artist as an Infant." *Flash Art* 128 (May/June), pp. 42-45.

Schneller, Johanna. "Subterranean Cool: Why I Wear What I Wear" [interview]. *Gentleman's Quarterly* 56, no. 6 (June), p. 43ff.

Jones, Alan. *New York Talk* (June), cover.

Gardner, Colin. [Exhibition review]. *Los Angeles Times*, June 20, sec. VI, p. 13.

Haygood, William. *Boston Globe*, July 3.

[Biography]. *Current Biography* (August), pp. 197-200.

Zimmer, William. [Exhibition review: Real Art Ways, Hartford, Connecticut]. *New York Times*, August 3, sec. XXIII, p. 20.

Howe, Marvine, and Frank J. Prial. *New York Times*, September 19, sec. II, p. 3.

Donato, Marla. "Hanging Out." *Chicago Tribune*, October 1, pp. 30-32.

Howe, Marvine, and Kathleen Teltsch. *New York Times*, October 2, sec. II, p. 5.

Johnson, Richard. "Page Six: Crack is Wack is Back." *New York Post*, October 4, p. 6.

New York Times, October 4, sec. I, p. 28.

Seaman, Debbie. "Haring's Exacting Approach." *Adweek*, October 13, p. 44.

New York Post, October 24.

New York Times, October 24, sec. III, p. 9.

Findlay, Catherine. "Shop Till You Drop." *Travel & Leisure* 16, no. 11 (November), pp. 124-31.

Andersen, Kurt. "Pop Goes the Culture." *Time*, November 3, p. 46.

Garcia, Guy D. "People." *Time*, November 3, p. 51.

Small, Michael. "For a Few Fleeting Hours Keith Haring Makes a Bright Canvas of the Berlin Wall." *People* 26 (November 10), pp. 52-55.

Kimmelman, Michael. *Philadelphia Inquirer Sunday Magazine*, November 23.

Bass, Ruth. "'Crack Is Wack' Is Back." *Artnews* 85 (December), p. 11.

Saban, Stephen. "Word [Absolute Haring at the Whitney]." *Details* 5, no. 6 (December), p. 52.

Bryan, Susan McKearney. *Phoenix Republic*, December 17.

Goodwin, Betty. *Los Angeles Times*, December 19.

1987

"Arts 'n' Language." *New York Daily News*, January 18, Magazine sec., p. 6.
Mejias, Jordan. *Frankfurter Allgemeine*, Weekend Magazine, January 30.
Pely-Audan, Annick. [Exhibition review: Galerie Daniel Templon, Paris]. *Cimaise* 34 (January/February), p. 81.
Smith, Roberta. [Exhibition review: Tony Shafrazi Gallery, New York]. *New York Times*, February 20, sec. III, p. 23.
Reed, Julia. "To Be Rich, Famous, and an Artist." *U.S. News & World Report*, March 9, pp. 56-57.
Yale Vernacular (March/April), cover.
Cameron, Dan. [Exhibition review: Tony Shafrazi Gallery, New York]. *Flash Art* 134 (May), pp. 86-87.
Valenti, Chi Chi. *Men's Look* (May).
Frey, Lilith, and Alberto Venzago. Kunst am Körper: mal mich an." *Schweizer Illustrierte* 23 (June 1), pp. 24-36.
New York Times, August 12, sec. II, p. 3.
Sharratt, Philip. *Sky Magazine*, August 13.
Carper, Alison. "Muralist Takes Art to Wall." *New York Newsday*, August 21, p. 4ff.
Dowling, Claudia Glenn. "Loony Luna Luna: This Antic Amusement Part Will Raise Your Artbeat." *Life* 10 (September), pp. 76-79.
Miro, Marsha. *Detroit Free Press*, September 25.
"Notes" [exhibition review: Casino Knokke, Knokke le Zoute, Belgium]. *Artscribe* 65 (September/October), p. 13.
Von Waberer, Keto. "Keith Harings weltweite Duftmarken." *Esquire* [Germany] (November), pp.100-6.
Beaumont, Mary Rose. [Exhibition review: Alexander Roussos Gallery, London]. *Art Review* 39 (December 18), pp. 891-92.

1988

Saunders, D. J. "Pop Artist's New Work Is Nice Read." *New York Daily News*, March 30, p. M1.
Berens, Jessica. "In Warhol's Footsteps." *House & Garden* 160, no. 4 (April), pp. 35-36.
New York Post, March 30.
"Newsmakers: Subways Are for Reading." *Newsweek* 111, no. 15 (April 11), p. 54.
Los Angeles Times, June 10, sec. VI, p. 12.
Gross, Michael. "Social Notes." *New York Magazine* 21, no. 26 (June 27), pp. 30-38.
Drenger, Daniel. "Art and Life: An Interview with Keith Haring." *Columbia Art Review* (Spring 1988), pp. 44-52.
Pareles, Jon. *New York Times*, September 11, sec. II, p. 1.
Drenger, Daniel. *Wiener*, October 10.
Haring, Keith. "Remembering Basquiat." *Vogue* 178 (November), pp. 230-34.
Levin, Kim. "Voice Choices." *The Village Voice*, December 20, p. 66.
Hess, Elizabeth. "On Track." *The Village Voice*, December 27, p. 97.

1989

Bass, Ruth. [Exhibition review: Tony Shafrazi Gallery, New York]. *Artnews* 88 (March), pp. 172-73.
Pogatchnik, Shawn. "High School Art Students Brush Up Their Talents on Grant Park Mural." *Chicago Tribune*, May 18, sec. 2C, p. 5.
Svetvilas, Kanchalee. *Iowa Press Citizen*, May 23.
Cummings, Paul. "Interview: Keith Haring Talks with Paul Cummings." *Drawing* 11 (May/June), pp. 7-12.
Leigh, Christian. [Exhibition review: Tony Shafrazi Gallery, New York]. *Flash Art* 146 (May/June), pp. 132-33.
Couturier, Elisabeth. "Les Gens." *Paris Match*, August 3.
Eauclaire, Sally. "Artist, Writer Stir Brew of the Uncanny, Familiar" [exhibition review: *Apocalypse*, Gallery Sin Nombre, Santa Fe]. *Albuquerque Journal*, August 4, p. C1 ff.
Sheff, David. "Keith Haring: An Intimate Conversation" [interview]. *Rolling Stone*, August 10, pp. 58-66.
Guglielmo, Connie, and Suzanne Weber. "Keith Haring Meets his Mac." *MacWEEK* 3, no. 33 (September 19), pp. 56, 60.
Hamilton, Denise. "Artist with AIDS Races the Clock to Spread his Message." *Los Angeles Times*, December 1, p. F11.
Walker, Christian. "Ritts, Haring Feel the Lure of Physical Graffiti" [exhibition review: Fay Gold Gallery, Atlanta]. *Atlanta Constitution*, Dec. 15, p. G2.

1990

Arnault, Martine. "The Hectic World of Keith Haring" [exhibition review: Galerie 1900-2000, Paris]. *Cimaise* 37 (January/March), pp. 137-40.
"Keith Haring, 31" [obituary]. *Boston Globe*, February 17, p. 52.
"Keith Haring: Subway Pop Graffiti Artist" [obituary]. *Los Angeles Times*, February 17, p. A36.
Yarrow, Andrew L. "Keith Haring, Artist, Dies at 31: Career Began in Subway Graffiti." *New York Times*, February 17, sec. I, p. 33.
"Keith Haring: Popular Mural Artist" [obituary]. *San Francisco Chronicle*, February 17, p. C 12.
"Keith Haring, N.Y. Artist, Dies." *Washington Post*, February 17, p. B6.
Wilson, William. "Keith Haring: Another Artistic Voice Silenced." *Los Angeles Times*, February 19, p. F3.
"Keith Haring, 31, New York Artist" [obituary]. *Washington Times*, February 19, p. B4.
"World-Wide: Died — Keith Haring." *Wall Street Journal*, February 20, p. A1.
Miro, Marsha. "Death Stills Keith Haring's Childlike, Innocent Vision." *Detroit News and Free Press*, Feb. 25, p. K3.
Yasui, Todd Allan. "Keith Haring's Imprint on Life." *Washington Post*, February 26, p. C7.
Aletti, Vince. "Keith Haring, 1958-1990" [obituary]. *The Village Voice*, February 27, p. 3.
"Keith Haring, the Bad Boy Master of Wriggly Urban Art, Leaves a Legacy of Courage and Heart" [obituary]. *People* 33, no. 9 (March 5), p. 94.
Scharf, Kenny. "Keith Haring Remembered" [obituary]. *Interview* 20, no. 4 (April), p. 157.
Degener, Patricia. "Keith Haring." *St. Louis Post-Dispatch*, April 18, p. E1.
Thompson, Robert Farris. "Requiem for the Degas of the B-Boys (Keith Haring)." *Artforum* 28 (May), pp. 135-41.
Yarrow, Andrew. "Friends Memorialize Keith Haring in Song and Playful Reminiscence." *New York Times*, May 5, sec. I, p. 31.
Deitcher, David. "Crossover Dreams." *The Village Voice*, May 15, pp. 107-11.
Goldstein, Richard. "My Keith Harings – and Ours." *The Village Voice*, May 15, p. 113.
Dieckmann, Katherine. "Tag Team." *The Village Voice*, May 15, pp. 114-15.
Trebay, Guy. "Parting Gestures." *The Village Voice*, May 15, p. 116.
Caley, Shaun. "Keith Haring" [interview]. *Flash Art* 153 (Summer), pp. 124-29.
"In Search of the Real Haring." *Newsweek* 116 (August 18), p. 68.
Rubell, Jason. "Keith Haring: The Last Interview." *Arts Magazine* 65, no. 1 (September), pp. 52-59.
Lacayo, Richard. "Keith Haring: The Legacy Lives On." *Metropolitan Home* 122, no. 9 (September), pp. 97-102.
Kimmelman, Michael. "A Look at Keith Haring, Especially on the Graffiti" [exhibition review: *Future Primeval*,

Queens Museum, New York]. *New York Times*, September 21, p. C19.

Hess, Elizabeth. "Quick Draw" [exhibition review: *Future Primeval*, Queens Museum, New York]. *The Village Voice*, October 9, p. 101.

Kenner, Robert. "Sketchbook: Haring Hoaxes." *Art and Antiques* 7 (November), p. 33.

[Exhibition review: Tony Shafrazi Gallery, New York]. *New York Times*, November 6, p. B3.

Larson, Kay. "Underground Man" [exhibition review: *Future Primeval*, Queens Museum, New York]. *New York* 23 (November 12), pp. 94-95.

1991

Galloway, David. "Keith Haring: Made in Germany." *Art in America* 79 (March), pp. 118-23.

Moehl, Karl. [Exhibition review: University Galleries I and II, Illinois State University, Normal]. *New Art Examiner* 18 (April), pp. 37-38.

Stuttaford, Genevieve. [Review: *Keith Haring: The Authorized Biography* by John Gruen]. *Publisher's Weekly* 238, no. 38 (August 23), p. 53.

Zvirin, Stephanie. [Review: *Keith Haring: The Authorized Biography* by John Gruen]. *Booklist* 88, no. 2 (September 15), p. 130.

Gruen, John. "Wild about Haring." *Vanity Fair* 54 (October), p. 164.

Patrick, Stephen Allan. [Review: *Keith Haring: The Authorized Biography* by John Gruen]. *Library Journal* 116, no. 16 (October 1), p. 96.

Bonetti, David. "He Wore his Art on his Sleeve." *San Francisco Chronicle*, October 13, p. C 1.

Baker, Kenneth. [Review: *Keith Haring: The Authorized Biography* by John Gruen]. *San Francisco Chronicle*, November 3, Review sec., p. 4.

Plagens, Peter. "The Young and the Tasteless." *Newsweek* (November 18), p. 80.

Brown, Christie. "The Hazards of Deathbed Speculation." *Forbes*, November 25, p. 208.

Levin, Eric, Lorenzo Carcaterra, and Sara Nelson. "Picks and Pans" [review: *Keith Haring: The Authorized Biography* by John Gruen]. *People* 36 (November 25), p. 43.

Bromberg, Craig. [Review: *Keith Haring: The Authorized Biography* by John Gruen]. *Times Literary Supplement* 4628 (December 13), p. 17.

1992

Henry, Gerrit. [Review: *Keith Haring: The Authorized Biography* by John Gruen]. *The Print Collector's Newsletter* 22 (January/February), pp. 223-24.

Rosenberger, Jack. "Haring Estate Sues Playboy." *Art in America* 80 (May), p. 160.

Tacoma News Tribune, February 8.
Elle Decor (March).
Des Moines Register, April 18.
Philadelphia Inquirer, July 19.
Entertainment Weekly, July 24.
Reading Eagle, July 31.
Australian Vogue (August).
New York Times, August 1.
Allentown Morning Call, October 24.
Boston Herald, October 30.

1993

Miami Herald, January 15.
Newsweek, January 18.
Palm Beach Post, January 24.
Harper's Bazaar (February).
Miami Herald, February 21.
Travel & Leisure (March).
Schweizer Illustrierte, March 15.

1994

Daily News Record, May 2.
Art and Auction (May)
Flash and Art (May/June)
Santa Barbara News-Press, June 28.
San Jose Mercury News, June 28.
New York Newsday, June 28.
Long Island Newsday, June 28.
New York Times, June 28.
Gainesville Sun, June 28.
New York Post, June 30.
Max Magazine, June (cover).
New York Newsday, June 28.
New York Times, June 28.
Dan's Papers, August 26.
Nashville Tennessean, August 17.
Condé Nast Traveler (September).
Palm Beach Society (September).
Boston Globe, September 8.
Die Zeit, September 9.
Die Tageszeitung, September 10.
Boston Herald, September 16.
Kultur/Szene (October).
Vanity Fair (November).
Boston Herald, November 2.
Palm Beach Daily News, November 27.
Palm Beach Post, November 27.
Oakland Tribune, December 9.
Ithaca Journal, December 10
San Francisco Examiner, December 12.
Jerusalem Post, December 23.

1995

Berkeley Grand Times (January).
Greenwich Time, January 16.
New York Times, January 19.
Greenwich News, January 26.
Hartford Cournat, January 22.
New London Day, January 22.
Greenwich News, January 19.
USA Today, January 27.
Boston Herald, January 27.
Phoenix Gazette, January 31.
Art Direction (February).
New York Times, February 19.
Film/tape World (March).
Art Business News (March).
Antiques and the Arts, March 3.
Greenwich Time, March 19.
Chicago Herald, April 8.
St. Louis Post-Dispatch, April 13.
Vivien Raynor. *New York Times*, April 16.
Citizen Register, April 17.
New York Times, May 21.
Greenwich News, June 8.
The New Yorker, June 12.
Anastasia Aukeman. "Out of the Subways: Cave Painting Goes Pop."*Art News for Students*, (November/December).
Telegraph Magazine, London, December 23.

1996

Roberta Smith. *New York Times*, March 8.
Paper Magazine (May).
Publisher's Weekly, May 6.
Calvin Tomkins. *The New Yorker*, July 8.
The New York Times, July 21 (excerpts from *Keith Haring Journals*).
Vince Aletti. *Out Magazine*, July.
Michael Wiener. *Time Out New York*, July 24 - 31.
Glen Helfand. *The Advocate*, July 9.
Harriet Zinnes. *The Philadelphia Inquirer*, August 25.
The Washington Post, August 25.
Brooks Adams. *Art in America* (October).
Flash Art (October).
The Guardian Weekend (U.K.), October 5 (excerpts from *Keith Haring Journals*).
Stephen Greco. *POZ* (November).
Richard Flood. *Artforum/Bookforum* (November).
Michael Thompson-Noel. *The Financial Times*, Weekend November 9/10.
Elisa Turner. *Miami Herald*, November 8.
John McDonald. *Sydney Morning Herald*, December 28.
Diana Simmonds. *The Bulletin*, Sydney, December 31.

1997

Joanna Mendelssohn. *The Australian*, January 3.

Index of Names

Photographic Credits

Galleria Salvatore Ala, Mailand p. 10 (top); Plates 43-46, 54, 55, 60, 61, 67, 68
Barry Blinderman (photo Michael Sarver) pp.27 (bottom), 28 (top)
C.A.P.C. Musée d'Art Contemporain, Bordeaux, France plates 105, 106
Gianfranco Gorgoni frontispiece
The Estate of Keith Haring p. 15 (bottom), 29; plate 182
—Brian Albert plates 51, 177-179
—Tseng Kwong Chi pp. 28, 30, 51-53, 116-121; plates 3, 6-9, 64, 65, 69, 70, 95-98, 102, 104, 125-127

—Joseph Coscia, Jr. pp. 14, 16-19; plates 13, 17, 21, 28-32, 34, 37, 47, 80, 89, 109, 110, 137-169, 173
—Klaus Richter p.21
—Joseph Szkodzinski p. 10
—Ivan Dalla Tana back cover; pp. 11 (bottom), 13 (top) 21; plates 12, 18, 56, 57, 74, 78, 91-93, 103, 108, 128-136
Galerie Paul Maenz Cologne (photo Ivan Dalla Tana) plates 53, 62
Galerie Hans Mayer, Düsseldorf p. 25 (bottom)
Phoenix Art Museum p. 16 (top)

Tony Shafrazi Gallery, New York plates 5, 19, 20, 52, 180
—Brian Albert plates 1, 11, 22-24, 124, 176, 181
—Joseph Coscia, Jr. plates 25, 26, 33, 77, 101, 175
—Ivan Dalla Tana fronz cover pp. 9, 12, 13 (bottom), 23, 25 (top), 27 (top); plates 2, 4, 14-16, 27, 35, 36, 38-42, 48-50, 58, 59, 63, 66, 71-73, 75, 76, 79, 81-88, 90, 94, 99, 100, 107, 111-123, 170-172
Drew Straub p. 50